DOING RESEARCH IN DESIGN

DOING RESEARCH IN DESIGN

Christopher Crouch and Jane Pearce

BERG

London · New York

English edition
First published in 2012 by
Berg

Editorial offices:
50 Bedford Square, London WC1B 3DP, UK
175 Fifth Avenue, New York, NY 10010, USA

Berg is an imprint of Bloomsbury Publishing Plc.

Library of Congress Cataloging-in-Publication Data

A catalogue record for this book is available from the Library of Congress.

British Library Cataloguing-in-Publication Data

A catalogue record for this book is available from the British Library.

ISBN 978 1 84788 580 7 (Cloth)
 978 1 84788 579 1 (Paper)
e-ISBN 978 0 85785 219 9 (individual)

Typeset by Apex CoVantage, LLC, Madison, WI, USA.
Printed in the UK by the MPG Books Group
www.bergpublishers.com

CONTENTS

LIST OF ILLUSTRATIONS

The illustrations have been chosen to represent key concepts and the more complex methodological processes.

INTRODUCTION

The purpose of this book

This book has been written to help the designer become an independent researcher. It takes a new perspective on what design research is and what it does, drawing from discussions in the design and research communities. It provides a practical and theoretical context for design research and then offers a set of research strategies that are applicable to the particular circumstances of the designer. Design research (research within design) and research into design (research from outside design that looks into design practices) are established activities in professional practice and in academia, and this book aims to familiarize the reader with ways to approach researching professionally and productively.

The distinction between researching from within design and into design is briefly discussed in Chapter 2, but our position throughout is a practical one. However, while this book privileges the idea of designers researching from within their practice, there will be occasions when designers will be researching other specialist design practices that they are unfamiliar with. Doing research in design involves adopting a broad range of concepts and strategies and applying them to a wide spectrum of circumstances.

Research that is productive for the designer is research that examines the practices of the designer, the ways in which design is produced and the effects of design upon the end user. The practices of the designer (discussed in Chapter 3) are technical, intellectual, individual and social and cut across other creative and scientific disciplines. It seems unreasonable to make too strong a case about the uniqueness of design when other disciplines (such as the medical profession) are currently enriching their practices by absorbing new ideas from outside their professional knowledge base (Bolam, Glesson & Murphy, 2003). There are aspects of designing which are particular to design, but much about the way in which designers work as professionals within socially established ways of thinking has resonance in other professional practices. Sometimes designers have to examine their own practice, and sometimes, the practice of others. In both circumstances, a variety of research strategies is needed.

The many ways in which design is produced, either in the form of objects or as organized systems of management, are key areas of investigation that respond both to research from within design itself and to research that takes a broader view. The process of production or the product itself may rely on systems outside the

designer's initial understanding, or the consequences of production might impact upon other interests in ways that the designer did not foresee. For example, ethical designers may wish to research the ways in which their products are made and their systems administered, or a company may wish to understand how its design team can be best motivated to work with the material and economic framework it has adopted for a new product. Such research requires strategies that enable designers to explore the broader contexts in which an object is conceived of, produced and consumed. To research an object is not just a case of making objective measurements of materials and production costs, central though such information is to the design process.

Similarly, the end user of products and systems needs to be considered from a number of perspectives and not simply as a user of a single item. Objects and users interact with one another in different ways in different circumstances. It is impossible to think of researching end user use of a washing machine, for example, without an examination of gender, physical ability, washing needs, ideological attitudes to environmental issues, concerns over energy consumption and so forth. Researching the designer and his or her products, and systems and their relationships with the end user requires an ability to move in and out of different frames of reference. To be able to conceive of the interrelationship between maker, object and consumer is also to begin to understand why a single approach to researching cannot possibly find a way of revealing the complexity of designing and its effects.

Research is fundamental in the conceptualizing and marketing of products both tangible and intangible, and the thought of producing designed objects without a rigorous testing of materials is unthinkable. There is an abundance of texts that instruct and inform research strategies for creating prototypes, for developing and testing technical material and system processes, for articulating marketing goals and understanding user needs. Because these texts are specialized and focused on discrete areas of practice within design, they are often unable to provide a broad picture of how design and research work together. This book addresses that gap by providing a foundational understanding of what design and research do at their most fundamental level.

Throughout the book is the explicit assumption that design is transformative. By that we mean that design has an effect on the world, both the man-made world and the natural world. That transformation is sometimes purposeful and sometimes incidental. In the discussion about design research, the ways in which the individual designer is connected to the processes of social and environmental change is unravelled, with the intention of making design researchers fully aware of the surrounding circumstances, how they interact with them and how they impact upon them. The proposition is that an understanding of research can empower designers to make their ideas tangible in objects and processes, and understand the effect they can have on the world. Our intellectual, emotional and physical environment is moulded by the processes and objects of design. It is this constructed environment that in turn informs the next wave of design innovation. Understanding the cyclical

nature of thinking and doing in design, and understanding how these processes feedback and influence one another, enables the designer to move seamlessly from understanding the processes of design into an understanding of the processes of research. The act of researching is also transformative; its results can alter the individual practices of whoever is undertaking the research and can also influence the broader field of practices in which the individual acts. The intention of this book is to explain the links between the ideas and the conceptual processes that contribute towards the creation of objects and systems that facilitate change.

The transformation of the world that takes place through design is both material and conceptual. Materials are changed into objects that effect changes in our world and affect how it is thought of. New thoughts about the world alter the way in which it is perceived and how it is managed through organizational systems. The material world *and* the world of ideas are the realms researched and managed by designers. This is not a new phenomenon. Although they weren't called designers at the time, the architects and engineers of the industrial revolution were designers who researched the conditions of the material world in order to develop ideas and mechanical systems to better manage it. They developed new ways of using industrially produced materials, and their research and their designs were to effect such enormous change that it continues to shape the way we live and behave today. For example, Isambard Kingdom Brunel (1805–1859) redesigned and developed existing iron and steel technologies so that these materials could span greater widths and support greater weights in buildings and bridges than ever before, but he was also a designer of systems. He designed a railway system; then he further conceptualized it to create an integrated system of transportation that saw goods moved across Britain by railway to docklands on the west coast, which were then transferred onto metal boats and transported across the Atlantic to the United States. Brunel's work as a designer can be seen as a series of discrete projects such as a bridge, a railway station, a railway line, a ship. But it can also be seen as a coherent body of work in which his research and design was unified in the production of objects and systems informed by his understanding of materials (Pugsley, 1980).

Materials, ideas and systems have always interacted together in design with an interdependency that becomes more complex as their dependency grows and new social and cultural conditions develop. Contemporary design is in part immersed in the possibilities that digital technologies increasingly offer us. These technologies inform the design of systems for managing people, products and communications and have created contemporary design disciplines such as Web design and games design. Digital technologies have also revealed fresh ways of understanding how industrial materials can be used. Frank Gehry's Guggenheim Museum in Bilbao (completed in 1997) is a good early example of this, where his use of computers made his intuitive and expressive drawings technically and economically viable (Forster, Gehry & Richter, 1998, p. 11). In the contemporary fashion industry, computer programmed laser cutting and etching is used to decorate cloth. As textiles become increasingly removed from handcrafts, the ways in which the potential for

using cloth is understood will inevitably be affected, in the same way that Gehry's use of computers changed the way in which the potential for expressive form in architecture is understood.

Understanding the relationship between materials, ideas and systems is fundamental to comprehending the design process. The knowledge that comes from that comprehension is the result of research. Sometimes research is unstructured, as when talking over issues with friends while a task is in progress. Other times it is structured, such as when the designer has to gather information in order to begin the task of designing. The technical skills of the designer are developed and improved by the conscious examination and application of them. It follows that the ability to make judgements about when, where and how they might be applied can be improved by a conscious examination of how research is undertaken.

Design research is the investigation of how materials, ideas and systems operate and intersect in the processes and objects established by design. Design research also investigates the way in which those objects and processes then further impact upon the world and in turn influence how materials, ideas and systems operate. The more we reflect on the way in which the world of designing is part of a network of functional and social activities embedded in the natural world and the built environment, then the more necessary it becomes to find out how this can be used to the designer's advantage. Research into these relationships is part of the designer's equipment, and when it is used carefully and strategically it can enable the designer to be more insightful about his or her practice, enabling it to become more productive and more creative.

The designer's continual interconnectedness between the built environment and the natural world, between physical and intellectual modes of communication, between software and hardware, has been the lens through which we have focused on a portfolio of research practices that act as a core set of investigative processes for the design researcher. We have taken a big picture approach to design research practices, and while acknowledging the importance of specialist research practices into the nature of materials or the development of service and system design, we have chosen research practices drawn from the social sciences. This is because design is a social and cultural activity. We will later discuss in more detail the relationship between the social and the cultural, but for this introduction it is enough to say that cultural practices are created by social groupings of people in societies. Designers develop the social infrastructure of our lives (things such as drainage and sewage systems, transport systems, power-generating systems and medical systems) as well as enrich our lives through more obviously cultural activities such as communication design, product design and service design.

Research in the social sciences examines the way in which the lives and practices of individuals are bound up in the material circumstances that surround them. The research strategies of the social sciences provide a holistic approach to understanding design and designing. Research into the specifics of the design process, such as consulting end users, collecting data on materials and testing the efficacy of systems,

will be implicit in the strategies suggested and will be raised explicitly in the brief cases presented in the book. In choosing this approach, we have stressed the importance of the individual designer, yet still acknowledge his or her relationship with the wider network of surrounding concepts and practices whether that happens as part of working in a team or when finding solutions to design problems individually.

During the course of this book, we slowly change the way in which we refer to the design researcher. Initially we make reference to the designer and the researcher separately as we establish links between their two practices; then in the course of Chapter 3, the distinction between designer and researcher ceases to be made. From that point we talk of the researcher with the assumption that the reader knows we are talking of the design researcher and the researcher into design. This strategy does have its drawbacks and there are occasions when we draw back and separate out the designer and researcher to compare and contrast their separate professions. This book makes a pragmatic case for encouraging designers to embrace a systemization of thinking processes that are already implicit in the way they practice.

How this book is structured

The book starts with three linked chapters that discuss the cultural and theoretical positioning of the designer, explain the way in which designing and researching are similar, and discuss how thinking about practices can improve the ways researching and designing take place. The relationships between the designer and the design institutions are understood differently depending on how the researcher frames the designer. Chapter 1 is spent examining what design is and what the designer does, to enrich the designer's understanding of how research fits into that picture. We also introduce, define and give working examples of a number of terms from design, research, philosophy and sociology that are used throughout the book to explore the possibilities for research in design.

Chapter 2 builds on the relationship established between researching and designing and draws from designers' ideas about how the designer thinks and practices. Part of this practice involves understanding the relationship between questions, problems and solutions. How to frame questions and how we think about creative thinking—where ideas come from and how we can best develop them—is a useful way of demonstrating how central research thinking is to designing. Research is not an activity that runs parallel to designing but is a process that is already embedded in it.

The third chapter deals in detail with the ways in which practices may be conceptualized, and shows how framing them in different ways alters our view of what we do as researchers. The act of research is introduced as a specialist way of understanding the world, and it is proposed that with a practical understanding of what research is, and how it functions, research principles can then be applied in a measured and productive way in designing. In this chapter we also develop the ideas of

the consequences of thinking and acting in a transformative way and suggest that if design and research do transform, then an understanding of how that transformation works at a personal and social level is an empowering position for the designer and researcher.

Chapters 4 and 5 lead into the remainder of the book. These chapters focus on the ways in which research can take place and provide readers with a generic understanding of research tools and processes that are particularly significant for designers. The subsequent chapters give a more detailed examination of four fundamental methodologies: ethnography, narrative, case study and action research, with suggestions for how each might be applied to problems emerging from different design contexts, giving examples of when and how they could be used. Following each of the chapters on methodology is a series of brief sketches of possible research projects drawn from different specialist areas in design and using the methodological approach that is the focus of each chapter. In each sketch we identify a possible research focus and frame a research problem, then suggest some sensitizing concepts, recommend appropriate methods for data collection and analysis, indicate the type of data that would result, suggest what type of research text might be produced, and indicate who might benefit from the proposed research. We follow this pattern in each of the chapters on research methodologies.

Finally, the question of how to tell the 'story' of the research is addressed, with a discussion of the different possibilities for presenting research in and about design to different audiences.

How to use this book

The structure of the book mirrors the processes involved in thinking about and planning research in and about design. It begins with a philosophical orientation that invites you to think about design practice and reflect on how research might inform it. The chapters on methodology and research processes focus on developing a general plan for a research project, informed by an understanding of methodology, and the final chapters focus in on different research approaches, providing ideas about how to conduct the research and create the final research text. We suggest that when working through the book you take time to think through the questions for reflection provided, and begin to keep a record of this thinking as your ideas about researching develop and become clear.

1

POSITIONING THE DESIGNER

The world of designers is already close to the world of researchers. This chapter starts by positioning designers within their everyday practices, and then positions those practices in a broader context of what goes on around them, with the intent to establish an 'ecology' of design. An understanding of what a designer does and how that practice sits within a design ecology will provide concepts that can be used later to understand the practices of research and of the researcher.

A basic strategy for both the designer and the researcher when faced with a problem to solve is to ask questions. Using this strategy, a series of questions might be asked about what designers do. Is a designer someone who possesses a specific skill that is applied to a specialist area, or someone who has a set of transferable skills that can be applicable across a range of specialist areas? Does a designer produce objects, or systems and strategies to make things happen? Does the designer work individually or as part of a team? A questioning process like this could be endless in the attempt to describe everything the designer does, and although it is good to get a glimpse of the range of activities that constitute designing, attempting to define what a designer *is* by saying what the designer *does* is akin to saying that electricity is something that makes refrigerators, hairdryers and torches work. While it is perfectly true, it is not the whole picture. A greater sense is needed of what lies at the centre of being a designer. One way to do this is to go straight to existing sociological and philosophical ways of understanding the world, and then apply them directly to the work of a designer. In this way we can move backwards and forwards between ideas about the real world and real life to see how they illuminate each other.

What the designer does

The specialist tasks facing the designer range from the disciplines of cybernetics to engineering and the built environment, with the colloquial view of design as something rooted in the visual and the object sitting somewhere in the middle.

What unifies the design disciplines is the transformation of cultural and social life that happens as a result of designing. These acts of transformation initiated by design have become bigger and more complex in a world in which the interaction of local and global actions has resulted in a new word, 'glocalization' (Roudometof, 2005). In the glocalized economy, designers work in a space where their actions are both more far reaching than ever before and at the same time more personally circumscribed.

Because of the complex chain of events in the production of mass clothing in industrial societies—where specialists shops, customers, textile manufacturers, clothing manufacturers and transport systems are all involved in the venture of making sure clothing sells—the fashion designer effects transformation over materials and people. But fashion designers are not necessarily autonomous. The designer is subject to demands from the producers of textiles to ensure their products are used, clothing manufacturers want clothing that can be assembled economically, the customer demands certain styling and the retail industry is always trying to promote new consumption through new designs. The designer has to work within those competing constraints, and at no point in the process are decisions made without some kind of research. For example, the Swedish fashion company H&M has several dozen global production offices where local staff are responsible for liaising with the suppliers and manufacturers of H&M products (mainly in Bangladesh, China and Turkey). The production offices ensure that products are produced according to quality specifications and test for things such as shrinkage, twisting, colour fastness and dry rubbing. In some cases, production centres are asked to turn around goods from conception to consumer within three weeks (Runfola & Guercini, 2004). Designers are not just involved at the fashion level but also in processes of materials testing, developing systems for sourcing, testing production and so on. Designers who are unable to position themselves personally and institutionally are unable to function at their best. The need to identify and develop research strategies for designers are evolving as designing itself becomes increasingly complex (Cross, 2001). Finding out who designers are and what they do determines how to find ways of researching that can benefit them.

The designer works within both a society and a culture. These two concepts are linked and in colloquial language often used interchangeably. At this point they must be separated in order to understand their differences as well as their similarities before the terms can be used efficiently as analytical tools. A culture is the network of objects and ideas that *communicate meanings* to the members of a particular group of people. A society is a group of people who *live together* within a particular physical territory and who share a sense of identity. Some societies can be very big, others very small, but all share the phenomenon of having attitudes and behaviours characteristic to the group, and shared objects and ways of living (or material practices) that produce a culture of mutually understood meanings and values. Different societies have different cultures. For example, the design culture that emerged from the practices of the society created by the Soviet Union in the

1920s is different from the design culture produced by the post–Second World War society of the United States. In her review of theories about design, the design historian Helen Armstrong describes the Soviet designer Alexander Rodchenko as utilising 'new technology and mass production in an attempt to give form not just to revolutionary concepts of functionalism and economy but to ideal citizens as well' (Armstrong, 2009, p. 27). We can compare this view with a 1950s perspective of design from a design exhibition catalogue from the New York Museum of Modern Art which proposes that 'democratic' freedom 'leaves no room for total standardization in the furnishings of a home. . . . Modern design for the home is more appropriately used to create an atmosphere of "the good life" than of "a brave new world"' (Kaufman, 1950, p. 8). Here, two different views of the cultural expectations of the designer emerge from two different societies. One cultural view is of the designer as someone in a planned economy who designs the collective environment in which individuals live; the other is of the designer working within a consumer culture who designs for individuals who wish to mark their domestic environment with a personal touch. The designer working within those differing contexts is still designing, but within markedly different social and cultural circumstances. The designer practices in an ecology that is both material (to do with production and objects) and ideological (to do with ideas about the purposes of production and objects).

The individual designer positioned

At this point what can be said is that a designer practices what is called design. This may seem like a very obvious and rather naive point to make, but in making it, it suggests two things. Firstly it suggests that the designer is someone who is autonomous (who has the capacity to make decisions independently). Secondly it proposes that what the designer is doing is understood by others as being a specific way of thinking and acting in the world. (One's cultural activity as a designer is moulded by surrounding social circumstances.) These observations can be developed by saying the designer has a set of unique practical, intellectual and emotional attributes that are used to facilitate the way in which the world is understood by others. Some of those ways might be considered inappropriate by one society, but not by another. This suggests that design is not a fixed and unchanging set of practices, but is fluid and responds to different conditions in different circumstances.

There may also be differing expectations within a single society about what designers should do. An extreme example from the contemporary world might be whether designers should help to design bombs or prosthetic limbs. Different groups of people will hold different opinions, but still belong to a shared social and cultural space. Raising these points reinforces that what the designer does is to design, and that the purposes and products of design are the result of other discussions about the world into which he or she fits. The designer is someone who is autonomous and who has insights into the nature of the world, and who is also in a constant dialogue with the social insights and expectations of others. These other

insights and expectations may be congruent with, or contradictory to, those held by the designer. The views about design that surround the designer may be developed by institutions, such as governments or museums, or held by individuals who align themselves with such views. If the proposition is now restated that 'the designer practices design', it is clear that at the core of this statement is a dynamic relationship between the individual designer and what can be called 'institutional' views of what design is.

Is it possible to find a way of talking about the way institutions influence the role of the designer that encompasses the different aspects of what the designer does? A key thinker about how institutional views are formed and how they act on us as individuals is the French philosopher Louis Althusser. He argues that an individual is defined by his or her social function, that a 'single subject', a 'such and such individual' (that we can call a designer), has ideas that are 'material actions inserted into material practices governed by material rituals which are themselves defined by the material ideological apparatus from which derive the ideas of that subject' (1971, p. 158).

The idea of the 'such and such individual' is a way of describing how someone constructed by an institutional view is understood. We might say, 'Who is that?' And an answer might come, 'That is Ann; she is a designer.' What is happening in this exchange is that the body of ideas and practices that Ann is engaged in becomes the way in which we define who she is. In this way she becomes incorporated into an institutional model of what a designer might be, and as much as she is an individual, Ann is also defined through her design practices as a designer. That is, to use Althusser's words again, she has been identified as an individual who designs: a 'such and such' individual. How might our brief Althusserian definition now unfold?

We can assume that Ann's ideas about design are turned into real designs (her 'material actions') which become part of the way in which designers work ('material practices') within the design community with its codes of professional conduct ('material rituals'). These professional practices (it is not unusual to hear the phrase 'best practices' used colloquially in the design industry to talk about the way things should be done) that Ann is engaged in are regulated by the value systems that are promoted by organizations such as governments, design associations, museums and companies ('the material ideological apparatus') that formed the ideas about design that Ann had in the first place! Institutional ideas about what design is and what it should do have helped form not only her identity as a designer but also what her *role* might be as a designer.

This theoretical model gives a very deterministic view of the designer. That is, Ann has been constructed as someone whose identity has been conditioned by a set of institutional traits, but of course this is only half the picture. In describing the objective, or measurable, conditions that impact on the designer, what has been neglected is the sense of autonomy that the designer has; that sense of self and uniqueness which allows personal interpretations of circumstances to evolve. This

personal, emotional and intuitive aspect of understanding the world it what is called a subjective viewpoint.

The designer's identity

It is important to find a way of discovering how to talk about the relationship between the subjective world of the individual and the institutional values that affect that world, not only for designers but also for researchers. If it can be understand that design is the result of a negotiation between the designer and the objective circumstances that shape the world that the designer works within, then it helps us to understand that research is similarly the result of the researcher attempting to resolve their inquiries about the world. A useful concept in talking about how individuals negotiate with the social and cultural institutions that surround them is that of *reflexivity*. This concept will be the subject of a closer examination in Chapter 3 but is briefly introduced here in the discussion about the designer.

Reflexivity is a sociological term used by two sociologists whose work is featured throughout the first chapters of this book: Anthony Giddens and Pierre Bourdieu. Giddens uses the term reflexivity to describe the processes of learning about who we are and of creating our identity. Pierre Bourdieu uses it as a way of trying to ensure that social scientists are aware that the subjective cultural position the individual holds may influence the way in which he or she understands new information. Both writers describe reflexivity as a process that enables individuals to identify their subjective relationship with the objective world.

Giddens suggests that 'What to do? How to act? Who to be?' are the central questions that individuals living in complex contemporary consumer societies perpetually ask themselves (Giddens, 1991, p. 70). His argument is that the complexity of contemporary life, with its multitude of options for behaving and interacting with the world, means that we have to *work at* discovering our identity. He suggests that the construction of our self-identity is something we engage in continuously, whether it is through the clothes we wear, the films we watch or the values we promote. These views and actions might be at odds with our family's values, or cut across national boundaries, or rest inside a very narrow set of traditional cultural boundaries. Hence designers may have aesthetic views that are in opposition to those of a client, or to those of the institution where they are being educated. Giddens suggests that the reflexive process of understanding who we are (and we do this by looking at how we are constructed by outside influences, how we are moulded by institutional attitudes and how we then negotiate with them in order to find our own voice and values) is in effect a continual process of writing our own biography as we live it.

There is a distinction here between the invention of a fantasy life and the quest to realistically engage with the outside world. Giddens makes the point that the individual's construction of self-identity cannot be fictional if the individual wishes

to maintain real relationships (and these could be personal or professional) and that the individual 'must continually integrate events which occur in the external world, and sort them into the ongoing "story" about the self' (Giddens, 1991, p. 54). To relate this back to our task of positioning the designer, let us revisit our example, Ann.

Ann is a designer because she has been identified by others as working as a designer, but she has also chosen to work as a designer and has made a series of conscious decisions to strategically position herself in that role. She has done this by making a series of life decisions that range from big issues, such as what she should study at school and college in light of discussions with her family about her career options, to smaller ones such as choosing the spectacle frames she wears and where she goes to have lunch with her friends. Ann is a designer because others see her as conforming to the conditions that define her as one, but she has also constructed herself as a designer through symbolic acts (choosing her accessories) that identify her as part of a group and by entering into a set of institutional relationships (choosing her course of study) that will enable her to become part of the profession.

The concept of reflexivity has a threefold relevance. Firstly it is a useful idea to set against the view of Althusser. Althusser's model of how institutional values mould us doesn't allow much autonomy for the individual. Using Giddens's way of explaining identity, we can see that Ann has been acted upon by the institutions that have told her what design is, *but* she has also acted and chosen to accept some of what she has been told in the past and rejected other advice (maybe to study urban design rather than advertising), otherwise she wouldn't now be at this juncture of being identified as a designer. Secondly, using Giddens's ideas about the way the individual interacts with institutional structures suggests both that we have the intellectual and emotional space to negotiate with the institutions that form us and that we make choices (either consciously or unconsciously) about who we wish to be. Thirdly, the ability to understand who we are, what our views are and where they have come from allow us to try to position ourselves as objectively as possible in both the act of designing and of researching. Just as Ann's childhood delight in the colour purple should not necessarily impact significantly on every piece of design work she undertakes as an adult, so too the researcher's personal worldviews must be put aside if they are to be able to see the world as objectively as possible. This may seem obvious, this idea of both acting and being acted upon, but until it is understood how we have been constructed as designers or researchers by this process and can articulate it to others, we cannot fully understand how to research. This is the whole purpose of this book.

The context of designing

How may this discussion of the designer both acting and being acted upon be developed? There are two approaches we wish to introduce now, one from a sociologist and the other from a philosopher. Pierre Bourdieu, a French sociologist, and

Jürgen Habermas, a German philosopher, both deal with the dynamic relationship between individuals and their social and cultural context. Successful design and research is dependent upon the meaningful exchange of ideas between individuals and the cultural and social circumstances they find themselves in. By looking at the intellectual, emotional and material structures that enable these exchanges, it is possible to examine the different ways the designer enters productively into cultural and social dialogues.

So far it has been determined that designers have a subjective understanding of the world that they use to interact with an objectively existing environment that defines what they do. We have variously described that environment as being institutional, having to do with professional practices, and being bounded by sets of ideas. These sets of ideas can also be called ideologies, and Althusser's definition of ideology as 'the imaginary relationship of individuals to their real conditions of existence' (1971, p. 109) is quite a useful one. Bourdieu's most famous work, *Distinction: A Social Critique of the Judgement of Taste* (1984), examined ideas about art and culture in France (through data he collected about visitors to the country's art museums) and attempted to explore this notion of the 'imaginary' relationship people had to their 'real' cultural surroundings. The kind of questions he asked were: Why do some people make art and others consume it? How does culture help to interpret and understand the world? What kind of role do people from different social and cultural origins give to cultural artefacts? The 'distinction' in the title of his book refers to the practice of exercising aesthetic choice and how this practice of distinction is informed by the economic, social and cultural experience, or in Bourdieu's own words, the economic, social and cultural 'capital' of those who exercise it.

The social and cultural capital reserves that the individual can draw from are used to frame their understanding of the world, and the way in which they are used is the way in which the 'imaginary relationship with the world' develops. The more individuals know and the more socially adept they are, the more likely they are to be able to understand the complexities of how the world is organized. The reverse is also true; the less cultural information individuals possess and the more socially excluded they might be from the activities of an institution, the more difficult it is to understand the way in which institutional life operates. For example, if Ann is offered a job as a member of a design team engaged in the restoration and redevelopment of an eighteenth-century precinct in an Irish town but knows nothing about the cultural and historical contexts from which the precinct emerged and how that might be echoed in the development, then her contribution will be minimal. If she is asked to help design a system of signage for a Danish company relocating to China and she knows nothing about the conventions of signage in China, then again she is destined to exist in a contextual haze. If she were to attend a meeting with an elderly and conservative client wearing a Death Metal T-shirt then that, too, might impact her ability to communicate effectively, and prompt ways in which she might be positioned within the client's worldview. This sometimes conscious, but often

unconscious, exercising of social and cultural capital results in individuals acquiring symbolic capital within their surroundings. This symbolic status may be expressed in a number of ways in the world of design, from the owning of design companies and receiving awards for creative work to attaining a respected status amongst one's peers or achieving high-ranking administrative roles in teaching institutions. An important idea to grasp here is that the notion of symbolic capital is not a neutral one. It is dependent upon a shared understanding of the context in which it is exercised. We will return to this idea shortly.

Habitus and field

Two concepts that Bourdieu developed as ways of understanding the literal and metaphorical spaces in which these forms of capital are exchanged are 'habitus' and 'field'. Bourdieu's ideas are endlessly debated, but they are applied here as a way of understanding what it is to be a designer, and not to argue their legitimacy or their details (Danaher, 2002; Jenkins, 2002). For the purposes of this discussion, the first question that needs to be raised is: what is the 'field'? There is a colloquial English language question, 'What field are you in?' It allows professionals to quickly determine a colleague's specialism. So the concept of field already has an everyday meaning that we may build on, but it has to be developed very rapidly so that it is understood not just as a professionally designated space but also as a much more complex environment where individuals and institutions interact to produce hierarchical sets of the 'material practices and rituals' that have already been encountered.

The field is a space that is demarcated by individuals and their actions, institutions and their debates. Bourdieu was examining what he called the cultural field, a vast metaphorical expanse of overlapping concerns and specialisms. We could talk of a field of commodity design operating within the field of design, and that field might in turn be intersected by a field of German design. The field of design does not exist just because a series of design institutions say it does. It also exists because outside the design field, in the wider field of cultural production, there are institutions deciding what is art and what is design, what is design and what is engineering, what is design and what are management systems, and so on. The field of design further exists because, within it, formal and informal groups of designers and individual designers contest what each other is doing by making reference to what is going on in and outside of the field. This contestation takes place through actions in which participants with differing cultural and social capital reproduce and transform their ideas. The word contest is used here, rather than debate or discuss, because not all the participants engaged in this contestation of ideas and material actions possess the same amount of social and cultural capital, and their symbolic capital within the field might be different. This means that there is a struggle taking place in which some participants are more powerful than others, and it is their views (or acts of discrimination) that are the only ones considered. What Bourdieu

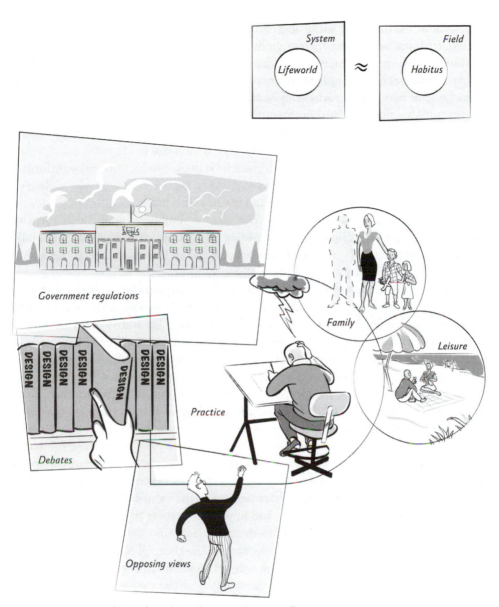

Figure 1 Habitus, field, lifeworld and system (Stuart Medley).

suggested was that these fields can be studied objectively in order to understand their hierarchies of discrimination. That study is part of the researcher's job.

The reproduction of dominant ideas and their transformation in the design field can be seen to be taking place in the theoretical discussions found in books, magazines, journals and design school seminars. It takes place in the founding of design

partnerships, in design schools, and in the ways in which these institutions are staffed. It also takes place in the design of goods for the consumer market, in designing bureaucratic management systems, in design for sustainable production and so on. At every level of designing there are opposing views and approaches about what looks good or bad, what works well or what doesn't. What the individual designer does is to find a space within these practices that can be claimed as his or her own. Sometimes it is easy and sometimes it is difficult to do this. Even finding regular work as a designer is part of this bigger struggle within the field.

One way in which Bourdieu characterized how the reproduction and transformation of the cultural field takes place was to develop the idea of 'symbolic violence'. It is valuable to look briefly at his term and see how it is made manifest in the world of design. We have already mentioned the idea of symbolic capital, that form of capital that is based on the success of wielding social and cultural capital. Generally speaking, the higher the reserves of economic, social and cultural capital the higher the symbolic capital of the individual will be. With symbolic capital comes material power. Material power gives individuals and groups of individuals the ability to promote ways of looking at the world that favour them, and sometimes the ability to control or change the way in which others live their lives. It is often characterized by wealth and the benefits it entails. Symbolic violence describes the way in which order in the field is maintained at arm's length, by those who possess material power in the field. Symbolic violence is a kind of power that is not fully identified as such by those suffering it. Bourdieu calls the failure to identify this exercise of power 'misrecognition'. This is because the wielding of power through the managing of ideas and people is often invisible to those who are being managed. The reproduction of the values of the most powerful group by the least powerful in this way is often seen as unproblematic because those in the field reproducing these values are also not necessarily aware they are doing so. Values are personal or cultural belief systems that form the basis for action, and so the values of the field frame the way in which the individual operates and how their actions are given worth.

How might the designer excel within the field? Can, for example, a designer start to practice before he or she has been educated in the principles of design? The field says 'No', and for good reason. No one wants to use medical equipment that has been designed by someone with no understanding of the medical procedures they will be used for. In the same way, no one wants to use a computer interface that has been designed by someone who doesn't use computers. There is an objective purpose in ensuring that designed objects function and designed systems work because design is a social practice and these aspects of the designer's education are regulated for our collective health and happiness.

Research is useful in discovering where rational regulation in the design field slips into systemic violence. Different institutions (whether educational, professional or informal) vary in their emphases, and it is legitimate to ask why they promote certain practices and not others. What aspects of design are privileged, and why? What kinds of design practices and outcomes are rewarded by professional associations?

Who chooses what is designed? These are the sort of questions designers can ask themselves in attempting to plot their position in the field, and in so doing are reflexively engaging with the institutional values that have moulded their values. These are also questions that can and should be asked by researchers. During this process of questioning, designers may find they hold personal positions that either challenge or support dominant value systems. They might also become aware that their field is bound by cultural or material expectations that they have not previously been able to see or articulate.

How can this be? Bourdieu explains it in this way. Individuals within the field are so caught up with that field's practices, both emotionally and intellectually, that they start to live within the confines of the field and its values. They begin to inhabit the field 'like a garment' (Bourdieu, 2000, p. 143), comfortable inside it and displaying their own identity through the wearing of it. To continue Bourdieu's simile: How many buttons are on your shirt? Who made the shoes you are wearing and where? What are the proportions of renewable, sustainable and finite materials in the outfit you are wearing today? Just as we may not instantly know the information needed to answer those questions without a closer examination than is usual of what we are wearing, on examination, our position in the field might be revealed to be different from how we first assumed it to be.

This is a very important insight for researchers, because as Bourdieu points out researchers need to know how their own views might intrude into what they are researching and distort their understanding of what is going on. Researchers need to be reflexive in order to understand how they are being influenced. But how does reflexivity relate to designers? How does this need of researchers to understand their position in the field correlate with a need for designers to position themselves? We would argue that there is exactly the same need. The designer needs to objectively assess a problem in order to be able to solve it productively in just the same way as the researcher aspires to the condition of objectivity, as impossible as that condition might be, in order to critically examine information. Understanding the concept of misrecognition in relation to the exercise of power is an essential part of the reflexive process for both the designer and the researcher, for 'misrecognition also helps us make sense of the double dealing strategies whereby leaders, managers, officials or delegates of a field appear to be acting in a disinterested or principled manner "for the field" and its values' (Danaher, 2002, p. 26).

Misrecognition is one of the consequences of not fully understanding the way in which we operate in the field. In order to be as independent as possible, we have to struggle for autonomy within the field. In this way, by discovering how we are framed by the field's values and then making decisions as to whether we wish to be framed in that way, we are able to create a personal 'space'. Bourdieu calls the personal space we inhabit the 'habitus'. He uses this word to describe the way in which we behave and live our daily lives in response to the way that the field might organize us. Our habitus appears to us to be common sense and natural; it becomes a space that we regulate 'without being in any way the product of obedience to

rules' (Bourdieu, 1990b, p. 53). This is really the key to understanding habitus. It is of our own making, but made unselfconsciously. We can see it as a response to the conditions of the field because it is intimately connected with our experiences, which are the result of our engagements with the external world. But it is only by engaging reflexively with the institutions that mould us that we can reveal our habitus. The field and habitus are intimately linked, almost inextricably so, unless we make a conscious, reflexive effort to look at their interconnections. We will develop this premise in more detail in Chapter 4.

Lifeworld and system

Habermas talks about the relationship of individuals to their institutional surroundings in a slightly different way. He talks about 'lifeworld' and 'system'. In this model, the personal world, which is formed through informal and unconscious negotiation with the institutions that regulate us, is called the lifeworld. Habermas's lifeworld is roughly similar to the concept of Bourdieu's habitus in that it is a subjective realm, and is the result of the individual coming to terms with the systems of economic and governmental management that operate in a modern consumer culture. In Habermas's view, institutions try to manage the lifeworld of individuals in an attempt to legitimize their institutional existence. Unlike Bourdieu, whose intention was to objectively map the (often difficult) relationship between individual and institutional relationships, Habermas makes the *a priori* assumption that the relationship between the subjective and objective realms are antagonistic, and that individuals are already compromised in their relationships with contemporary economic and civic institutions. He calls this institutional encroachment on the individual's lifeworld 'systemic colonization'. Once again it is the reflexive process of understanding how this 'colonization' of the individual takes place that opens up a space for what he calls 'communicative' action, that is, a way of remediating the circumstances that individuals find themselves in. The difference between Habermas's and Bourdieu's approach is the 'distance' they have put between their viewpoint and their object of study. Bourdieu takes a detached view. He has observed power relationships in the field and has tried to devise a way of characterizing and analysing them. Habermas on the other hand has already arrived at a decision as to how the world is and is now interested in finding ways by which individuals can work against the acts of control that they see as being exercised against them.

As an example, Ann's aspirations as a designer were based on her experience at high school and her individual reading about design. In her reading she was exposed to the work and ideas of designers such as Raymond Loewy and Neville Brody who worked across design specialisms, rupturing assumptions about how things should look and in the process produced designs that were to change the paradigms of what design could and couldn't do. Ann also collected knick-knacks from second hand shops that caught her eye, and thought carefully about her wardrobe. In this way, ideas about design were incorporated into her lifeworld. At university she

studied in a design department where the philosophy for design was 'the client gets what they want' and in which she was taught standard solutions to standard design problems. During her course she was encouraged to think of taking up immediate employment in the local franchise of Doubleplusgood Printers. She was also constantly admonished for not sticking to marking criteria and for having unrealistic daydreams about design having dimensions beyond the cutting and pasting of images and text and making models of retail interiors. Not only was Ann's lifeworld subject to colonization by the immediate agents (to use Bourdieu's term) of institutional systems, those agents were themselves colonized by bigger ideas about the role of the designer, the function of education and the value of established design practices within a consumer culture. By engaging with her circumstances reflexively, Ann was able to determine how she was being colonized/acted upon and chose to change the institution she was studying in.

If we were to think of Ann's experiences in terms of habitus and field, we could see that she made a reflexive decision to examine the way in which her habitus was being formed by the reproduction of certain practices in the field. She chose to contest them, and part of her decision to change institutions was made with the ultimate intention of transforming those practices. What of those in her peer group who remained? According to Habermas, their lifeworlds were successfully colonized by a dominant set of ideas. According to Bourdieu, they had misrecognized the practices in the field and were reproducing them, oblivious to the ways in which their further movement in the field might be controlled by them.

Ann redesigned her future after having researched her problem and the solution to it. This illustrates our idea that the designer is someone who not only designs *but also researches*. How the designer and researcher might be positioned within the field is dependent upon their reflexive engagement with it. As we shall be examining in more detail in the following chapter, the things they do and the processes they employ when they design and research are very similar. In the meantime we might say that like any other individual, both designer and researcher:

- have a lifeworld/habitus;
- exist within a system/set of material and ideological practices/field;
- have the potential to reflexively examine their position within that system/set of material and ideological practices/field;
- have the potential to act as well as be acted upon;
- have the potential to reproduce or transform the system/set of material and ideological practices/field in which they are positioned.

The discussion in this chapter could be summarized by saying that the designer brings objects and systems into fruition with the intention of facilitating action in the world outside the designer. The reason this point is raised is to introduce one last concept that will be developed in the book. That is the idea of praxis. Like reflexivity this is a concept we will be talking about in more detail in Chapter 3, but by

way of introduction we can talk about praxis as the dynamic relationship between thinking and acting, between theory and practice.

The designer and the researcher act within a social realm. The work that they do is not private: it has the purpose of making a mark on the outside world and its structures. An aspect of the individual/institution dialogue that we have talked about above is the way in which institutions mould thinking. We have so far neglected the way in which thinking leads to acting. Like our definition of the designer as someone who designs, this might at first glance seem to be a very obvious thing to say; of course thinking leads to action. However, the dynamic relationship between thinking about the world (theorizing) and putting those thoughts into action is something that has obsessed philosophers since the ancient Greek philosopher Aristotle first talked about 'praxis'.

Praxis describes the way in which thought becomes action. In the models of habitus and field and lifeworld and system that we have discussed we have seen that there is a dynamic relationship between the circumstances that surround an individual and the ways in which that individual acts. Praxis is a way of approaching the dialogue between the two from yet another perspective, from that of the individual. Briefly, praxis is the term we use to talk about the interrelationship between thinking and acting, and reflecting on the result of our actions. It should be immediately obvious that designers need to continually consider how their actions impact the social world.

The reason we have spent so long discussing the position of the designer is to be able to finally make this point. If the designer exists within a social framework where ideas about design objects, practices and processes, and questions about their validity take place in a series of political, cultural and social contexts, then that suggests that these contexts should be taken into account when engaging in any design process.

Researching is already part of the design process, whether it is finding out about the problem that needs solving, researching the qualities of materials, working through the efficacy of a system or reflexively engaging with other designers or clients on a project. It is from this position that we argue for the usefulness for designers of research ideas and processes that have their origins in social research paradigms.

The next chapter examines how the designer thinks about problems and about finding solutions to them. Using ideas developed by designers who have reflexively engaged with design processes, we discuss ways of raising questions about design and research problems.

2

WHAT DO DESIGNERS AND RESEARCHERS DO?
THINKING, DOING AND RESEARCHING

Previously it was discussed how, using ideas drawn from philosophy and sociology, we can conceptualize what a designer does and how the individual designer might be placed into a bigger picture of social and institutional design values. We have argued that the central concern of designing is the transformation of the world, and in this chapter this idea is developed with the intention of enabling readers to apply their knowledge of themselves as designers to their developing understanding of the research process. Some time is spent identifying the ways in which designers think and the ways in which design thinking has links with research thinking. By the end of the chapter readers should be able to identify the similarities between design and research, and understand that research is a component of design. Later on, in the main body of the book, the appropriate research strategies for different design tasks will be unravelled, but at the moment we approach the relationship more broadly.

In order to understand the relationship of the design problem to its solution, an exploration of the role of the research question is central. A problem is a difficulty that presents itself and needs a solution. It is a condition or a circumstance where there is gap between what we want or need to happen and what is actually happening. The questions that are asked about problems are central to understanding what the problem is. Problems for designers exist at every level of designing, from overarching issues such as managing river flooding to small issues such as finding a suitable adhesive for foamcore boards.

Over the last fifty years, ideas about the ways in which designers think have centred on the jump that the designer makes from thinking about the problem to ways of solving it. These 'creative leaps' are not the sole preserve of the designer, though designers exploit them in their discipline more than others. Such leaps are colloquially ascribed to intuition, but here we develop the idea that just as the brain thinks logically and procedurally so, too, there are ways in which the brain comes rapidly to conclusions based on accumulated bodies of information. This rapid decision-making is the subject of continued study because the rapidity in which decisions

are made is difficult to follow (Lehrer, 2010). Philosophers have called this intuitive way of thinking, 'abductive' thinking. By categorizing and examining the way abductive thinking is related to solving problems, it is possible to gain an important insight into the designer's thought processes. We suggest ways in which research can amplify and work with this insight, principally by aligning research thinking as closely as possible to the habitus and lifeworld experience of the designer.

We shall also discuss 'wicked problems': problems that are so complex that they have no single solution, are in fact never solvable, and require continued

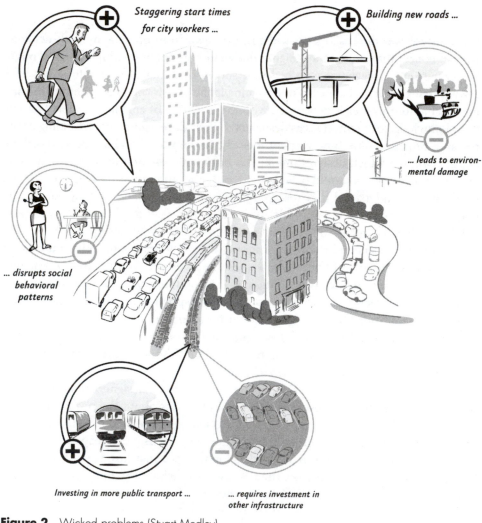

Figure 2 Wicked problems (Stuart Medley).

research in order to be kept within our understanding. In the light of their complexity, collaborative design principles, where problems are addressed by designer and user together, are often the way forward in dealing with complex design problems, and in such cases research is of paramount importance. The contingent nature of solutions for wicked problems, where 'solutions' are qualified by further conditions or circumstances that follow on from the first in a continuing train of transitional resolutions, means that the researcher needs to have a broad grasp of how differing aspects of problems are interrelated. At the end of the chapter the idea of 'sensitizing concepts' is raised as a way of framing problems that provide the researcher with a variety of perspectives that enable different readings of the same issue.

Initiating change

Designing and researching are not new partners. Designers have always thought about what they do and have always researched information to help them tackle the tasks they are faced with, but the history of the formal relationship between research and design as we know it today goes back to the founding of the Design Research Society in the United Kingdom in 1966. The society was formed out of the interest generated by a mould-breaking conference in 1962, the 'Conference on Systematic and Intuitive Methods in Engineering, Industrial Design, Architecture and Communications'. It was held at the department of aeronautics at Imperial College in London, and the intentions of the convenors were in part to erode the discipline boundaries associated with different specialist design activities in an attempt to discover the links between them. It represented an important institutional response to the new conditions that surrounded design. The importance of thinking about the broader function of design and the functioning of designed goods had increased after the Second World War as social dependence on designed industrial goods became ubiquitous. Increasingly the everyday life of the western consumer was one lived inside a designed world. In his book *Design Methods*, first published in 1972, John Christopher Jones (who had been one of the conference convenors and was a key figure in the founding of the Design Research Society) wrote that:

> Perhaps the most obvious sign that we need better methods of designing and planning is the existence, in industrial countries, of massive unsolved problems that have been created by the use of man-made things, e.g. traffic congestion, parking problems, road accidents, airport congestion, airport noise, urban decay and chronic shortages of such services as medical treatment, mass education and crime detection. These need not be regarded as accidents of nature, or as acts of God, to be passively accepted: they can instead be thought of as human failures to design for conditions brought about by the

products of designing. Many will resist this view because it places too much responsibility upon designers and too little on everyone else. If such is the case then it is high time that everyone who is affected by the oversights and limitations of designers got in on the design act. (Jones, 1991, p. 31)

This is an important observation that we have included in its entirety to reinforce the centrality of the function of design as a means of identifying and solving problems that exist in the world. These are often problems that are to do with the effects of both designed objects and designed systems. In the introduction to his book, Jones argued for a vision of design that could be understood not just by its processes but also by its results, and suggested a definition of design as something that initiates change in man-made things (Jones, 1991, p. 4). The purpose of a solution is to initiate change in order to resolve the problem, and this relationship between problem and solution has become a central one in contemporary ideas about the ways in which designers think (Lawson, 2008). If design is about initiating change in man-made things, and we would suggest that there is such a compelling body of opinion around this proposition that it can be assumed to be the case (Berman, 2008; Brown, 2009), then the questions of why change is needed and how it is best facilitated are both central to designing and researching.

If we return to Jones's observation about the problems caused by man-made things, we can see that its wider implication is that it is necessary for the designer to understand the interconnectedness between design decisions and their outcomes, and hence take notice of the broader social consequences of design and designing. By taking an example of a problem that he raises—the issue of 'parking problems'—we can elaborate on how the act of initiating change can in this case be more broadly contextualized as having effects in the social realm. Let us assume that the problem surrounding parking is a lack of car parking space in a historic town centre that was designed before the advent of the motor car. One solution might be to design an object and build a car park; the other might be to design a system and increase the provision of public transport so that drivers choose not to drive into town. In 'solving' the problem, both approaches have added further material consequences to the original problem. In the first instance, the way the physical nature of the town would be changed would in turn alter how civic space is both used and thought of. Where is the car park to be situated? Is it an open block or multistoried structure? Does it sit in the centre of the town or on the edge? In the second instance, an efficient public transport system might considerably diminish the use of private cars, which in turn impacts on the collection of parking revenue available to maintain civic spaces. From these initial observations emerge the even bigger considerations of how private and public access to shared spaces is managed, how environmental issues might impact upon designing for communities, and how the rights of citizens to use their cars wherever they want is compromised. The 'solution' and the 'problem' are thus obviously intertwined, and without some kind

of initial scoping of the consequences of a design decision, the success of the design is likely to be only partial.

Thinking about questions, problems and solutions

How does research relate to this concept of the design problem and solution? Bryan Lawson in his book *How Designers Think* (2008) maps out the nature of problem and solution in design thinking. We want to look at his main ideas and match them to research thinking. We must also make the point at this early stage that both a design 'problem' and a research 'problem' are different from a design or research 'question'. We will be talking in more detail about this in the methodology chapters, but it is useful to establish our terminology early on. A problem can be considered as an unresolved dilemma or circumstance, or an obstacle to the resolution of a task. A question, on the other hand, is an intellectual tool for eliciting information and, in relation to design and research, it's a way of eliciting information about strategies for resolving dilemmas or the resolution of a task. We think that the introduction of the question into the mainstream contemporary thinking about the problem/solution dialogue is a useful addition to ways that designers might think about researching.

Lawson suggests that design problems cannot be comprehensively stated because of the impossibility of being sure when all the aspects of a problem have emerged (2008, p. 120). In research, a problem might need a question to act as a starting point to resolve what the problem actually is. The problem and the question about the problem move backwards and forwards with one another, and it is this asking of questions that stimulates ways of finding solutions just as much as determining what the problem might be. For example, an increasing shortage of water for suburban gardeners in Australian cities means that 'traditional' lawn-based, water-hungry gardens cannot be maintained. This problem of water shortage can be framed in a number of ways. By asking the simple question, 'Is the problem the shortage of water, or the gardeners' demand for it?' the problem is still rooted in the fundamental condition of water shortage, but the problem is no longer just about a lack of water. It's also about how water might be managed better. Another question might ask whether there is a shortage of water because of a decrease in the amount of water available or because of an increased demand for what is there. What at first might appear to be a problem about how to get more water to users (that could be solved in part by rationing) can be reframed by making the problem an eradication of the need for water by reducing the need for it (solved in part by encouraging the planting of drought-resistant native plants). What started as a single problem, through judicious questioning, becomes a series of different problems with different solutions.

Lawson says that design problems 'should be seen as in dynamic tension with design solutions' (Lawson, 2008, p. 120), and this makes sense if problems are conceived not just in abstract terms of materials and product (water and use) but also in

terms of initiating change (why water is used) through the strategic asking of questions. If we place design and research into a social context then what constitutes a problem will shift as ideas in social and cultural contexts change. It is impossible for us to determine the value of either things or information, or to determine what problems might be, without making reference to the dialogues that take place between ourselves and the institutional values that construct the practices we engage in. To explain this point we can say that the shortfall of water needed to maintain a dazzlingly emerald lawn in Australian suburbia is after all only a problem if one thinks such a lawn is a desirable addition to the world. Lawns are disastrous environmentally, but for many who possess a lawn they are seen as aesthetic necessities. A native garden full of plants that need little water encourages native birds and insects but looks ill-disciplined to those whose aesthetic sensibility has been framed by a tradition of gardening based on English parks management. Given the fraught relationships between habitus and field, it should not come as a great surprise to us that problems of this nature can be difficult to define and fully uncover.

Lawson's next point reaffirms this notion of contingent value. He observes that 'design problems require subjective interpretation' (2008, p. 120). This is affirmation that, far from being the objective, scientific activity that modernist designers such as le Corbusier and Walter Gropius said it could be, design is as subject to the vicissitudes of the subjective struggles in the field as every other discipline. Lawson makes the point that an understanding of design problems and the information needed to solve them depends on our ideas for solving them. We have addressed this issue in the paragraphs above, but it is worth adding that subjectivity is both a tool for making creative jumps as well as also being a handicap in research unless one reflexively engages it. The experience of the habitual mower of lawns frames the world differently from the experiences of the bush walker, and if the individual can acknowledge his or her subjectivity and realize that personal approaches to a problem can both frame the problem imperfectly and provide an interesting insight, then that is a useful default position.

Lawson's last point about design problems is that they 'tend to be organized hierarchically' (2008, p. 121). By this he means that problems are interrelated and follow on from one another. He suggests that it is beneficial to 'begin at as high a level as is reasonable and practicable' in addressing them. For the researcher this is a useful strategy, too, but it does not preclude breaking the problem down into its interconnecting parts before attempting to find ways of addressing the overarching or meta-problem. This research view is intimately connected with one of Lawson's observations about design solutions. 'There are . . . no optimal solutions to design problems but rather a whole range of acceptable solutions' (Lawson, 2008, p. 122). What we can extrapolate from Lawson's observations is a model that suggests a network of problems and solutions in design that are in a constant state of play with one another. Nigel Cross in his book *Designerly Ways of Knowing* reinforces this 'co-evolution' (2006, p. 114) of the design problem and solution. He acknowledges that

there is 'still considerable work to be done to establish a reliable understanding of design cognition' (p. 114), but even with this qualification it appears that research into how designers practice reveals that this constant dialogue between problem and solution—where one feeds the other—is fundamental.

We can summarize what has been a dense and discursive couple of pages in these key points.

- Design and research are about initiating change in man-made things.
- Initiating change puts design into the social realm, where research already sits.
- The dynamic relationship between problem and solution in the social realm means that a solution is never in itself complete, and may well reveal, or create, new problems.
- A question is the mechanism that can model the problem/solution dynamic.
- The role that individual subjectivity plays (in framing problems, questions and solutions) needs to be acknowledged as both a help and a hindrance in these processes.

Thinking productively and abductive thinking

Jones builds on Broadbent's views (1966) that originality is hampered by routine on one hand and wishful thinking on the other. Broadbent goes on: 'These are evident when a person acts either in a far more regular way than the situation demands or else is incapable of perceiving the external realities that make his [sic] ideas unfeasible' (Broadbent, 1966, p. 29). We would further argue that the role of the research question is to help elucidate not only the problem/solution dynamic but also to create a space in which the individual can take stock and see a space between the two where they are able to engage with that dynamic. The question thus becomes part of a broader reflexive engagement with the problem.

We can further develop Jones's point that routine hampers originality by introducing the idea of a 'paradigm'. A paradigm is the generally accepted view about a topic within a discipline or within the field. Paradigms can be challenged and tested in the field as we have already seen. Those paradigms might be intellectual, ideological or be based on outdated research into what materials can do. A good example of the shattering of paradigms in design is the invention of television. As Raymond Williams points out in his book *Television: Technology and Cultural Form* (2003) the majority of the technology that was to be used in the development of television in the 1920s had been available for forty years or more. What stimulated the amalgamation of parts into a unified artefact was what he calls the 'social dimension' (2003, p. 10) in which new ways of thinking about images and their transmission changed the paradigms of why and how it could be achieved. Routine is something that is governed by paradigms, and routine is the expression of the limits of an 'accepted view'. Questions are useful ways of finding out about the limits of paradigms for sometimes they are self-imposed limits on thinking about subjects and practices. Given this we suggest that when designers and researchers work towards a goal they are also engaged in intellectual processes that include:

- evaluating paradigms of practice;
- interpreting paradigms of practice;
- identifying problems;
- assessing/evaluating problems;
- using intellectual tools to conceptualize/analyse/make meaningful a problem, to make it capable of being understood or solved;
- testing intellectual and practical paradigms to understand/solve the problem.

Engaging in these intellectual processes helps to resolve existing problems and/or develop new ones. The same processes also apply to solutions.

Cross makes the point that the 'ill defined nature of design problems means that they cannot be solved simply by collecting and synthesising information' (2006, p. 52). The solution to a problem emerges during the reflexive process of its resolution, and information gathering and ordering are not enough *by themselves* to provide solutions. The 'opportunistic' resolution of a problem that suddenly appears as if from nowhere is sometimes called intuition (2006, p. 52). We would like to develop Cross's suggestion that, rather than talk about 'intuition', it is better to talk about 'abductive' thinking. We wish to widen his view of it as something that is particular to design thinking and suggest that it is a way of thinking that can be found in research and indeed in any form of practice that requires a solution to a problem.

The debates around how it is that we can make jumps into new knowledge based only on what we already know goes back (at least) to Plato (1901). Rather than recommend the reader to hasten to their Plato, it is probably better to start with Charles Sanders Peirce and John Dewey. Both of these philosophers identified that the ability to acquire new insights or new understandings of a subject, seemingly without prior study, is a particular way of thinking akin to others that are more readily identified, such as inductive and deductive thinking. This transformative way of thinking they called abductive thinking. Peirce suggested that deductive thinking proves something must be the case, and inductive thinking shows that something is in operation (Hartshorne & Weiss, 1934). Deductive thinking allows us to reason that orange peel left on a tabletop indicates the past presence of a complete orange or of a person eating one, because deductive thinking is based on logic and allows us to make assumptions that should be correct. It is inductive thinking that might lead us to think that orange peel and kitchen tables are operationally related. Inductive thinking points out relationships, and can be the basis for providing theories about what may or may not be the case about the relationship between things or information. While inductive thinking can encourage speculative thinking, it is through abductive thinking that we are able to make leaps that connect information together rapidly, and decide about how things *might* be put together to make sense of them. Abductive thinking encourages us to think what *might* happen, or what *might* be the case, or what could happen if things were rearranged. Abductive thinking often takes place unconsciously and decisions are arrived at quickly, hence its colloquial name 'intuition'. It is abductive thinking that could lead us to see orange peel on a

kitchen table and view it as the ideal material for making scary orange teeth that, having been shaped with a kitchen knife, can be inserted skin facing out, serrated edge down, under the top lip.

All these categories of thinking are directly applicable to the process of designing. Let us imagine there is an issue with the use of hardwood planks used for flooring in a wooden frame house. Hardwood planks are useful in such construction because they can be screwed down easily to floor beams with power tools, they are hardwearing (unlike soft woods) and they are a material that homeowners find aesthetically attractive. The problem is that they are both expensive and environmentally unsustainable. Thinking deductively it follows that if hardwood planks have been traditionally used as flooring, and if their use has proven to be successful for practical and aesthetic reasons, then the continued use of wood *in some form* would be advantageous as a flooring material. Inductive thinking that identifies the operational relationship between floors, wood and users allows us to form ideas from our observations about the kinds of flooring that homeowners prefer. Abductive thinking, however, allows the designer to develop his or her deductive observations and make a jump from making planks from unsustainable hardwood to using sustainable hardwoods reconstituted into plank form. In the eighties and nineties, teams of designers looked at the potential for bamboo, used traditionally for thousands of years, to be used industrially. Understanding the lateral strength of bamboo, and understanding how bamboo has been used traditionally in woven form to create strong containers and panels, a system was devised in which the fibrous strands of bamboo poles were first separated out, then woven together again (to increase their strength), and finally compressed under heat and extreme pressure in moulds in standard plank lengths. The finished product appears to have a linear grain like a solid plank and has the same aesthetic qualities. Treated this way, bamboo becomes twice as hard as oak and is therefore extremely durable. It has the benefit of being quick growing and therefore sustainably managed, and cheap to harvest. How did the jump from a hollow pole of variable diameter into a simulation of a logged and sawn hardwood plank take place?

Common sense dictates that abductive thinking has to come from a base set of experiences. There has to be preparedness for making abductive decisions so that when different issues are put together for the first time, the individual is able to make that imaginative jump from one issue to the other and then back again. Without an understanding of orange peel's material qualities, there can be no realization that it can be cut into new shapes. It is equally unlikely that someone without knowledge of bamboo's properties and how it has been traditionally used could conceive that its cylindrical form can be so radically altered by heat and steam. Equally, why conceive of the transformation of bamboo into planking without the initial need to recreate planks? The designers who saw the transformation of one set of qualities (narrow vertical poles) into another (wide horizontal boards) needed an intimate knowledge of both sets of information to be able to make that transformation. There is an element of metaphorical thinking being used here as well,

comparing one thing with another in order to understand it better. The often-used description by town planners of parks as the lungs of urban communities is a powerful metaphor that conveys the need for green spaces in industrial cities far more potently than would a didactic position that lays out the deductive thinking behind the need for them.

In acknowledging the complex nature of designing, Cross quotes the structural engineer Ted Happold who worked on the Sydney Opera House and other landmark international buildings and who founded the United Kingdom's Construction Industry Council. 'I really have,' said Happold, 'perhaps one great talent; which is that I don't mind at all living in the area of total uncertainty' (2006, p. 53). It is uncertainty, the rejection of routine and the questioning of paradigms, that creates the open space in which abductive thinking seems to thrive. To relish uncertainty as a condition for abductive thinking is as valuable for the researcher as for the designer. Abductive thinking is an intellectual tool that crosses disciplines, and is as much use to the researcher as deductive and inductive thinking.

Wicked problems

The limits of deductive and inductive thinking are revealed by the concept of the wicked problem. The wicked problem concept emerged from social planning and as a phrase has its origins in an article published in 1973 by Horst Rittel and Melvin Webber (Rittel & Webber, 1972). A wicked problem is a problem that is highly resistant to any kind of solution and is contrasted to the idea of the 'tame' problem. The tame problem is not necessarily a simple one, but one that can be readily defined. The wicked problem is a problem that responds to different formulations depending on who is asking the questions about it. We can say that depending on one's habitus or lifeworld experience, or dependent upon one's social, cultural and symbolic capital, a problem could be interpreted from many different viewpoints. When the problem becomes lost in the middle of multiple causes and when different formulations of the problem generate multiple solutions, then we can say it is wicked.

A wicked problem stretches the problem/solution dialectic we have established almost to breaking point. It may seem odd for the authors to set up a way of thinking and then attempt to demolish it, but we are doing so deliberately because that is what researching is like. The model of problem/solution we have discussed before is one that is commonly seen as being central to design, and works well when the problem is seen from a controlled set of perspectives. However, by its very nature this dialectical formulation implies that ultimately there is a solution to a problem, and all that is needed to ensure the success of this dialectic is the use of significant questions. We have observed already that a solution might in turn create new problems, but our observations up to this point have assumed that a problem is solvable. The issue of the wicked problem is that the problem/solution dialectic is framed from different vantage points with multiple value systems and conflicting goals.

Rittel and Webber suggested that there is no definitive formulation of a wicked problem because the problem and the solution are the same thing and every time a solution is proposed it changes the nature of the problem. This is a very different proposition to the idea that a solution may create new problems. Let us return to our previous example of parking problems in a historic town centre. The way in which we analysed the problem previously was to say that there is a problem parking cars because there is not enough space. We knew it was a complex issue and were aware that our different solutions formulated new problems. We framed the initial problem as something that was solvable though, and despite realizing that different solutions would cause fresh problems, we didn't question the initial framing of the problem. We went to the problem looking for a solution. Perhaps what we should have done was to look at the problem and say, 'There are so many factors impacting on this single issue, that to try and resolve it in isolation is impossible.' It would be wise at this point, when defining the design problem, to decide that the issue of parking cars is a wicked problem.

The idea that there is no solution to a problem is anathema to the orthodox designer or researcher. It seems to fly in the face of everything that a designer or researcher does, but we would argue it is actually a far more common experience than is generally acknowledged. When we can get used to the idea that not everything can be solved from a specialist perspective and that collaborative strategies are sometimes needed to do even simple things such as frame a question about a problem, the nearer we are to finding ways of managing design and research problems.

So in addition to our previous observations, we could now suggest that in understanding the relationship of the problem to its solution we must realize that sometimes there is no solution to a problem. We would argue that this realization, that the designer and the researcher possess strategies to engage in their tasks but that sometimes these skills are not enough in themselves, is a liberating one. This is because it makes us think about:

- using multiple systems,
- being flexible in our approach to problems, and
- working collaboratively.

Most problems are thought to sit on a continuum between the tame and wicked (Australian Public Services Commission, 2007, p. 6). This implies a sliding scale. A better metaphor is that tame problems sit within wicked ones. This we think gives a better indication of how the complex network of interaction takes place. A series of tame problems surrounding the parking of cars sits within the bigger wicked problem of cars and their use. If problems are looked at in this way, the contingency of solutions becomes much clearer. Some design problems can be solved through the production of an object; some research problems can be solved by the gathering of information. However, it is frequently the case that the way in which our lifeworld is colonized, and the way in which our habitus is formed through negotiation with

institutions in the field, render the interconnection of design practices and other issues opaque.

We can see from our discussions of the problem and its relationship to the solution that a whole range of skills are shared between designing and researching, because both of the skill sets are linked fundamentally in their engagement with the social realm—the way in which it is constructed, physically and intellectually, and the way in which that construction throws up other issues. The wicked problem initiates as many fresh challenges, whether its solution is addressed as a research question by a designer or by a researcher. Asking questions is fundamental to both the researcher and the designer; sometimes questions are framed inductively, sometimes deductively. In both designing and researching, the definition of a problem is fundamental to its solution, though sometimes the problem is unsolvable. We suggest that the question is an important tool in fashioning an understanding of what the problem is. By asking questions we can evaluate how problems sit in habitus/field relationships.

Empirical designing and researching

Some design problems may seem initially to sit outside the framing of them in this chapter. Functional items such as knives and forks, for example, may appear to be designed solely for use, and any research around them might appear to be of a purely empirical kind. Empirical research is the name given to a way of gaining information through the observation of observable phenomena. For example, what happens when materials are tested for suppleness, strength or longevity or designs are tested for their usability? In our cutlery example we might need to test how well balanced the pieces are, check the durability of the materials they are made from or assess how comfortable they are to use. In research like this, deductive thinking is used to deduce how useful or effective a planned design might be. Empirical research for design tends to be based around inductive and deductive thinking, where facts are gathered, ideas are formed and testing and evaluation takes places. We will talk about this process of planning, acting and reviewing in more detail and in relation to the idea of praxis in Chapter 3, and with regard to action research in Chapter 9. An examination of the history of cutlery and of the cutlery available in shops will quickly reveal that while empirical research into the use and economics of the materials used to make cutlery might be absolutely necessary, this research is counterbalanced by other issues which impact upon the way cutlery is used. Ideas about styling, marketing strategies that tie functional items up with bigger style trends, ideas about planned obsolescence and ideas about conspicuous consumption all impact upon cutlery's appearance. Even that most utilitarian of Western cutlery items, the spork, a functional hybrid of a spoon and a fork that is used extensively by campers, the military and fast food restaurants, can be found in different forms. Sometimes the fork tines project out from the spoon bowl and other times the tines are designed sitting within it. The

spork can be made of stainless steel or plastic, the use of materials determined by efficiency, but whose? Is it efficient to throw away plastic cutlery? It is cost efficient for those catering institutions that don't wish to go through the procedural bother of employing people to wash cutlery to throw dirty, cheap things away. But framed inside a bigger picture of sustainable production, resources management and waste disposal, the role of cheap plastic sporks need further examination. The spork designer sits within the field of cutlery design, but this field overlaps and interlocks with other design and social fields all with their conflicting ideological demands. We would suggest that even attempting to define function is a wicked problem.

Collaborative designing and research

Just as the individual designer is connected to networks of interlocking ideas, he or she is also always connected to other designers, systems and users. Designers have to think of their relationship to the processes and people involved in the change that their design initiates whether they are working independently or as part of a concept development team. At the heart of their practice, designers are people who have to work in cooperation with others. Sometimes designers choose to develop their skills by working with others; in other cases, the nature of design tasks are too complex to approach intuitively and singlehandedly: the design of a railway system for example, or a network of drains for a new housing estate or the evolution of a computer game. Complex design problems can no longer be solved without some kind of research. We now briefly introduce two examples of the way in which the designer has to work cooperatively, using the concept of co-design and the function of teamwork. We are doing this to show that inherent in the act of cooperation is also the act of research, even if the research operates at an abductive level. 'I wonder what the client will think of this?' is, after all, a potential research question even if it is not framed academically. We want to frame co-design and teamwork as activities that demand that the designer thinks in terms of interrelated activities that complement design creativity rather than limit it. If we can establish the value of this networking attitude as it currently exists in designing, it will be clearer for the designer to then understand how researching can become part of creative networking processes.

Co-design is a shorthand phrase used to cover a variety of design activities that all share the basic principle that the design process includes other participants, either individuals or communities, in the process of designing a solution to a problem. In research this is often called participatory action research (the process of which is developed Chapter 9). Co-design can also refer to the bringing together of human thinking and practices and machine systems, the development of which has increased exponentially as digital technologies have advanced. Co-design was first articulated in architectural design (King et al., 1989) where

cooperative and collaborative work by architects and end users led to a very different kind of designed environment, one that was in distinct contrast to the rigid town planning that characterized much of the sixties and seventies. Co-design tried to incorporate the lifeworld of the urban user of social space into the built environment, with the ambition that 'the economy, community, ecology and the whole way of life of [the user's] day' (Day & Parnell, 2002, p. 10) was integrated into a design. This approach has led to urban successes similar to the community design project in Bangalow in New South Wales, Australia, where the community was involved in the redesign of their small country town (Sanoff, 2000, pp. 231–239).

The success of this and other similar projects, which range from large scale architectural down to small scale disabled handicraft projects (Peters, Hudson & Vaughan, 2009), were the direct consequence of the partnership between design and user. The need for the designer to work alongside the user is a logical development of the client-based work that is the traditional staple of the designer, but in co-design of this sort the relationship is deeper and more intense. It is about changing the fabric of the man-made world with the focus on why and how change should be initiated and with the associated problem-solving shared between the designer and the end user. (In the chapter on narrative methodology we will discuss in more detail the role of narrative research, in which stories and life histories are researched to give insights into social practices that can be used to understand the habitus or lifeworld of the end user of a design.)

In some ways this kind of research is closer to the intimate relationship the crafts-person had with the user of their goods before industrialization. It was industri-alization that formalized and codified the practices of the designer into specialist areas to suit the needs of mass production, as the production of standardized forms of objects was a necessary part in the construction of an early consumer society. Co-designing is a development of a closer relationship with the individual user of design that mass production precluded. The co-designer is still an initiator of change in the man-made world, but co-designing principles suggest that the designer is also a mediator of change. The act of mediation requires an understanding of systems and how they interconnect. This kind of understanding cannot be acquired without research on the part of the designer.

Co-design also plays a role in the evolution of commodity design. It is over a decade since Gilmore and Pine wrote their article 'The Four Faces of Mass Cus-tomization' for the *Harvard Business Review* (1997). In it they examined the ways in which designers of business models were responding to the new opportunities in marketing and production largely afforded to them by the advent of what were then new digital technologies. Gilmore and Pine proposed that the future trend for mass producers of commodities was a form of mass customization of goods and services. They argued that consumers could no longer be thought of as members of a homogeneous market grouping, their research revealing that consumers often

customize the commodities they buy. (Gilmore and Pine use stronger language, saying that consumers are 'forced to modify' the products they buy.) It is true that those of us without recourse to *haute couture* clothing may change buttons or hems on mass-produced clothing, that shoes do often need insoles inserted, and that flat pack furniture may sometimes need adaption to fit the awkward corners of strangely shaped rooms. Gilmore and Pine however build an entire case around the need for consumer driven processes, arguing that 'collaborative customization replaces such back-end solutions with front-end specifications'. They argue that unlike the distributors of mass goods that wait for consumers to come to them, a collaborative approach not only delivers the commodity to the consumer but also customizes the delivery system. 'In effect' they say, 'there is no supply chain anymore; instead, a demand chain is created.'

The implications for the designer and the researcher of this adaption of co-design's origins are that design is no longer just about producing objects but also about designing the systems that facilitate the procurement and transport of raw materials and the production, distribution and marketing of objects. In such complex conditions new knowledge about design has to emerge from research into design, and the designers need research to understand the problems that they face. Working within a team becomes the only way in which these complex contemporary design problems can be fully identified and resolved. If one looks at the ideas promoted by the Next Design Leadership Institute, what is clear is that a new conception of design is emerging (what the co-founder of the Institute, G. K. Van Patter, calls social transformation design) in which the concept of multiple stakeholders and organizations interacting with multidisciplinary design teams will increasingly become the norm. This is because it is the only way in which wicked problems can be fully addressed. This does not mean that old design practices disappear. Rather, they become incorporated into the bigger design picture where design is no longer seen as a series of objects and events but as a network of ideas and practices. Using the design and research skills that are needed to solve problems within a collaborative network might involve working individually or as part of a team. Whatever the case, team-based and networked designers need clear communications frameworks as working as a team member requires additional skills to those that are used when the designer is working alone.

There is an increasing dialogue between design and research in the contemporary design field. New practices in both fields inform the other, and just as it is clear that the networked designer is designing differently from the designer working on his or her own, so too the researcher is part of a wider community, what Wenger (1999) calls a community of practice. Wenger and Lave's observations, which may seem obvious now they have been absorbed into mainstream thinking, are that individuals do not learn on their own but in a social environment. It follows from this that gaining knowledge is not a process of individual acquisition but achieved by participating socially. The need to understand team behaviour and the processes

of collaboration becomes very important once this is understood. We would again propose that researching and designing are fundamentally linked activities in our new contemporary circumstances.

Thinking about research

There is a burgeoning group of designers and researchers engaged in contemporary discussion about research into design. The designer Gui Bonsiepe is a key figure in this community of practice because he is unafraid to frame big questions about the nature of design and research. He is both a prolific and practical designer and has proposed, 'The material base of products with their visual, tactile, and auditory conformation provides a firm base for the designer's work' (2006, p. 33). This pragmatism—which connects him directly to Jones's ideas of half a century ago about design and change—does not mean he is interested only in the material world. He uses this example to demonstrate that design is not solely about styling and how that styling communicates (sometimes referred to as the semiotics of design), but also concerns the ways in which design affects the world in any number of ways. He has proposed a design 'humanism' which he suggests is a form of designing organized to interpret the needs of social groups, in order to 'develop viable emancipative proposals in the form of material and semiotic artefacts' (2006, p. 30). Bonsiepe has spent his career talking continuously about the function and purpose of design in this way, trying to frame design practice within the field where it currently sits with the intention of repositioning it and framing new ways of thinking about it. His theorizing about design is also a form of research into design.

This framing of attitudes and principles towards design practice can be thought of in terms of what researchers call 'sensitizing concepts' (Patton, 2002). These concepts are theoretical devices that provide ways of starting to understanding the things or ideas we wish to research. Framing and organizing information in a thematic way through sensitizing concepts allows us to find a way to interpret it. We have already used concepts in this way. We have talked of habitus and field and lifeworld and system in the first chapter as a way of beginning to analyse what design is. In this chapter, by using the concepts of co-design and team designing to further understand the field of design as it currently exists, we are developing ways to interpret what is happening in the field and to explicate its values.

In his essay 'The Uneasy Relationship between Design and Design Research', Bonsiepe (2007) argues for the indispensability of research in contemporary design, and proposes a way of thinking about the sorts of design research that are taking place. The sensitizing concepts he uses to make sense of current research in design are 'endogenous research' and 'exogenous research'. By endogenous research he means research that has sprung up spontaneously from within the field of design. This kind of research has emerged from the material conditions of the act of

designing and is then returned back into the body of knowledge about design. It is a very concrete form of research, based within the discipline of design. Bonsiepe's aspiration for such design is that knowledge that emerges from research *within* the design disciplines then has the potential to be transferred to other disciplines. On the other hand, exogenous design research is the kind of research that looks into design practices from *outside* of the material conditions of acts of designing, and looks at design through the lens of other disciplines. Bonsiepe observes that this kind of research into design, while useful, is removed from the internal contradictions and confusions of designing itself. The danger is that research removed from an understanding of the internal contradictions of designing can lead to sweeping demands and judgements as to design's purpose. This makes it clear to us that the need for designers to do their own research and thereby to shape discourses about designing is paramount.

One way into the process of thinking about design is to ask questions that are framed by particular themes or 'sensitizing' concepts. The sensitizing concepts that we use in this book are centred on four ways of thinking about the design process that provide useful ways of starting to think about research. They are the designer, the object, the system and the end user. The ways in which they are used throughout the book are straightforward. The concepts provide ways into the initial ordering of your thoughts about the kind of research you choose to do, and will assist you in choosing the research methodology you will eventually use. As a first step towards identifying how ideas about the research process might be applied to your own research circumstances, you might wish to ask orienting questions similar to the following, bearing in mind that your own sensitizing concept might be an amalgam of the four we are using here.

- The designer. Does the research you are engaged in examine:
 - An individual's approach to designing objects or systems?
 - The ways in which an individual fits into a collective approach to design?
 - How an individual designer has achieved his or her design outcomes?
 - How you have approached solving a design problem?
- The object. Does the research you are engaged in examine:
 - The materials and processes used in the manufacture of an object?
 - How the object fits into a commodity market?
 - How the object has been conceptualized?
 - The social use and impact of an object?
- The system. Does the research you are engaged in examine:
 - The ways in which a system has been designed and functions?
 - The ethical or environmental impact a system has on a community
 - The ways in which a system can be established, modified or curtailed?
 - The collaborative nature of designing a system?
- The end user. Does the research you are engaged in examine:
 - The way in which the end user interacts with a system or object?

- ○ The end user's design needs?
- ○ The end user's design wants?
- ○ The way in which the designer can interact with the end user in the design process?

The next chapter moves into a discussion about what research is, the way in which it relates to design and how it affects our understanding of what design practice is and what it does.

3

PRACTICE AND PRAXIS, REFLECTION AND REFLEXIVITY

This chapter introduces two sets of paired concepts—practice and praxis, and reflection and reflexivity—that help explain the way in which we think about practice in design and research. These concepts are important because they help link physical and social concepts of the world, giving us a unified sense of the way in which our actions impact ourselves and our surroundings. We further illuminate the way in which design and research are related to each other by discussing the nature of researching itself.

The first two chapters of the book developed the proposition that designing and researching are processes of initiating change in the manmade world. This ability to initiate change is what sociologists call 'agency', a term which describes the capacity of individuals to act in the world and which is a reflection of the empowered individual's ability to make decisions based on rational choices (Barnes, 2000). We have spoken of the way in which designers' and researchers' agency within the fields of design and research can lead to action, whether that action is the act of designing or researching or the co-relationship of the two. The ability to conceive of action, because of one's agency, enables change. It is important as a designer and a researcher to understand the way in which the change envisaged by action is understood practically and ethically. Practice and praxis are terms used to explain the way in which action takes place, and reflection and reflexivity are ways to begin to understand how we manage agency and actions.

Reflecting on the relationship between design and research, it is evident that there is an intimate relationship being thinking and acting at many different levels. The Japanese designer Kenya Hara is one of the contemporary designers who has built on Jones's idea of design as an initiator of change and who is now engaged in debate about the purpose and consequences of design. In his book *Designing Design* (2007), Hara proposes that to discuss the nature of design is not only an essential part of understanding what design is, but is itself a form of designing. Opening up the design process to scrutiny from all directions, and defining design

as a way of thinking as well as making, develops an understanding of design as research.

Practice

The researcher into design is active in at least two communities of practice, that of research and design. Researchers both look out from their community of practice and look into another. Researchers have to manage the task of being mindful of both their own subjective position and their aspiration for objectivity. Sometimes practices overlap seamlessly; sometimes they appear incompatible. If researchers are reflexive they will realize how they have been moulded by their own research community, how they operate within its paradigms, how they contribute to its maintenance and how this has the potential to frame the way in which they view other communities. This is a central insight into the way we make sense of the world and is of fundamental importance to researchers as they move backwards and forwards between different value systems and processes. It is in this way that new information is reordered and shared as applicable knowledge. In order to research well, and in order to research both the design community's practices and understand how the processes and aims of the research community frame the researcher, the researcher needs to examine what is meant by practice and how it operates.

We wish to introduce a working definition of practice (and practices) that draws from sociology. It has links to the colloquial use of the term(s), but differs in the way in which it is used. If we reflect on the conversational way in which practice is used, it is often used to describe an activity which is normalized and has been validated by an established authority such as a professional association. We wish to suggest that practice is not necessarily indicative of how things ought to be, and is not a 'commonsense' activity. It is in fact a body of knowledge that is in constant flux, responding to new material conditions and ways of thinking. Both research practice and design practice grow out of the relationship between agency, action and the social structure in which they are contested and validated. The tensions and contradictions within a practice are managed by the community that defines it. That process of management within the field privileges certain aspects of practice at the expense of others. This means that often the first task of researchers is to contextualize their research question and give it some sort of background in order for the framework and circumstances of their research question to be understood.

Practice is not just made up of 'doing', it is also related to ideas and theories. Ideas exist both as personal and as socially shared thoughts. They are the product of mental activity and can be the thought, or mental representation of something, or an abstract concept such as a belief or conviction. They are the result of testing or interacting objectively with the material world, or are produced through social interactions and adopted as part of a shared ideology. For example, one might be part of a design team that has been given a brief to simplify the feeding regime of intensively reared

chickens. One might have ideas about how much food and exercise a chicken needs in order to develop, which are largely objective ideas. There are also ideas about chickens that are less easily tested but which may nevertheless be held to be true. Such subjective ideas might include thinking it acceptable to intensively farm chickens in industrial conditions, where they have no connection to the natural world at all. Designers are endlessly confronted with design problems that emerge from ideas situated on this continuum from the objective to the subjective. As mentioned in Chapter 1, ideological positions are created in the relationship between subjective viewpoints and social consensus, and designers and researchers have to navigate ideological issues as much as practical ones when designing.

Theory

A theory is a set of ideas developed to explain facts. Sometimes a theory is based on objective data and sometimes it is speculative. To theorize is to speculate and construct explanations about the world and our relationships with it. Theories exist about ideas and objects, and can be tested against the material conditions of the world. Once put to the test they may be found to be useful or useless, but their intention is always to explain. Sometimes theories are not immediately testable. This may be because they are ideological, such as theological theories about the nature of gods, or more data may be needed before the theory can be proved, as is the case in contemporary theorizing about black holes. The designer and the researcher exist in a world of theories about design and research as well as in relation to the other theories that make up our ideological environment. Sometimes ideologies are visible to us. They are usually expressed in the values and actions of other societies and cultures, and because they are different to ours we can readily identify them. We are less likely to identify ideological positions within our own society and culture because they have become 'normalized'. Food is a good example here. The rights and wrongs of eating pigs is contested the world over on religious/ideological grounds. Less fraught is the debate over whether horsemeat is edible or not. When aspects of others' ideology is evident they are often contested, but those ideologies that are 'ours' and are absorbed into our everyday lives (as part of practice) are less noticeable and thus less likely to be contested. The familiar theories that inform our everyday lives (theories of the value of consumption for example) are often difficult to identify because they seem to be normal and uncontestable. Their everyday quality makes them 'transparent', to use Stuart Hall's term (1977). Hall argues that sometimes, everyday practices (what he refers to as 'commonsense' discourses) appear to be ordinary, and it is because they are so unremarkable to us that we are unable to articulate how they work and what their effects are. The way in which practices operate on us becomes invisible to us; it is part of the job of the researcher to reveal the ideas, theories and ideologies that form the context for the agency of the designer.

The need for research into design practices has increased as the nature of design has changed in response to the new conditions in the communities of practice

that surround it. The industrial consultant and writer on design Don Norman has pointed out (2010) that as the conditions that formed designers in industrial societies (and their work, which was primarily focused upon physical products) has altered beyond recognition so, too, has their work. Yet we still think of the designer as someone who makes, rather than as someone who thinks. This is why our working definition of designing as an act which impacts on the man-made world is useful. It is flexible enough to encompass the new ways in which man-made systems impact our world.

Contemporary designers work on organizational structures and systems many of which, as Norman points out, involve complex social and political issues. Decisions about designing are not simply based on questions of doing and acting but also of thinking about action and its consequences; we will be developing this idea as the chapter progresses. The same pressures exerted on the design community are also exerted on the research community. Researchers must understand how complex their own community practice is before any kind of meaningful research into other communities can take place. The act of researching is not simply the application of information-gathering methods but also involves a consideration of the ways in which those methods are appropriate or inappropriate to the circumstances and for the purpose of researching. It is through this dialectical process that the researcher determines what kind of research methodology (by this we mean the thinking that surrounds how a research enquiry is undertaken) is suitable for the research task.

As we have indicated, communities of practice can be observed from the outside. But we also exist within them, sometimes fully aware of the way in which they affect our thinking and sometimes not. As researchers, we need to be reflexively aware of how practices act upon us and how we act upon them. Building on our introduction of Pierre Bourdieu's ideas of habitus and field, we wish to develop his idea that the individual's habitus governs personal practices. This does not occur through a strict mechanical relationship of cause and effect between habitus and field, but rather through a more complex and subtle process in which the individual's habitus has 'an endless capacity to engender products—thoughts, perceptions, expressions, actions—whose limits are set by the historically and socially situated conditions of its own production' (1977, p. 95). This view of the origin of practice gives researchers into design practice an understanding of how they might approach a subject for research, by asking which of the researcher's presuppositions need to be identified as factors that might influence the research process or the interpretation of research findings. An understanding of how the design community of practice functions in the field also helps researchers grasp the ways in which individual designs (and ideas about designing) are related to wider sets of values.

Creativity

This approach leads to a very particular way of understanding creativity, or productive thinking, in design because creativity is seen as 'an acquired system of

generative schemes' where 'all the thoughts, all the perceptions, and all the actions' (Bourdieu, 1977, p. 95) of the creative individual are consistent within the conditions of the field. Thinking of creative practice in design as a dynamic relationship between the habitus and field empowers the researcher because it locates design thinking in the context of a dialectical engagement between ideas and the material world, positioning design in a continuously changing social environment. If we further develop the ideas about abductive thinking raised in the previous chapter, then it can be suggested that the framing of invention and creation through the concept of abductive thinking makes creativity a form of productive thinking that can be materially examined even if it is not perfectly understood.

The researcher should not see practice as deterministic: the result of simple cause and effect. Nor should the researcher see practice as monolithic and fixed, because practice does change, sometimes led by ideas about practice and sometimes because of the introduction of new technologies that affect the ways in which things are done. It follows then that the relationship among habitus, field and practice is a dynamic one and that there is a connection between the capacity to act and the social structure that surrounds actions. Bourdieu acknowledges the possibility of reflecting on one's habitus and urges the adoption of a reflexive position (1990a) where the individual is able to understand the relationship between his or her own and others' ideological assumptions in the act of communication and meaning making. How else can practices change? This has great significance for the researcher who must realize that research is an objective quest for knowledge that is always informed by the subjective position of the researcher.

The role of subjectivity in researching and creating practice is important, because if traces of practices can be identified with the field then it follows that there must also be a residue of those practices within the individual who engages with the field. Researchers can attempt to reflexively engage with the conditions that inform their sense of self and frame their way of thinking, but how can researchers make sense of the subjective positions of others? The problem with researching subjective knowledge is trying to find ways of identifying it and making it 'measurable'. It is possible to measure the outcome of design thinking through the objects that are produced by designers; it is also possible (through the concept of abductive reasoning) to identify the jump from creative thinking into action and examine the intellectual and emotional circumstances that facilitated that jump. Both these approaches privilege action that emerges from the subjective realm in the form of systems and objects, but is there a way of conceptualizing the reservoir of knowledge that the designer draws from?

Tacit knowledge

The concept of 'tacit knowledge' can help to explain this concept and provide the researcher with ways of understanding how tacit knowledge might be conceived as the engine that drives abductive reasoning. Tacit knowledge exists both within the

individual and within a community of practice, so the researcher needs to find ways of navigating its terrain. The term 'tacit knowledge' comes initially from the philosopher Michael Polanyi who described it as the phenomenon that 'we can know more than we can tell' (Polanyi, 2009, p. 4). Polanyi's ideas have been developed philosophically and practically by others since he first raised them in the 1960s, and the question of how tacit knowledge can be made explicit runs through many disciplines. Exactly what constitutes tacit knowledge is still being argued, and as Harry Collins puts it, 'questions about the nature of tacit knowledge are tied up with questions about the transfer of tacit knowledge, and questions about the transfer of tacit knowledge are tied up with questions about converting the one type of knowledge into the other' (2010, p. 8).

As a working definition for our purposes in this chapter, tacit knowledge consists of sets of information and practices that we call upon unconsciously but cannot fully articulate. For the researcher, this body of knowledge might need to be made explicit in order to develop and extend an understanding of a practice. For example, the traditional Chinese practice of decorative paper cutting is under threat as contemporary rural communities disperse and individuals go off to find work in the ever-growing industrial cities. A researcher might wish to discover how paper-cutting practices can be preserved. There is the clear question of how the social and cultural context that sustains the practice can be maintained, but this is explicit. The tacit knowledge within the community itself is more difficult to extract. How are the paper cuts made? How is this tacit, embodied knowledge transferred in the community? Might it be codified in a handbook, to be taught to others? Could a machine be programmed to do it or would this destroy the integrity of the objects? How are choices about the subject matter of paper cutting made in the different regions of production, and could a computer be programmed to make such choices? These are all questions that could elicit information about the knowledge that craftspeople have within their community but which at the moment is theirs alone, unarticulated and unrecorded. Does the articulation of that knowledge mean the objects can then be duplicated identically outside the community? These are obviously rhetorical questions but by raising them we hope to demonstrate that in researching design practices there must be a realization that it is impossible to reduce practice down to a set of immediately understandable and reproducible skills.

Practice is a combination of tacit and explicit knowledge, and it is the researcher's job to try and unravel the two. Tacit knowledge is embedded knowledge whose principles and practice may be difficult to identify and separate, and so almost impossible to reproduce, but we think it is simplistic to imply that tacit knowledge cannot be articulated but simply demonstrated and imitated. Tacit knowledge is intellectual knowledge as well as physical knowledge; its practices are the result of using both intellectual and material tools.

Practice is a whole conglomeration of shared habitual activities, some of which are easily communicable and others of which are less so. Practice creates and reproduces the field it exists in, but it also has the capacity for change because if it is

based on the agency of the individual, then practice has the capacity to transform as well as reproduce the status quo. Practice, when thought of this way, as a constructed phenomenon, becomes an approachable subject for the researcher who can identify its parts and processes and subject them to scrutiny. When research takes place into design practice, designing and researching practices are engaged in a dialogue between how things are done and how they might be done. We can develop this thread to propose that if practice can change, then it is because practice is being *thought* about. Practice is not just doing but also thinking about actions.

The relationship between theory and practice

In his *Outline of a Theory of Practice* Bourdieu talks about the dialectic between perceiving, understanding and acting that takes place in practice. He says that 'practice always implies a cognitive function, a practical operation of construction which sets to work, by reference to practical functions, systems of classification (taxonomies) which organise perception and structure practice' (1977, p. 97). In this modelling of practice, thinking and acting are partners, informing each other.

We have already mentioned the commonly held idea that practice and theory are in opposition to each other. It doesn't make much sense the more one examines it, but it might be worth briefly discussing why this view is sometimes held. Colloquially, theorizing has come to represent a detachment from the material world that may be expressed by the apocryphal 'how many angels can dance on the head of a pin?' which is often used as an example of theorizing at its most abstruse. It is obvious that there is a continuum that stretches between thinking and doing; to think about sweeping the yard is different from doing it, and thinking about designing a broom is quite different from using one. We think the important point is that both ends of the continuum are linked to one another and that both ends of the continuum are enriched through their dialogue with each other. While thinking about designing a broom is not always a substitute for the lack of one, theorizing what is a broom is for, how it might best be designed and how it might be produced is a productive exercise in resolving its absence. Theorizing is hypothesizing the world as a way of understanding our interactions with it. Ultimately, theories have to be tested, and if they are useless then they are discarded. If theories are useful as tools, then they become incorporated into the structure of our lives and will in turn be tested and revised. To theorize is not something that is done separately from doing; theorizing about something is thinking about how things are done. With this in mind, it becomes evident that practice is not in opposition to theory, but that the two are entwined. Part of the researcher's job is to understand that relationship.

Praxis

Another way of thinking about the agency of individuals and their practice is to examine the idea of praxis. The researcher will come across this word and its related

concepts frequently in readings about practice. Practice can be thought of in two ways. In the lazy way, in which it is simply tasks and skills that are learnt and administered, and the way in which we have addressed it, as skills that are reinterpreted and reapplied even as they are learned. Praxis relates to the latter conception of practice, where action and thinking work dialectically. The term praxis holds its core meaning more coherently than practice does, despite being used in a number of different forms and contexts. It retains that consistency of meaning because unlike 'practice' it has no colloquial usage and it has philosophical origins that go back to classical Greece.

We wish to examine praxis from four different aspects. We hope that by doing this we can demonstrate both how praxis is descriptive of a way of thinking about the world and how it can be used as a critical tool for researchers. The four ways in which we frame praxis are:

- as a way of conceptualizing practice;
- as a philosophical tradition that informs cultural analysis;
- as a tool for research;
- as a way of framing the consequences of designing objects and systems.

Conceptualizing praxis

The concept of praxis has a long history and has been open to interpretation and contestation throughout its two thousand year evolution. Its origins lie with Aristotle who divided human activity in to three parts, *theoria, poiesis* and *praxis*. Theoria can be thought of as theorizing or contemplation, especially the theorizing of what 'truth' might be (the typical preserve of philosophers, but we will be teasing this idea out in more detail in the next section). Poiesis is the activity that produces things, using technical and planning skills. Praxis refers to the *way* in which we do things. So in an Aristotelean sense, praxis sits in a relationship between thinking and doing. Thought of like this, in its simplest form, praxis can be considered to be a way of thinking about action and a way of acting on thought. David McClennan refers to it as 'a philosophy of practical activity' (McClennan, 1969, p. 10).

For the Greeks, praxis was the privilege of those who were free, for they alone had the agency to act as individuals. There is a sense of social obligation to those engaged in praxis; skills can be used for either good or bad, but in the dynamic relationship between theory, making and praxis, the ethical role of praxis was important. The outcome of successful praxis is *eupraxia*, where action has been performed 'well'. Eupraxia has both a social dimension and a personal one. It acknowledges that we have not only become free 'to engage in the activity that is most truly the realization of ourselves' (Lawrence, 2006, p. 60) but also that the individual has an ethical responsibility to others. More recent philosophers, developing the idea that praxis is the privilege of the free, have further suggested that one can become free by exercising praxis.

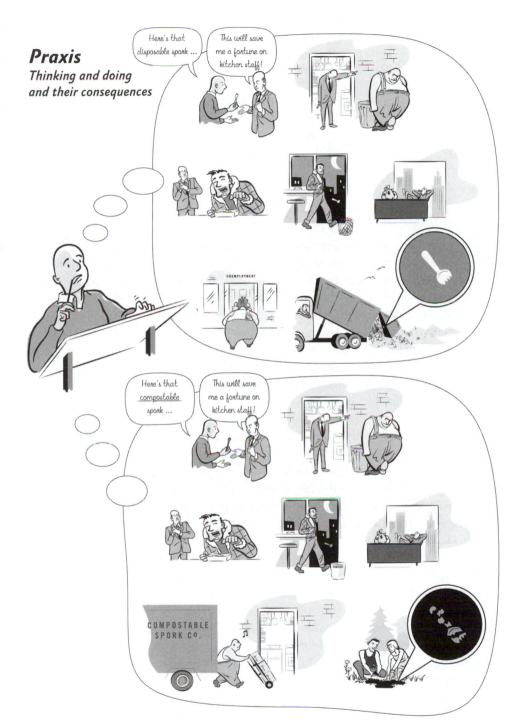

Figure 3 Praxis (Stuart Medley).

The German philosopher Karl Marx suggested that praxis was the way by which we developed a 'capacity for conscious creativity' (Kitching, 1988, p. 26). Un-reflexive practice, (practice that is the exercise of skills without thought) is not praxis, and Marx explains it this way:

> A spider constructs operations that resemble those of a weaver, and a bee puts to shame many an architect in the construction of her cells. But what distinguishes the worst architect from the best of bees is this, that the architect raises his structure in his imagination before he erects it in reality. At the end of every labour process, we get a result that already existed in the imagination of the labourer at its commencement. He not only effects a change of form in the material on which he works, but he also realises a purpose of his own. (Marx, 2007, p. 198)

The importance of this observation (if we ignore the worrying gender assumptions about both architects and bees) is one that may seem self-evident in contemporary terms; practices can not only change but can also be changed. This is a fundamental position for the researcher who adopts a critical as well as an interpretive stance. Antonio Gramsci, the Italian philosopher whose ideas were of great importance in the development of research into cultural studies (Hall, 1980, 1990), describes praxis as the 'worldliness of thought' and a philosophy of 'self-consciousness' (Gramsci & Forgacs, 1999, p. 429).

Two things are happening here in our discussion about praxis. Firstly, we are reinforcing the idea that practice is more than the exercise of technical skills, and secondly, we are beginning to address the consequences of practice beyond the conception that practice is just 'doing things'. The concept of praxis can explain how practice is bound up in the individual's relationship to issues that intersect and cut across the idea of a single discipline field. If the researcher maps out a design field for research, there is always the likelihood that the researcher gets too focused on specialist activities at the expense of seeing the interconnection between issues that are common across the design field and other fields that encompass social activity. Jurgen Habermas, whose ideas about the lifeworld we introduced in Chapter 1, has observed that specialization has shattered the possibility of making everyday communication socially coherent (1981). His view is that the disparate forms of specialist knowledge need bringing together in order for us to fully understand the complexity and interrelated nature of the social realm. If we directly relate this to design, then we might ask questions such as, how often does the car designer reflect on the environmental effects of the mining industries that produce the raw materials that a car is made from? Does the graphic designer working for a tobacco corporation need to reflect on the effects of death by lung cancer? Does the product designer working for an electronics company need to concern herself about the working conditions of those who will be manufacturing the company's products? Specialization is a useful strategy for ensuring the perpetuation of skills, but the separation of different skill sets from one another can lead to lopsided development

in the material world where, for example, the development of attractive consumer packaging might be in direct conflict with concerns for the environment.

The role that praxis can play in such circumstances is to establish the significance of agency and the ways in which theories inform action and vice versa. Praxis allows the researcher to ask questions about the purpose of theory and action. As Kitching points out, praxis helps to determine 'what is at stake in deciding whether . . . [ideas are] . . . true or false. Or in other words, what follows, what difference does it make in the world if a theory is true or false?' (1988, p. 33).

Praxis as a tool for research

A philosopher like Habermas is interested in explaining existential questions because that is his job. For the researcher, those 'big' questions might seem to be peripheral to the issue being investigated, but the more the researcher understands praxis the clearer his or her understanding of Habermas's characterization of the colonization of the individual designer's or researcher's lifeworld by the ideas and practices that belong to the system becomes. The more the researcher, aware of praxis, reflects on the habitus/field relationship, the clearer it becomes that issues of symbolic and cultural capital are bound up in the maintenance of practice.

Understanding praxis can help the researcher in the following ways:

- By giving the agency of the individual a context. The designer, the researcher and the end user of design exist within a cultural context that has been constructed, no matter how haphazardly, and the individual's personal agency is directly related to the practices that surround him or her.
- By helping to define the context of the individual's practice. What dynamic mix of theory and action, both historical and contemporary, distinguishes the individual's practice from others', or from the dominant model in the field?
- By demonstrating that particular kinds of action are related to particular ways of thinking, and vice versa. This means that different models of the conception of individuals and their relationship to practice can be understood more clearly. Praxis can help the researcher define habitus and field by observing the formation of practice. It can also help the researcher to understand the relationship of the lifeworld to the systems that colonise it by identifying how dominant practices are formed and validated and then identifying ways in which the lifeworld can resist acts of colonization.
- By helping to determine the ways in which the context of the user of design frames the way in which that individual responds functionally, emotionally and intellectually to designed objects or systems.
- By giving the need for an object a social context. The purpose and consumption of designed objects rests within a complicated network of sometimes conflicting demands.
- By giving the need for a system a context. The purpose and consumption of designed systems rests within a complicated network of sometimes conflicting demands.
- By exposing the researcher to a reflexive engagement with the practical, theoretical and ethical issues of research practice.

- By facilitating the researcher's understanding of the complex relationship between the ideological circumstances of the observer and the observed.
- By encouraging researchers to examine their own theoretical positioning and how that informs their practices.

<div align="right">

Praxis is a way of framing the consequences of designing objects and systems

</div>

In design, the result of practice is tangible. Design effects social change whether through systems of management or through the production of objects. By returning to praxis as a way of understanding action, it should be clear that thinking and doing result in action which then has a consequence. Researchers investigate the consequences of designing as often as they research the formation of the design.

Praxis can be used as a way of understanding both agency and the consequences of agency. Agency is social and if change is enacted in the world it has consequences that are both material and ethical. This is at the core of the philosophy of praxis. Theorizing and acting in conscious union leads to tangible outcomes, and to ignore the consequences of what is designed is to neglect the conclusion of the design process. The philosophy of praxis would suggest that the role of the researcher is not only to research the nature of design but also to contribute to the formation of ideas about what design is for.

Praxis suggests that the individual is neither completely passive, nor completely free. If modern consumer culture itself is based on this principle, and the British sociologist Anthony Giddens has argued this case for some decades, then it follows that the researcher into design needs to find tactics to determine his or her own position so that the ideas of praxis can be used strategically and to one's advantage. The next sections of this chapter look at the ideas of reflection and reflexivity with this intent in mind.

Reflection

Reflecting on what we have learned in order to develop and apply that knowledge further is an essential part of practice. The term reflection is one that the reader will find constant reference to in research texts. Like the idea of tacit knowledge, it is a concept that is related to ways of understanding that are difficult to categorize as the simple acquisition of knowledge through deduction and/or induction. Jean Paul Sartre spends several hundred pages in his book *Being and Nothingness* examining the process of reflection and how it contributes to the idea of how we know what we are. We can grasp enthusiastically just one sentence: 'Reflection is a knowledge; of that there is no doubt' (2000, p. 155). This idea of reflection as a special way of understanding—that is, in Sartre's words, 'a lightning intuition . . . without a point of departure and without a point of arrival' (p. 155)—has occupied those interested in both reflecting on others' practice and reflecting on one's own.

Reflection is a skill and can be learned. In 1983, Donald Schön wrote an influential book called *The Reflective Practitioner: How Professionals Think in Action* (1983), in which he discussed the ways in which reflection, action and knowledge are related. In the decades since, his ideas have continued to be developed and are now particularly significant in the fields of education, nursing, health sciences and architectural design. His ideas are useful to the researcher into design, because Schön's perspective on professional practice was informed from a philosophical and design background. What made his ideas so influential was his drawing together of existing ideas about creativity, practice and knowledge into a coherent body of thought that could be applied as a critical strategy. Like all the other models of conceptualizing the world we have examined up to this point, his ideas are continually analysed and open to different interpretations, some supportive (Waks, 2001) and some not (Webster, 2008). Schön's interest in conceptualizing design processes emerged from his interest in technology and the technological state. His realization, which was not a new one but which is important in contextualizing his practice, was that the modern technological state was in a constant state of dynamic change and to attempt to find finite solutions to social issues caused by endless change was flawed (Schön, 1973). We can think of this insight as one that reinforces the relevance of the wicked problem. Just as the wicked problem is unsolvable and the recognition of this fact allows the designer to think about solutions as being strategic and contingent, so too the recognition that social structures are in a state of flux suggests that discovering solutions to problems needs to be flexible and strategic.

What is especially important about his theorizing of praxis is his introduction of the terms 'reflection on' and 'reflection in' practice. Reflection on practice is when the practitioner has finished a task and is able to spend time considering why decisions were made the way they were or people behaved in the way they did. This could be a researcher or a designer reflecting on a completed project. The phrase implies an engagement with a set of circumstances or facts summing up events in which 'the unfamiliar, unique situation' is seen as 'both similar to and different from the familiar one, without at first being able to say similar or different with respect to what' (Schön, 1983, p. 138) in order to gain a fresh perspective. This ability to be reflective requires an understanding of how individuals learn, how information is gathered and how knowledge is constructed. Just as we have suggested that abductive thinking is a process linked to other circumstances (a well rehearsed body of knowledge to draw from, the ability to make connections between seemingly separate things), reflection too requires an understanding of its broader contexts for it to be used productively.

Reflection in practice requires the ability to think about 'doing' while one is engaged in the process of doing. This is especially important when the individual is working in what Schön calls the 'indeterminate zone' (1987, p. 12) of practice where there is ambiguity and instability. It is at this point that drawing from our experience but thinking in fresh ways and reinterpreting information become essential if new knowledge, the outcome of research, is to be produced.

Both reflection on and reflection in practice are ways of thinking and interpreting, but Schön has been criticized for not making the *critical* aspect of his modes of reflection more explicit. Schön's conception of reflection is limited because it operates within the parameters of practice and does not question the social conventions that have created the circumstances of practice itself (Usher & Johnston, 1997, p. 147). The examples of reflection Schön uses in his texts involve reflection about practice at an individual level. This is important because the individual is important, but if we also frame practice in terms of habitus and field or lifeworld and system we know that practice is bigger than the individual engaged in it and that practices are contested and contestable. It is important at this point to remember that the purpose of research varies, and that sometimes the researcher's aim is not just to interpret but also to critique.

Critical reflection is a form of praxis, where the observations, ideas and theories that have emerged from the research undertaken are given the potential to facilitate change or become agents of change. We can characterize the process and development of reflection as follows:

Identifying.
 What is the object (experience/topic/data) of your reflection?
 What is the purpose of your reflection?
Describing.
 What are the objective circumstances surrounding the object of your reflection?
 What is the structure/framework/sequence of the object of your reflection?
 What is the context of the object of your reflection?
Analysing.
 Breaking data into its component parts.
 Giving structure to data.
Interpreting and synthesizing.
 Comparing and contrasting new data and meanings with existing data, ideas, meanings and theories in the field.
 Making meaning of data by relating new data to what is already known and creating a context from:
 Existing ideas.
 Existing theories.
Revising existing ideas by:
 Identifying the value of other perspectives.
 Reordering theory in the light of new data and ideas.
 Building new theory.
Acting.
 Establishing a response to the meanings derived from the data reflected on.
 Formulating different ways of acting.
 Initiating action.

Another model of conceptualzing reflection that the researcher might encounter was developed by David Kolb (1984). This model of what he called the 'experiential learning' cycle is a continuous cycle of theorizing, action, observation and

reflection. It forms the basis for theorizing the production of learning, which we can easily adapt to a way of generating new knowledge by the researcher. In this endless cycle, where action is informed through theorizing after observation and reflection, new knowledge is created when new action is informed through the theorizing of old experience. The cyclical nature of this process, where old experiences and understandings are changed into similar but new ones, means that the cycle is not a 'flat' one but rather a three-dimensional spiral where each time the process is repeated a new cycle is created.

In using models of reflection on and in practice, the researcher is not just looking backwards in order to understand what has happened, but is also finding ways of looking forward. These ways of thinking are techniques that assist not just in consolidating past experience and knowledge but also help in anticipating new events. Reflection needs to be distinguished from critical reflection because one stays within the confines of a system of practice while the other leads directly to praxis. Reflexivity is a way of thinking about reflection that puts reflection into action, and acts as a concept that can unify many of the points that we have raised in the first part of this book.

Reflexivity

We have been using the term reflexivity since our first introduction of it as a way of framing the concept that when individuals act they are also acted upon. This idea is from Anthony Giddens's book *Modernity and Self-Identity: Self and Society in the Late Modern Age.* Giddens's purpose in writing his book was to demonstrate the effects that modern institutions have on moulding our sense of who we are. We have raised his ideas because they are central to an understanding of research as a mechanism which both responds to the world as it exists and also has the potential to alter it. The point that Giddens raises about the empowered individual also has a direct relationship to the empowered researcher:

> Just as the self is not a passive entity, determined by external influences, in forging their self-identities, no matter how local their specific contexts of action, individuals contribute to and directly promote social influences that are global in their consequences and implications. (1991, p. 2)

We wish to talk about reflexivity in two ways. Firstly we develop our discussion about Giddens's concept of the dynamic relationship between the individual institutional practices and how reflexivity is directly related to praxis, and then we address the key role that reflexivity plays in the research process.

Giddens's premise is that 'the narrative of self-identity has to be shaped, altered and reflexively sustained in relation to rapidly changing circumstances of social life, on a local and global scale.' The reason for this is that unless individuals can

understand their lives as unfolding against a 'backdrop of shifting social events' they will be unable to claim their 'authenticity' (1991, p. 215). What Giddens means by this is that the individual evolves from a complex (and sometimes difficult) relationship with the world of institutions. Unless individuals understand this they will never be fully autonomous (or have a real sense of who they are) because they have neglected this fundamental aspect of how they were formed. When Giddens talks of the self-actualization of the individual or of writing the 'narrative of the self', what he is referring to is the need for individuals to contextualize themselves.

Giddens's view of the power of individuals to emancipate themselves is a very optimistic one. Bourdieu's view of how the habitus and field work together suggests a much tighter space for individual manoeuvring. Struggle in the field 'pits those in dominant positions against those in subordinate positions' (Swartz, 1997, p. 124). Bourdieu also talks of the antagonism between the curators and the creators of culture, and suggests that recognition in the field demands the adoption of the field's values. Bourdieu's observations on the nature of power in the field suggest that 'for fields to operate there must be agents with the appropriate habitus to make them capable and willing to invest in certain fields' (Swartz, 1997, p. 126). Giddens holds the more optimistic view that agents can *change* institutional values (or field activity) by engaging with it. This is obviously contestable.

Giddens also identifies another problem in the project of the reflexive self, and that is the confusion between the struggle for self-identity and narcissism. The struggle for self-identity is part of a struggle for emancipation, whereas narcissism is the 'pre-occupation with the self which prevents the individual from establishing valid boundaries between self and external worlds' (1991, p. 170). Karl Maton (2003) has attempted to categorize the different ways in which reflexivity has been enacted because of the elision between an empowering form of reflexivity and what he sees as a narcissistic adaption of it.

'The road to reflexive practice is paved with good intentions', suggests Maton, '[h]owever, theoretical intentions are one thing, research effects are another' (2003, p. 56). One role of reflexivity as constructed by Giddens is one of self-awareness through social positioning, but it is the emphasis on self-awareness at the expense of the construction of social meaning that bothers Maton.

> There is, indeed, no logical reason for why anything about the author should be excluded from the discussion. For example, autobiographical reflection might include one's childhood or what one did on holiday, and as a virtuous researcher I could make public not only that I am Caucasian or male or heterosexual but also that I am 5'7' tall, support Manchester United, and live with two cats. (2003, p. 56)

Underneath Maton's pantomime performance there is a valid point that addresses both the position of the individual along the self-actualization/narcissism continuum and the purpose of that positioning. There is a difference between using

reflexivity as personal praxis and using reflexivity as a research tool. It is important to conceptualize the relationship between the reflexive individual and the reflexive practitioner, in our instance, the researcher. In both these circumstances—the struggle for self-identity and the adoption of a reflexive position as a researcher—the central concept remains that individuals are in a dialogue with the institutions that form them. In both cases that relationship is one that enables praxis, for action is informed through a theorizing of the individual's position. The difference lies in the purpose of the praxis. For the reflexive individual concerned with their agency, praxis is about change in habitus. For the researcher, there are two possibilities. The praxis could be about change in personal practice and/or could mean acting as an agent of change in the field.

We could develop our definition of the purpose of reflexivity within the field of research to say that reflexivity is a way of addressing the process by which knowledge is constructed. To be a reflexive researcher is to understand that the position of the researcher shapes the nature of research. Reflexive researchers attempt to understand how their habitus informs:

- How their own experiences frame the way in which they understand the world. This understanding might be one informed by ideologies of race, class or gender. It might be informed by geographical location and how that affects their worldview, or it might be informed by a set of normalized practices.
- How their own experiences frame their sense of agency.
- How their worldview might affect the framing of the purpose of the research.
- How their worldview might affect the framing of the research question.
- How their worldview might affect the gathering of data.
- How their worldview might affect the analysis of the data.
- How their worldview might affect the interpretation of data.
- How their worldview might affect the way in which their research is communicated.
- Their praxis in applying their findings.

An understanding of reflexivity allows the researcher to reflexively engage with the experiential learning cycle of theorizing, action, observation and reflection and the dynamic cyclical relationship of cause and effect. An understanding of reflexivity allows researchers to situate themselves simultaneously within both habitus and field.

Another way to frame reflexivity: agency, disposition and context

A final way of understanding the functioning of the reflexive researcher and the benefits to the researcher of thinking reflexively is to frame reflexivity within three sociological concepts: agency, disposition and context. The concept of agency, the ability to act and the ability to conceive of action, is important to the researcher.

Firstly, individual practitioners need to be able to position themselves within a community of practice. Without this ability they will remain unable to draw from and contribute to a shared body of knowledge. Secondly, understanding the processes of reflexivity assists in understanding the praxis of those being researched. The agency of others is bound up in their reflexive engagement with the institutions and practices of their field, and one cannot fully understand this until one understands how one's own self is constructed in this way.

The engagement of the individual with institutional practices and values is not purely deterministic, and not mechanistic. The value of the concept of reflexivity is that it acknowledges the disposition, or the inclination, or the characteristic tendencies of the individual. Reflexivity allows us to acknowledge that habitus and the predispositions it gives the individual can determine action. For example, a designer with a family background in making his or her own clothes becomes a textile designer because this interest was stimulated in early childhood, but this does not mean everyone whose family makes clothes becomes a fashion designer. Disposition is sometimes reinforced by institutional circumstances and is sometimes challenged by them. Reflexivity can be understood as the dialogue between disposition and agency as well as that between habitus and field or lifeworld and system.

Understanding the context within which disposition is formed and agency takes place completes the dialectical relationship between disposition and agency. These contexts can range from the environment of a design company, to a design culture disseminated through the university system, through to the mass media. Contexts are not always supportive and are often complex and contradictory. In his essay 'Design and Reflexivity', the Dutch designer Jan van Toorn describes a design industry whose context is one of maintaining the status quo:

> Every professional practice operates in a state of schizophrenia, in a situation full of inescapable contradictions. So too communicative design, which traditionally views its own action as serving the public interest, but which is engaged at the same time in the private interests of clients and media. To secure its existence, design, like other practical intellectual professions, must constantly strive to neutralise these inherent conflicts of interest by developing a mediating concept aimed at consensus. This always comes down to a reconciliation with the present state of social relations; in other words, to accepting the world image of the established order as the context for its own action. (1994, p. 319)

In understanding the context of the object of research, the context that allows researchers to research can be defined, as can the context that allows researchers to disseminate their research within their community of practice. Such practices, as we have already examined, are always open to contestation. The researcher needs to be mindful that even though the need to initiate change might be identified by research, that change might not be forthcoming.

As has been shown in this chapter, the researcher's agency is bound up in a multitude of interacting concepts and material circumstances. An understanding of one's own agency allows the researcher an insight into the processes by which other circumstances and other concepts are generated. In the following chapters we will discuss the capacities and intellectual processes needed to develop this insight and turn it from something that generally addresses the circumstances of knowledge acquisition to the very specific generation of new knowledge. We will raise new sets of questions about the purpose of research and how we conduct it and develop the idea that our disposition and our theorizing, which are the result of praxis and reflexively engaging with it, can be turned into methods of researching.

4

THINKING ABOUT RESEARCH: METHODOLOGY

From this point on the focus of this book is how to 'do' research in design. In the previous chapters we explored ideas about the transformative nature of design, about what designers do, and about the practical and theoretical relationships between designing and researching. This chapter looks in detail at how to do research, focusing on what is meant by a research methodology.

What is a research methodology?

As you begin your research it will be important to think about where you want the research to take you. Just as a journey begins with a sense of purpose—you need to know where you are going before you begin—so, too, does a research project. Where do you want this research to take you? What are the core questions that you would like be able to answer? This is not to say that early decisions about your research cannot be changed. Much research is characterized by false starts, dead ends and new directions, but it is important to begin with a sense of purpose. Once you know where you want to go, the decisions about how to get there—which in research are methodological decisions—will follow naturally. To continue the analogy, it is helpful to see methodology as a map for the research journey.

It is useful to begin thinking about methodology early in your research project. Sound methodological choices are hallmarks of a successful project; so on what basis are these methodological choices made? The analogy of a map can be used to describe a methodology, but a methodology can also be thought of as the lens through which to begin to conceptualize (or map out) the research. The methodology then guides the whole project, from data gathering through analysis to the final presentation. Questions about the purposes of the research, the nature of the research and the appropriateness of the methods are all significant in a discussion of methodology. A methodology is therefore made up of a number of elements that in practice combine together in intricate ways. It is helpful to separate them into three distinct components: our research position, which influences the other components;

the particular theoretical or conceptual lens through which we view the phenomena we are studying; and our methods (Walter, 2010b). Because a research position is the basis on which all methodological choices are made, it is important to consider this first.

What is a research position?

To begin to unravel what is meant by a research position, it is necessary to return to the concepts of habitus and lifeworld. As for a designer, a *researcher*'s positioning is reflective of habitus or lifeworld, inasmuch as every individual's habitus is shaped by the particular ideas or ideologies that form the cultural or social reserves that he or she is able to draw on. For researchers, it is important to realize that, in order to understand the world better, they need to first become aware of how these ideologies already shape the way in which the world is 'seen'. In other words, they need to be able to explore the particular ideological filters through which the world is understood.

Habitus and ideology

Designers, researchers and users all interact with objects and systems within a cultural and material context that frames the way that the world is understood. Recently, the manager of a shopping centre in northern England decided to install two 'squat' toilets, to cater for the different preferences of his customers. This decision was greeted with a range of impassioned responses, described by the local press with such phrases as 'public fury' and 'public revolt', that reflected highly diverse ideologies. The Web site *Jihad Watch* (2010) posted comments suggesting that the introduction of such toilets—in pandering to the preferences of British Muslims—was a threat to the British way of life. In contrast, *Islam Today* (2010) noted that toilets for squatting on are more hygienic than toilets for sitting on, since no part of the body comes into contact with a toilet seat, and that there are health benefits in using such 'natural position' toilets. Others pointed out that such toilets are by no means particular to Islamic cultures, but are found throughout the world.

The response in England to the introduction of squat toilets reflects particular ideological positions that are specific to a particular time and place, and shaped by habitus. Elsewhere in the world, positions differ. Singapore, described by A. T. Kearney as the most globalised country in the world (2007), is a culturally diverse, multi-faith community and global air hub. Flights from every part of the globe arrive at and depart from Changi International Airport, and the restrooms at Changi provide options to squat or to sit. The ladies' toilets in Terminal 3 have been designed to evoke luxury. Pastel coloured, frosted glass walls surround you as you enter, and soft light brightens the space. The washbasins are elegant, shallow glass saucers that have been designed to appear as if they are floating above the bench top. Taps and

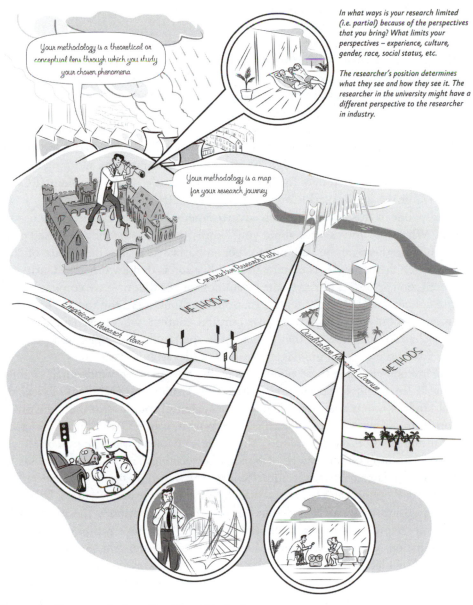

Figure 4 The researcher's position (Stuart Medley).

soap dispensers operate automatically. These are 'state of the art' facilities. Yet on some of the cubicle doors there are 'watch your step' signs, indicating that there is a squat toilet within. Inside the cubicle there is a picture to show how to use the toilet correctly. There are similar pictures inside the cubicles where the sitting toilets are found. Thus all needs are thoughtfully catered for. It is unimaginable that the

furore surrounding the introduction of squat toilets in England would be repeated in a country like Singapore.

As we write, floods are having a disastrous impact on the population of Pakistan, with the first outbreaks of cholera being reported there. In this devastated region, the consequences of a lack of sanitation are deadly, and debates about how a toilet might be styled are insignificant. A lack of sanitation is an experience common in the majority of the world. Estimates indicate that 2.6 billion people, roughly a third of the world's population, do not have access to safe sanitation (Allianz Group, 2010). In response to this crisis, the United Nations (UN) declared 2008 the International Year of Sanitation (UN, 2008); numerous campaigns and a plethora of alternative designs for toilets further attest to the scale of the problem (ROCH, 2007; WaterAid, 2010; World Toilet Organization, 2010).

Meanwhile in Australia, television advertisements for toilet cleaners that use the slogan 'What does your loo say about you?' imply that by using the advertised product young mothers can be sure not to feel embarrassed by the dirty state of their toilets when their friends visit. Here, the implication is that a woman's identity as a mother (good or bad) is linked to the cleanliness of her toilet. So we come full circle to the connections between identity (national/personal) and the toilet. This advertisement can only work in a particular cultural context, where particular cultural groups share similar habitus that is shaped by particular ideologies and practices. These advertisements are unimaginable in flood-devastated Pakistan.

The intention in using these vignettes is to illustrate that every individual's habitus is value-laden, culturally specific and contestable. From a practical point of view, different kinds of toilets are essentially different technical solutions to the same practical problem—how to dispose hygienically of human waste. Over time, and as social and cultural practices have developed, the toilet is no longer value-neutral but begins to carry with it a complex range of associated meanings and inferences, so for the president of the Restroom Association (Singapore), the etiquette of toilet use 'reflects Singaporeans' culture' and tells the world 'how civilised we are' (Reuters, 2010).

When planning research in design the researcher's position is the most important component in defining a methodology. The researcher's position is based on a combination of his or her previous experiences, cultural and social positioning (informed by ideologies) and particular worldview, lifeworld or habitus. In the toilet example, a person's objection to the introduction of 'squat' toilets might derive from his or her previous unpleasant experiences of using one. This objection might then be strengthened by the person's beliefs about the negative consequences of patterns of migration from countries in the Middle East and South Asia to England. Such an individual might perceive a threat to traditional English cultural practices (epitomized in this case by a particular design for a toilet) by the presence of large numbers of migrants and, by association, might object to the introduction of toilets to suit the needs of migrants because it symbolizes this threat. Of course, the ideological positioning of a person who was culturally familiar with a squat toilet would be very different.

In the 'sanitary ware' vignettes it is evident that individuals' understandings of the world are shaped by their life experiences, by their ideological positioning, and by their habitus. It should be clear how, if our understandings of the world develop as a consequence of reflecting on experience, we acquire new knowledge (what Kolb [1984] calls experiential learning). Engaging in a process of reflexive self-questioning leads to the revelation of the limitations and the possibilities of habitus, and is an essential first stage in the development of a research project. This process is particularly important for the designer/researcher whose central role is to present new and informed understandings to others.

Reality, knowledge and values

Our research position, knowingly or unknowingly, underpins all our research: 'the questions we see, the answers we seek, the way we go about seeking those answers and the interpretation we make' (Walter, 2010b, p. 13). Even the capacity to comprehend what questions should be asked can be limited, since 'no-one can actually establish for sure what social reality is, [and] how it connects to knowledge and experience' (Ramazanoglu & Holland, 2002, p. 57). In making clear a research position, the researcher needs to pay careful attention not only to how a research position is influenced by habitus but also to what reality is thought to be, what is thought about how the world is known, and the ideologies and values that shape the ways in which the world is seen. These ideas form the second component of a research position.

According to Lather (1991), all social research is partial, perspectival, limited and constructed as a specific social production. Because events, objects or people are understood from a particular, limited perspective, an understanding of them is thereby always partial. This means that our understanding is always incomplete, since we cannot understand something from a perspective that we do not have or are unable to adopt. Besides meaning incomplete or in part, the word partial has other meanings. It can be used to indicate that someone has a particular liking or fondness for, or bias towards, something. This can be described as one's partiality. Time, place and culture all affect what we can know and how we know it, and in this sense all knowledge is contextual. So the perspectival, partial and contextual nature of what we know is a key problem that must be considered when designing research.

Two philosophical terms used to refer to ideas about reality and knowing are ontology, which refers to ideas about *what* can be known (or what reality is), and epistemology, which refers to ideas about *how* that reality can be known. The two terms are intimately connected, since questions about what can and cannot be known (which are ontological questions) cannot be separated from questions about how the world is known (which are epistemological questions). Factors such as our gender, our cultural background and our professional identities—which in part make up our research position—may either limit the ways it is possible for us to know the world, or provide possibilities by positioning us to know the world differently from

THINKING ABOUT RESEARCH

others. For example, a researcher who also happens to be a designer 'knows' what a fellow designer experiences in a way that a nondesigner cannot. Similarly, a designer whose practise is based in a developing country 'knows' what that is like in ways that are different from the ways a designer who practises in a global centre such as New York can 'know' what it is like. The one way of knowing is not necessarily better or worse than the other, and whether it is or is not will depend on the research context. The important thing is that these two ways of knowing will be different. Even though all research is 'embedded in commitments to particular versions of the world (an ontology) and ways of knowing that world (an epistemology)', the ontology and epistemology on which a particular piece of research is based are 'often taken for granted and not regarded as worthy of consideration' (Usher, Bryant & Johnston, 1997, pp. 173–176). We hope to have shown why these are worthy of consideration.

Another set of questions to consider when exploring a research position are those about what the researcher values. Such questions will further shape a research position and have particular relevance to decisions about the purposes of research. Values are a result of our habitus and field relations, and reflect both personal and professional contexts. They inform the way we answer questions about why we have chosen a particular research focus and why we think it is worthwhile. As well, our value position underlines our concerns for the emotional safety or professional integrity of the research participants, and our views about the exercise of power and oppression in human relationships (including those between researcher and researched). For example, there may be aspects of human experience that we feel it would be unethical to investigate. When this is the case, we will never be able to 'know' these aspects of another person's experiences. In other words our methodological decisions, which are decisions about how our research is designed and conducted, are necessarily informed by ontology, epistemology and by what we value, which are in turn formed in habitus and framed by the field.

For these reasons, it is important when you begin thinking about research to be aware of your position in relation to the ways your perspective is shaped by habitus and field relations, the particular ontological, epistemological and value questions that relate to your research. The questions for reflection found at the end of this chapter will help you identify where you are positioned with respect to these questions. When taken together, these interconnected elements all work in association to shape your research position.

To summarize, methodology's focus is on how we can and should study the world, and on what questions we can and should ask about it. One way of understanding methodology is to see it as the 'worldview lens through which the research question and the core concepts are viewed and translated into the research approach we take' (Walter, 2010b, p. 13). This worldview lens could also be thought of as a research position. From this point of view, methodological decisions are filtered and shaped by a research position, which in turn is shaped by the life experiences and the social, cultural, political and economic circumstances that make up habitus. Our position is not fixed, however, because our habitus can change.

A reflexive researcher is aware of this, and understands how his or her position shapes the nature of the research.

Theoretical lenses for research

A second component of methodology is the particular theoretical or conceptual lens through which the phenomena we are studying are viewed. Since the theoretical lens is a significant influence on methodological decisions, it is important to be explicit about the theoretical position we take. The particular theoretical position adopted in this book is based on the view that the world is not knowable objectively; that it is not possible to be a disinterested observer; and that knowledge is never impersonal, rational and value-neutral (Neuman, 2000). Since our view is that knowledge cannot be abstracted from the specific time and place in which it was made, we argue for reflexivity in research; in other words, researchers must be able to identify how their subjective cultural position influences the ways they understand new information.

This book also represents a particular view of the design process: that it involves engagement with the social realm. This view is in turn based on the theoretical position that underpins the way we view research in design in this book: that since social processes cannot be directly discovered, the role of research is to try to understand those processes through interpreting what we observe or experience. This positions us to use an interpretive lens. Similarly, since we understand that the world is characterized by inequalities, we see the role of research being to explore and attempt to expose examples of inequality. This positions us to use a critical lens. While other theoretical lenses from social science research, such as a functionalist, feminist or a postmodernist perspective (see Walter, 2010), might also provide lenses for research in design, in this book we use two associated research lenses (or theoretical positions): the interpretive lens and the critical lens (see Table 1). These lenses also inform the four specific methodologies examined in Chapters 6 through 9, and are now explored in more detail.

The interpretive lens

An interpretive (or hermeneutic) lens is particularly influential in social and educational research, since it 'focuses on human action and assumes that all human action is meaningful and hence to be interpreted and understood' (Usher, Bryant & Johnston, 1997, p. 181). Interpretive research is concerned with understanding the social world: understanding 'everyday lived experience' (Neuman, 2000, p. 70) and 'the way [people] construct their lives and the meanings they attach to them' (Sarantakos, 1993, p. 37). Moreover, the interpretive tradition of research holds that people are part of and create 'their own reality', and hence the world cannot be understood without us also understanding the people who create that reality (McNiff & Whitehead, 2006, p. 10).

Table 1 Theoretical Lenses Used in *Doing Research in Design*

Research lens	Epistemology/Ontology	Researcher's role	Research purposes
Interpretive	• It is only possible to represent aspects of social reality • Researcher is subjective observer • The world is open to interpretation	• Engage with other people's lives • Enable the 'voices' of others (i.e. designers and design users) to be heard	• To explore habitus of designers and users, in interaction with the field • To interpret design practices, objects and systems • To understand how the designer or the user engages with design practices, objects and systems
Critical	• The world is characterized by inequalities because the lifeworld is systemically colonized • Ideology is all-pervasive. Knowledge implies action	• Critically observe design practices • Engage with other people's lives, • Initiate or facilitate change	• To disrupt, emancipate, transform the habitus and field of design • To explore how the user is affected by design practices, objects and systems • To change design practices, objects and systems

Sources: Lather, 1991; Pearce, 2008a.

Hermeneutic research is associated with the interpretive tradition, and involves interpreting meaning that is 'embedded within text' (Neuman, 2000, p. 70). We assume that such text can comprise conversations, objects or practices as well as written words. There are several implications of using this research lens. One important implication is the recognition that, since the way we know the world is through interpreting it, both the researcher and the research participants are *jointly* engaged in acts of interpretation, and the research process becomes a conversation between the researcher and the participants (Usher, Bryant & Johnston, 1997). This means that in interviews, for example, part of the researcher's role will be to seek out and negotiate meaning with the interviewee. (This is discussed further in Chapter 7.) A second implication is that interpretation is always partial, in that it is always relative to one's existing interpretive framework, and hence what Gadamer calls our 'pre-understandings' provide the conditions (including the limitations) under which we experience the world (Gadamer, 1975, quoted in Usher, Bryant & Johnston, 1997, p. 182). Further, the hermeneutic circle of interpretation, where interpreting

part of something depends on interpreting the whole but interpreting the whole depends on interpreting the parts, means that 'knowledge formation always arises from what is already known', and is therefore not linear but 'circular, iterative, spiral' (Usher, Bryant & Johnston, 1997, p. 182). Hermeneutic interpretation always takes place within the specific context of related assumptions, beliefs and practices 'of which both the subjects and objects of the research are never fully aware' (Usher, Bryant & Johnston, 1997, p. 182). However, as mentioned in Chapter 3, praxis can help the researcher make more explicit the conditions that make up the particular context from which her or she approaches the task of interpretation.

To use an interpretive lens for research suggests that researchers 'read' the world to 'discover' the meanings embedded there (Neuman, 2000). Although the quest for disinterestedness in a researcher may be misguided, since our pre-understandings of the world shape our interpretations, it is possible for researchers, through the research process, to challenge and destabilize their pre-understandings. This is because it is 'precisely through the interplay between one's interpretive framework . . . and that which one seeks to understand that knowledge is developed' (Usher, Bryant & Johnston, 1997, p. 184). Thus by *acknowledging* our pre-understandings we can put them to work to become more open-minded researchers. So, in relation to research processes, when using an interpretive lens, every decision is filtered through that lens. This includes the choice of research participants, decisions about how to communicate with them, the questions asked and ways of conducting the analysis.

To reflect this, in the final research text the researcher will be as present in the text as he or she has been throughout the research process. This is one reason why autobiographical elements so often form part of interpretive research, and why research texts that are produced by researchers using an interpretive lens will use the first person pronoun in their writing, rather than representing themselves in the third person (as in 'the researcher conducted interviews with 20 participants'). The interpretive framework points to a reflexive, self-conscious researcher, and underlines the need for researchers to disclose the pre-understandings that have shaped their research. The processes of choosing research participants, identifying a research focus, choosing approaches to data collection and selecting what actions or views to report are decisive acts made from a particular research position. A researcher working within an interpretive lens acknowledges this by providing opportunities for the experiences of others to be given centre stage, and making the research a vehicle through which these voices can be heard. In research in design, the voices will be those of designers themselves, or of users of design, or of both, and the research purpose will be to explore, interpret and understand the experiences of designers and users of design as they interact with design practices, designed objects or designed systems.

The critical lens

The critical research lens draws from the interpretive lens in its views of the researcher and of the limitations of perspective. Research methodologies can readily

combine elements of both (for example in participatory action research). From the perspectives of both the interpretive and the critical research lenses, knowledge is seen to be interested (in the sense of having a vested interest in something) and not neutral. Critical research moves away from interpretive research in that it actively works to unmask the power relations hidden within social interactions, and seeks to go beyond the portrayal that results from research in an interpretive lens. Since the researcher's lifeworld is also systemically colonized, and subject to the same power relations as the research participants, to adopt a critical position is not just to acknowledge researcher subjectivity but also to build it into the research process.

The researcher does this by becoming reflexively aware of his or her subject position. Using a critical lens for research therefore places the researcher more centrally in the research process. Researchers who work within a critical position acknowledge that epistemology is culture-, value- and history-specific, and expect to be open about their political and theoretical positioning in relation to the concepts with which the research is concerned. They will be explicit about the way their ideological stance influences the texts that are produced, since to use a critical lens is to acknowledge that the researcher can never be hidden (Neuman, 2000). Critical researchers, then, will be explicit about their original position and document 'where their research took them as investigators and political actors' (Fine, in Apple, 1996, p. ix).

Since it includes the critique of existing ideological or institutional operations, a critical position towards research enables the process to extend beyond knowledge generation. Critical researchers look to possibilities for changing the world, and work to 'disrupt and transform existing ideological and/or institutional arrangements' (Fine, 1994, in Apple, 1996, p. ix). Critical research typically explores how individuals relate to the larger social and institutional contexts in which they work by questioning 'the assumptions which a discipline or field takes to be self-evident' (Stronach & MacLure, 1997, p. 3).

While critical research differs from interpretive research in the kinds of questions asked and the purpose of the research, researchers from both methodological positions will typically use the same techniques (Neuman, 2000). In a sense, all research that aims to 'uncover and demystify ordinary events' (Neuman, 2000, p. 76) lies within the critical framework. When using a critical lens, both the researcher's ideology and his or her position in relation to habitus and field become a central and explicit element in the design and conduct of the research. In research in design, the purposes of critical research may include disrupting, emancipating or transforming the habitus and field of design while exploring how design practices may affect users. The ultimate goal of critical research will be to generate knowledge that may lead to change in design practices.

Methodologies for research in design

Later chapters will specifically explore four distinct methodologies: ethnography, narrative, case study and action research. These methodologies have been chosen

partly because they are well established in social research, and have been used widely and successfully in professional contexts such as teaching, nursing and business. For these reasons, they are very suitable for research in design. However, these methodologies also fit well within the book's theoretical lenses. For example, ethnographic and narrative forms of research, where the focus is on the lived experiences of individuals or groups of people, 'fit' well within an interpretive research lens.

Participatory action research, where the research purpose is to bring about change, develops from a critical lens. A critical dimension can be introduced to all forms of research, if the research purpose includes the intention to expose injustices or challenge what is taken for granted. Hence, ethnographic or case study research can be 'critical' (Madison, 2005) if the intention is to uncover inequalities or experiences of marginalization in a group of people or in a particular case. When in later chapters we explore in detail how to conduct ethnographic, narrative, case study and action research, the relevance of each approach to both interpretive and critical research lenses will become clearer.

Conclusion: from methodology to methods

By now you should be beginning to be able to identify the particular methodological lens you might use in your research, and recognize that when designing a research project (that requires the selection of a particular method from a vast range of possibilities) your personal history, perspective, values and convictions and theoretical orientation are all significant. Such methodological considerations are central to the research process—the approaches to knowledge generation that you take will both limit and make possible what you are able to know as a result of your research.

The final components of methodology are the methods chosen as the means to conduct the research. The terms methodology and methods are often confused. Methodology can be understood as the study or theoretical framing of methods, or of the broader principles that underpin particular methods. Methods are the particular strategies used when conducting research. Examples of methods are interviews, observations, surveys and document analysis. Choice of the methods for collecting data will grow out of methodological considerations such as those discussed, and it is essential for researchers to consider how their research position is reflected in their choice of methods. Our four named methodologies—ethnography, narrative research, case study and action research—are all examples that combine a congruent set of principles to inform the whole process of the research, and have become well established because of their coherence and usefulness. Each methodology also typically makes use of a group of complementary methods that suit both the research purpose and the theoretical orientation of the methodology.

Since research practices both reflect and are developed from a research position, it is important to use methods that are congruent with that research position. Often, researchers adopt a methodology without first considering their research

position; for example when research decisions are made on the basis of efficiency. Sometimes, research practices are adopted without recognizing that every practice is underpinned by a particular research position and by a theoretical lens, with the result that the research processes might be incompatible with the underlying research position. You are encouraged to think of methodology as a tool for making intellectually sound and clearly reasoned choices about the conduct of your research, and for explaining the basis of those choices to others.

There will be many occasions when you will need to explain your methodological framework to people such as your research supervisors or colleagues, your research participants, your readers or your examiners. We encourage you to engage with ways in which others have described and explained their research decisions to help you explore yours. If a particular designer or researcher has clarified and developed sophisticated and nuanced ideas about research processes that work, then make use of them (but do not feel you have to follow them slavishly). As researchers, we all need to 'come clean' about our research positioning by explaining the ways in which we are partial, and by identifying the perspectives from which we understand and approach the design/research problem. When choosing a methodology, it will be important to explore the logic of the connection between what you want to know and how you go about knowing it. The most important thing is to ensure that your methodological choices are clear, purposeful, coherent and ethical, and capable of enabling you to engage in the kind of inquiry you intend.

Finally, it is important to recognize that what is capable of being produced as a result of the research process is at the same time circumscribed by the processes and methods used. The methodological decisions you make will lead you to produce certain kinds of knowledge, and by the same token that knowledge will be either limited or made possible by the decisions you make. This needs to be taken into account when choosing a methodology. Even if your research does not make use of a particular named methodology (and the potential of 'mixed' methodologies is becoming well recognized) you need to be explicit about how your research practices will lead to the generation of new knowledge—which is after all what every research project aims to do.

A sound understanding of methodological considerations is essential if you are to be able to go on to choose the most useful tools for your research purpose, which is the focus of the chapters in the remainder of this book. As your research expertise grows your methodological position will develop, and you will find you are able to make sound choices from the wide range of possibilities available, with a view to making the best choice for the research problem you are grappling with. The questions for reflection provided at the end of this chapter will support your thinking about methodology.

In the following chapter we illustrate how you might go about developing your research question, and show how the framing of the research question then enables you to make methodological decisions. Then in Chapters 6 through 9 we explore further some of the possibilities and limitations of different methodological choices,

and examine the usefulness of different methods or tools for inquiry for different kinds of research questions. It is through processes of developing our understandings of what it is possible to find out, of how knowledge is generated, and of how it is disseminated that our research praxis evolves. It is by actually engaging in the process of conducting research that we acquire the knowledge, skills and understanding necessary to engage in research.

Questions for reflection

1. What do you think your research problem is going to be?
2. What particular perspectives do you bring to this research problem?
3. What are the advantages of these perspectives, in relation to the planning and conduct of your research?
4. In what ways is your research limited (i.e. partial) because of the perspectives that you bring? What limits your perspectives? Consider experience, culture, gender, race, social status, age, geography.
5. What is the purpose of your research, and why is it important?
6. What changes might occur because of your actions?
7. Who is the audience for the research? Who might benefit from your research and how?
8. What theoretical lens would be appropriate for your research?
9. How would you describe your position as a researcher? Write a few paragraphs in which you describe and explain your research position.

5

DOING RESEARCH: FROM METHODOLOGIES TO METHODS

This chapter outlines the stages in the research process, from identifying a research purpose through to planning the whole project. It also outlines some of the distinctive features of quantitative and qualitative research, as it is important to be aware of the different possibilities offered by these two approaches when deciding where your research project best fits. Different criteria for evaluating research are then explored, and some ethical guidelines are provided for the conduct of research. In the final part of the chapter, the process of developing a research question is talked through, demonstrating how by careful framing of the research question, you can become better able to make methodological decisions.

Identifying a research purpose

Having spent time thinking about your methodological position you will now be able to begin 'doing' research. To begin, you will need to decide what you are going to research, and your first task will be to identify a research focus. Many of you will already have a curiosity, passionate interest or hunch that you would like to explore. The exploratory nature of research is something that makes it engaging and rewarding. Alternatively, you may have a particular task or design brief as a starting point. If you are a designer, research questions may emerge from your practice. In any case, your research focus will generally draw on your interests in a particular design specialism (such as the built environment, graphic design, fashion and textiles, and so on).

To help you refine your research focus, the four broad sensitizing concepts identified in Chapter 2 are reintroduced as a way of helping form your inquiry. These concepts (the designer, the designed object, the designed system and the end user) are intended to provide ways into the initial ordering of your thoughts about the kind of research you choose to do, and to help you in choosing the research methodology you will eventually use. These concepts will be returned to throughout the

remainder of the book to illustrate how they might be used to help organize and focus the research.

Another consideration that will help you refine your research focus relates to your research purpose. A key role of research in the social realm is to create knowledge that leads to solutions of societal problems. Based on this view, research should be capable of leading to action (Greenwood & Levin, 2008). This view of research resonates well with the idea that designers engage with the social world, and that an important role of design is to initiate change (Jones, 1991). Milton Glaser's idea, that 'good design is good citizenship' (Glaser, in Heller & Vienne, 2003, p. ix), expresses this well. This view leads to questions such as, why conduct this research? What is worthwhile about it, and how might your research contribute to the existing knowledge in the field, or lead to changed perspectives or practices? Who would benefit from your work, and how?

Our research purposes grow from what we know, since with a limited or partial perspective we can only see limited purposes. So a designer/researcher whose perspective comes from an interest in environmental problems is likely to develop different design and research objectives than someone whose perspective is shaped by a concern for social equity. The perspectival and partial nature of research was emphasized throughout the previous chapter, as a reminder that the recognition of one's particular, limited point of view must be taken into account whenever research is planned, conducted and explained. Thinking about the purpose or goal of research should take you back to ideas about researcher perspective and partiality; this is another important aspect to consider at this planning stage. A careful analysis of your responses to these questions about research focus, research purpose and researcher perspective will be important in helping you choose a methodological approach for your research.

Quantitative and qualitative research

Up to this point there has been a deliberate avoidance of a discussion of the distinctions between quantitative and qualitative research. In your reading elsewhere you may have noticed that many research methodology texts have a particular focus on either qualitative or quantitative methodology. We suggest that methodological decisions should grow from the research question, within a particular research position. Research in design does not sit obviously within either qualitative or quantitative research traditions, so now that our focus is on research decisions, it is time to outline some key characteristics of qualitative and quantitative research.

As its name suggests, qualitative research focuses on the collection and analysis of qualitative data, which are usually in the form of words or, less commonly, in the form of images, film or other artefacts. Quantitative research builds around the collection of numerical data, which is analysed using statistical or other means of measurement. Beyond these simple distinctions, however, qualitative and quantitative

research methods differ in numerous ways. How methodological choices are made based on the particular focus and purpose of research has already been discussed, and it has been suggested that methodological decisions should not be made solely on the basis of methodological preference without taking account of the requirements of the research project.

In a nutshell, the question is whether you need to generate research data that can lead to conclusions that are generalizable across a large population, or whether your intention is to understand in some depth the experiences of a small group of people. A colleague of ours once clarified this distinction very neatly. She remarked that some researchers attempt to generalize, by conducting research to demonstrate that 'things happen like this', while other researchers focus on understanding the detail of individual experiences and seek to show that 'things like this happen' (R. Pasqualini, personal communication, 2003). This distinction encapsulates the main difference between the intentions of researchers who use quantitative methods from those who use qualitative approaches.

In the following section we provide a more detailed comparison of the key differences between the traditions of qualitative and quantitative research. Beginning with a comparison of the different purposes and intentions of the two traditions, further distinctions between their approaches to data collection and analysis and the different criteria for judging research quality follow. It should be clear that the methods (i.e., strategies or approaches for collecting and analysing research data) grow logically from the methodological framework within which the research sits. All research projects begin by stating a purpose and posing a research problem or questions, and in the light of these, the researcher will make decisions about who should be involved in the research, will determine what kind of data is needed to answer the question and how it should be analysed, and will decide how the results should be presented. All researchers will also need to ensure that their practices are ethical. However, within these broad parameters for the conduct of research, qualitative and quantitative approaches differ significantly. Research methodology should always develop in light of the original purposes of the research; in other words '[t]he method must follow the question' (Patton, 2002, p. 247). It is worth reiterating that sound methodological decisions lead to sound research practices. We do not intend to provide recipes for research, but to offer possible approaches that can be developed by individual researchers to suit the particular research problem they are grappling with.

Quantitative and qualitative research: purposes and intentions

Key distinctions are made in how the two traditions understand the purpose and intention of research. Qualitative researchers tend to be interested in how the world is experienced by human beings in natural settings, and such research aims at achieving depth of understanding, not breadth. Qualitative research design is focused on ways to find out more and more about less and less, so strategies that

allow for a deeper focus are important. Consequently, such research uses multiple sources of data, depending on the research focus and the process of the research, and also uses multiple means of presenting the outcomes of the research. The use of multiple data sources (sometimes called *bricolage*) is typical of this eclectic approach to research processes.

A key intention of much qualitative research is to provide a vehicle through which participants' voices can be heard. This intention has consequences for the ways the researcher conducts the research, and hence there is a need to foreground the personal experiences and insights of the researcher. Qualitative researchers are particularly disposed to recognize that reality is subjective and value-laden, and hence there is an emphasis on exploring researcher reflexivity. Our position, however, is that the need for this recognition applies equally to quantitative research.

Quantitative researchers working in the social realm draw on principles of scientific research in their approach to research. Unlike qualitative researchers, their interest is in the development of hypotheses or theories about phenomena in the social world that are capable of being confirmed or tested. For this reason, researchers use objective methods such as surveys and questionnaires for gathering numerical data, with the intention of using the data to answer questions or test hypotheses. Such research needs to take place in carefully controlled settings, to ensure that other researchers are able to replicate the study should that be necessary. Because quantitative methods enable researchers to obtain responses to several different questions in a single survey, it can be a very efficient way to generate data.

Quantitative and qualitative research: selection of participants

There are significant differences in how qualitative and quantitative researchers select participants. Qualitative research typically involves small numbers of participants, and uses purposeful sampling to enable an in-depth focus. The in-depth nature of qualitative research makes the involvement of large numbers of participants impractical, so researchers have developed strategies for choosing participants in ways that best suit the research intent. Examples of purposeful sampling include finding participants who are typical of a particular case; finding participants who have significant qualities in common (such as age, gender, cultural background); or using techniques such as 'snowballing' which involves approaching those who are in a good position to identify participants who would be particularly knowledgeable or well informed. Existing participants can often provide useful information about other potential participants (see Patton, 2002).

Because quantitative research aims to generate data that is generalizable, researchers rely on different approaches to the selection of participants. Quantitative methods are chosen for their capacity to collect information from large numbers of participants, with a view to using the information as the basis for making inferences for the population as a whole (Ary, Jacobs & Sorensen, 2010; Creswell, 2008). Indeed some quantitative research will involve every member of the whole population

to which the research problem applies. If this proves too difficult, samples of a particular population may be chosen to represent a larger group. For example if a designer was researching disabled access to toilets, it would be important to seek input from participants who could represent all the different needs of individuals requiring such access, even though it might not be feasible to involve the whole population of people with disabilities. Such samples may be selected for a particular reason and to suit the research purposes, or alternatively random or cross-sectional sampling might be used where individuals are chosen at random to be representative of the whole population (Walter, 2010a).

Quantitative and qualitative research: approaches to data collection

Interview data and field notes or observations are commonly used as research data in qualitative research, but many other forms of data are possible. Given the researcher's interest in interpreting and understanding the experience of others, combined with the focus on allowing others' voice to be heard in the research, open-ended methods for data collection are typical. For example, participants may be asked to describe their experiences of a particular phenomenon from their own perspective, with no predetermined questions or pointers. Qualitative interviews are similarly open-ended, and participants can be given considerable scope to direct the interview to suit their own experiences and purposes. Researcher perspective is important in the interview exchange. While researchers can use strategies such as open listening, so they do not prejudice the telling, a reflexive account of how their own positioning might influence the interview process will be an important component of the final research text. Conducting qualitative interviews is a difficult skill, and needs practice. Further information about strategies for conducting interviews is found in Chapter 7.

Cultural artefacts such as written texts are commonly used as data in qualitative research. Consequently, in qualitative research there is a focus on how meanings are conveyed in discourse: the language, texts and social practices explored by the researcher. This interest has implications not only for the kind of data collected but also for the processes used in data collection and the interpretation of data. A typical research text in qualitative research is the interview transcript. When interpreting and understanding such texts it is important for researchers to be able to take into account the cultural and social contexts that gave rise to the creation of the text. This includes taking into account the nature of the relationship between the interviewer and the interviewee, the possibility for misunderstandings that may arise during the interaction, and the possible ways that interview texts may be presented as research artefacts to a wider audience. Further discussion of these issues is found in Chapter 7.

Given this focus on analysing and interpreting the meanings of cultural artefacts, qualitative research also takes into account the importance of the cultural contexts that give rise to the phenomena being explored, both when gathering data about

the phenomenon and during the process of analysis. As qualitative research typically takes place in naturalistic settings, observations of these settings can be very important in contributing to the researcher's understanding of participants' experiences, while rich descriptions of these settings will in turn help readers understand the research context.

Working with numerical data, as the name suggests, is the core focus of quantitative research. This research relies on measurement tools such as scales, tests, observation checklists and questionnaires, and as far as possible takes place in controlled settings (although this is difficult to achieve when the focus is research in social settings). Researchers using quantitative methodologies will take steps to control the influence of their personal value systems on the conduct of the research through strategies such as employing multiple observers to use highly structured observation checklists, or by constructing structured surveys where every participant is asked the same questions posed in exactly the same way and using the same phrasing. Even the way the research purpose is explained will have to be consistent for each participant (Ary, Jacobs & Sorensen, 2010).

We have already claimed that all our engagement with the world is perspectival, and that, hence, every researcher's values play a fundamental role in his or her choice of research topic and research approach. The points of view that can be captured in the research will be limited by the questions, the topics and the language used. Quantitative researchers, while acknowledging that values play an undoubted role in shaping research decisions, nevertheless aim to conduct investigations that are as value-free as possible by following carefully designed and systemic procedures.

Many research projects use a combination of methods for data collection. This strategy, called 'triangulation', can strengthen a study by providing different types of data gathered using both qualitative and quantitative approaches. Triangulation has been used in some of the examples of research projects discussed in subsequent chapters, for example in our discussion of case study research. The purpose of triangulation is not to ensure that all data leads to the same conclusions, but to obtain a range of perspectives and identify possible inconsistencies that can be explored, compared and discussed (Creswell, 2008; Patton, 2002). Using 'mixed' methodologies (Teddlie & Tashakkori, 2009) is one form of triangulation that allows researchers to obtain data from a range of sources and using a range of methods, perhaps by combining quantitative and qualitative approaches. A research project in chair design might combine a qualitative approach to obtain data about consumer preferences and buying intentions with a quantitative approach to explore the function, stability and durability of the chairs in question.

Quantitative and qualitative research: approaches to analysis

Qualitative and quantitative approaches to research differ in their approaches to data analysis because each uses different types of data. Qualitative researchers generally collect data in the form of written or spoken texts. The texts might be in the

form of interview transcripts, which contain the spoken words of participants (captured in interviews), or might have been produced by the researcher, in the form of written observations or research journals. The analysis of quantitative research involves working with numbers and using statistical analysis to reveal patterns and tendencies that emerge from the numerical data collected. While the approach to analysis of quantitative data will be set down by the type of data collected (see the examples in Chapter 8), there is no single right way to analyse qualitative data. Writing about analysis of qualitative data, Coffey and Atkinson have suggested that it is 'not about adhering to any one correct approach or set of right techniques; it is imaginative, artful, flexible, and reflexive. It should also be methodical, scholarly, and intellectually rigorous' (1996, p. 10).

Because of the different types of data collected, different strategies for analysis are used to make sense of the new information. But irrespective of the types of data collected, all research analysis involves detailed reading of the data to identify the strong themes, the patterns or trends or the essence of what is revealed. Such reading will take place within a framework provided by the original research problem or question, but depending on whether the research seeks to test existing hypotheses, or whether it seeks to generate new theories, the approach to analysis will be either deductive or inductive.

Deductive analysis can in simple terms be thought of as 'top down' analysis, where a researcher begins with a relevant theory or hypothesis and then collects data to test the theory's validity. In this case, the strategy is to examine the extent to which the data confirms the original hypothesis or theory that is being tested. This original hypothesis could have been developed by another researcher, or could have been developed as a result of your own reflections or experience. For example, you may have discovered research that reveals the attitudes of young men to different genres of video games. Your hypothesis (or 'hunch'), based on experience and observation, is that young women actually prefer the same types of games as young men. If you go on to develop a research project to test this hypothesis, your analytical process will be deductive, designed to test your initial theory. This approach is common in quantitative research, as it enables researchers to draw inferences or make conclusions based on statistical evidence (Creswell, 2008; Walter, 2010a).

If on the other hand you do not begin with a prior hypothesis about the types of video games young women prefer but wish to develop your own, you will embark on your research project with the aim of finding out what young women *do* prefer. In this case, your analysis will proceed inductively—in other words, by 'working up' from the data you have collected, you will be able to generate your own hypothesis or working theory. Qualitative research is typically inductive, in that theories are developed from the data and not the other way round. Because of the open-ended nature of such research, analysis is typically an exploratory, creative and iterative process (Patton, 2002) in that data will be examined in different ways and from different perspectives until 'saturation' is achieved and all possible ways of interpreting the data have been explored.

No doubt you will have realized that these two approaches (hypothesis testing and hypothesis generation) can work together in productive ways, for any new working hypothesis developed from the ground up can then be further put to the test. The work of Glaser and Strauss (1967) to develop 'grounded theory' has been highly influential in supporting the development of strategies for theory generation from the ground up.

Importantly, approaches to analysis depend on the original aim of the research, whether that be theory testing or theory generating. The approach taken to data analysis must be linked to the research design and methods of data collection, since the 'research problems, research design, data collection methods, and analytical approaches should . . . all imply one another' (Coffey & Atkinson, 1996, p. 11). In all the examples of research methodologies discussed later in the book the process of analysis goes hand-in-hand with the process of the research. The process of analysis works on several levels, at times being conducted deliberately and consciously as one works on analysis, while at other times taking place at an unconscious level. By this we mean that the analysis process often takes us by surprise, as understandings and new meanings suddenly spring into our conscious understanding without us having been aware of engaging consciously in the task of analysis, and new insights 'well up' from the data (S. Ball, personal communication, 1999).

The goal of all analysis is to produce a new research text, in which the research 'story' is told effectively and convincingly, by drawing on the important patterns and themes that have emerged from the research. Even numerical data must be explained using words, as without an explanation that gives meaning to the data, it is merely a collection of information. It is in writing about their work that researchers have the chance to engage audiences in the new insights and understandings that have emerged. This is an opportunity for researchers to make a contribution to the body of knowledge of the communities of practice of which they are members.

Analysis is briefly considered again in Chapters 6, 7 and 8, where strategies relevant to the methods introduced in those chapters are examined. However, all research analysis is complex, and the scope of this book doesn't allow the provision of detailed information or advice at the level of expertise that you may need. Our advice is that you consult the relevant literature if you need to obtain more specialist guidance.

Quantitative and qualitative research: criteria for judging research quality

'Traditional' criteria for judging research are based on scientific methods and apply in particular to research based on quantitative approaches. These criteria focus on the overall validity of the research, and on the strategies used to ensure researcher objectivity and to minimize bias. Questions of validity, reliability and generalizability apply in particular to research based on quantitative methodologies.

Qualitative research tends to use 'nontraditional' criteria for judging the quality of research. Typical criteria are connected to the rigour of the research, which

refs to the methods used to ensure that participants' experiences are 'faithfully' represented (Ezzy, 2010, p. 71). The research is expected to be authentic and trustworthy, and these criteria are linked to the extent to which researchers have acknowledged their own subjectivity. The extent to which the research has enabled participants' voices to be heard contributes both to the overall credibility of the research—does this ring true?—and indicates the extent of the respect accorded to participants and their experiences. These criteria apply particularly to co-design or community-focused research projects. The extent to which the research leads to an 'enhanced and deepened understanding of the phenomenon' is a further important criterion (Patton, 2002, pp. 544–545).

We would add that *all* research should be useful, that the final research text should be accessible and meaningful to the research audience, and that the conduct of the research should be guided by ethical principles from start to finish.

Ethical research practices

Many professional organizations have developed codes of ethical practice to provide guidance on professional ethics and conduct, for example the Australian Graphic Design Association Code of Ethics (AGDA, n.d.). Research is similarly subject to common agreements about ethical practice. All researchers are expected to work within the relevant guidelines to ensure that their research is conducted ethically, and ethical considerations should be at the forefront of every research project. Academic institutions where research takes place, as well as research associations, have their own ethical guidelines, and these will provide detailed requirements for the conduct of research. While there are some differences in the requirements of individual institutions or organizations, the basic principles and practices that underpin ethical research are the same. They can be summarized as follows:

Rights

- The rights of individuals who participate in research must be respected.
- How will confidentiality be ensured, and is confidentiality in any way limited?
- What kind of informed consent is necessary? How will the information be used, and who will have access to it?
- Participants should understand the purpose and the importance of the research.
- Individuals have the right to refuse to take part, and must not be coerced.
- Participants have the right to withdraw at any time, and have the right to withhold information either during data collection or after having reviewed the personal information collected (such as after reading an interview transcript).
- Participants have the right to know how the results of the study will be used, and how the outcomes will be reported and to whom.
- When research is conducted within a company or at a research site, visiting researchers should obtain consent to conduct the research from those in charge such as the company manager.

Reciprocity

- Participants should be aware of the benefits of participation, such as being able to contribute to a better understanding of the phenomenon they have experienced.
- No large financial inducements should be offered, although it is reasonable for researchers to offer to pay expenses or provide refreshments.
- Consider the possibility for in-kind contribution on the part of the researcher.
- Make sure that promises to provide copies of transcriptions or summaries of the research outcomes are kept.

Risk

- Steps should be taken to minimize the risk to participants of taking part in the research.
- Any potential risks, or social consequences of involvement in the research should be identified and explained to participants. For example, could legal issues arise? Should a participant's involvement in the research become known, what are the risks to that person, if any? Could there be emotional or psychological consequences?
- What strategies are in place to reduce or respond to negative consequences?

Ethical considerations will inform research practices throughout the project. Data should be stored securely, and who owns the data and who may access it should be made clear from the outset. Even when presenting the research, ethical considerations still apply. Research should be presented fully and honestly, without changing or filtering to satisfy a particular interest group. The research should not be plagiarized, and any research that has been specially commissioned or funded should acknowledge the sponsors. Finally, it is important to remember that ethical guidelines are also in place to protect researchers. In advance, consider whether steps should be taken to ensure your own safety, or the safety of research assistants employed to gather data, and identify who will be available to give ethical or legal advice should that prove necessary (see Creswell, 2008; Patton, 2002).

Framing a research question: narrowing down and opening up

To illustrate how you might go about developing your research question, and to show how the framing of the research question then enables you to make methodological decisions, in this part of the chapter we talk through the process using a simulated design brief as an example. As we 'think aloud' about the different possibilities for research based on this design brief, we illustrate a particular approach to developing a research question. The process of defining the overarching question that will guide your research involves identifying a series of 'subquestions' that in turn will inform the development of your data collection questions (see Creswell, 2008, pp. 143–146).

We also develop the idea of sensitizing concepts and show how they can be used to help narrow down a research focus. They can also be used to provide a starting point for thinking about what kind of data to collect and how to organize it (Patton, 2002). They are traditionally used by researchers conducting fieldwork, to provide ways in which to understanding a new and unfamiliar research setting. In this book we have suggested four general concepts—the designer, the designed object, the designed system and the end user—that can be used to provide an initial focus for the research. As the research process gets underway, further specific sensitizing concepts will emerge that are particular to each design/research problem.

The design brief

You are a member of a design team that has been asked to provide benches in East West Parade Shopping Centre. This comparatively new suburban shopping centre has been open for two years, and serves a demographically diverse community. Customer feedback has indicated a need for more seating, and the Centre Management has decided to respond by providing additional benches. In planning your research, your purposes are twofold. You intend to provide benches that will serve the needs of the centre's customers, while at the same time satisfying the centre manager's requirements that the benches be attractive, cost-effective and placed where they do not inhibit movement around the centre.

Using the broad scope of this design brief as a starting point, we demonstrate how you might successively narrow down the main focus to, first of all, frame a research question and then develop a research plan that will enable you to successfully complete the task. We use the four sensitizing concepts of the designer, the designed object, the designed system and the end user to illustrate how these concepts can help organize research process.

Narrowing down: the designed system

You might begin by thinking about the shopping centre itself and how benches form part of the designed system of the centre. Using this as a guide, the focus of the research becomes the way the shopping centre has been designed to function.

With this research focus you would need to explore the intentions behind the shopping centre system. Has it been designed to encourage customers to keep moving as much as possible, or is it expected that customers should be able to sit down regularly? Will there be dedicated areas for sitting, or will seating have to be fitted into a system designed to encourage movement? Using these ideas, your initial thinking about the research question might lead you to narrow down your inquiry into the following subquestions: What is the provision for movement in this shopping centre, and what is the relationship between this provision and the location of the new benches?

As has already been shown, researchers come to their research with particular perspectives based on personal and cultural experiences and a particular worldview. Before adopting the question you have framed already, it is important to ask yourself how these perspectives inform your thinking about the question. Your own perspective is possibly that of a *user* of the designed system. Your thinking about the research might begin with an analysis of your own practices when visiting shopping centres.

However, as a reflexive researcher you would take into account the limitations of your perspective. Do you prefer to rush in and rush out again as quickly as possible? In that case, are you irritated when ambling shoppers slow you down? Or perhaps you like sitting and people watching? Have you ever visited a shopping centre with a child or two in tow? Do you know what it's like to walk around a shopping centre carrying heavy bags when you suffer from arthritis? Have you ever spent an afternoon in a shopping centre just to escape from the cold, or the heat?

These are all questions about the user of the designed object. By recognizing the limitations of your own perspectives you also recognize that the design decisions you ultimately make should be the result of a co-design process. The users of the design should have a central role in the design process, and hence in the process of the research. Relevant research questions might be: What range of customer needs do the benches meet? What different needs might be met by alternative strategies?

Narrowing down: the designed object

Finally, the design team will need to consider the designed object itself. Having gathered information about the system that the benches will be part of, and having identified some of the needs of the users of the benches, you will be in a better position to make decisions not only about where to put the benches but also about the properties of the *designed object* itself. This research might take you away from a focus on the shopping centre and its clients and into research into materials, form and function, budget and ergonomics. A research question might be: What would be the most suitable bench design for this purpose, taking into account aesthetic appeal, ergonomics, suitability of materials and environmental impact?

The original design brief was to install some benches in East West Parade Shopping Centre. By exploring the different possibilities for research generated by this task we have been able to break it down into a number of more specific questions for inquiry. Note that each question above focuses on a particular concept (such as co-design, movement, usage, form and function) within the broader sensitizing concepts we have suggested.

Opening up: the research question revisited

From the original attempt to frame a question a number of options have also arisen. We do not yet have a 'big picture' research question that works well enough to

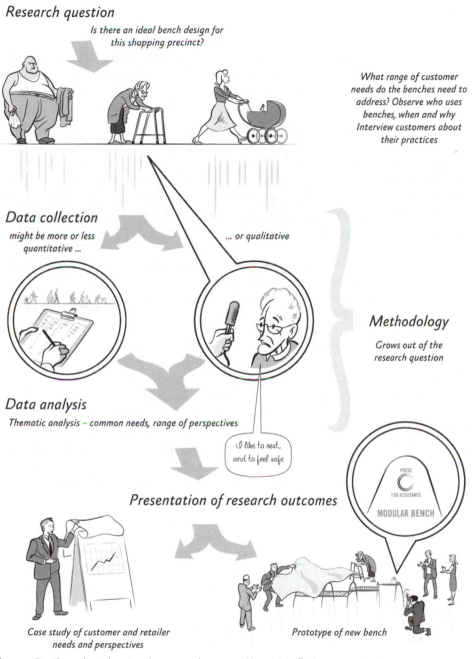

Research question

Is there an ideal bench design for this shopping precinct?

What range of customer needs do the benches need to address? Observe who uses benches, when and why Interview customers about their practices

Data collection

might be more or less quantitative ...

... or qualitative

Methodology

Grows out of the research question

Data analysis

Thematic analysis – common needs, range of perspectives

I like to rest, and to feel safe

Presentation of research outcomes

MODULAR BENCH

PRESS FOR ASSISTANCE

Case study of customer and retailer needs and perspectives

Prototype of new bench

Figure 5 Flow chart showing the research process (Stuart Medley).

guide the research component of the project. The exercise above has served to analyse the original brief by breaking it down into some component parts using the sensitizing concepts. We can now return to the original brief and recast it as a research question, such as 'What seating design and seating location best serve the needs of shoppers in East West Parade Shopping Centre?'

This is a very open question, framed in a spirit of inquiry that avoids pre-supposing a particular set of responses. It is important to avoid questions that are too general, too narrow or that are laden with assumptions (see Creswell, 2008, p. 144). This question captures the intention of the original brief, yet by rephrasing it as a research problem, it provides a starting point for a process of inquiry that was not immediately apparent in the original brief. The question also encapsulates all three sensitizing concepts: the designed system, the designed object and the user of design. Here, the research problem has been phrased in a single clear sentence that presents in general terms the main purpose of the inquiry, as recommended by Creswell (1998, 2008). The question also incorporates the more focused, research sub-questions developed earlier.

- 'What is the provision for movement in this shopping centre, and what is the relationship between this provision and the location of the new benches?'
- 'What range of customer needs do the benches meet? What different needs might be met by alternative strategies?'
- 'What would be the most suitable bench design for this purpose, taking into account aesthetic appeal, ergonomics, suitability of materials and environmental impact?'

These will remain in place as questions to be addressed by the research and to guide the development of the research and the data collection questions.

By breaking down the original design brief into its component parts, we have been able to unpack the original brief in terms of the different research questions that it implies. After narrowing down the original brief into a series of separate components, we then moved back to look at the bigger picture of the brief and rewrote it as a general, open question. This change in focus from broad to narrow and back again is characteristic of the cyclical nature of the processes involved in creating a research question that most clearly reflects the problem you are addressing.

The process of developing research questions is complex. It is worth spending time on the process, by documenting your developing ideas in a personal research journal, by talking to other designers and researchers who can be sounding boards for your ideas, or by talking to your supervisor. Some of your conversations with other designers/researchers take place as you engage with the literature. By exploring the relevant literature you effectively engage with the work of others in the research/design community, and in so doing you will be able to identify the different ways in which others have already responded to similar problems. Such exploration can help you discover gaps in the existing body of knowledge where your work

might fit, or help you refine the focus of your research, or help you locate your research within a broader inquiry.

Time spent clarifying and focusing your research question will not be wasted. You may find that your original ideas change direction as the research takes shape. Often as you collect and analyse data, you will find that you need to change, widen or narrow your focus, but a well-conceptualized research question will be invaluable in helping you keep the original focus in mind as the research takes shape. Once the research purpose and questions are in place then the decisions about methodology will readily follow and a research plan can be developed. (See Table 2.)

Table 2 Approaches to Data Collection, Data Analysis and Presentation of Research Outcomes for the Benches Project

Research question	Data collection	Data analysis	Presentation of research outcomes
What is the provision for movement in this shopping centre, and what is the relationship between this provision and the location of the new benches?	Structured observations of bench usage, including time spent and popularity of different locations Map bench positions Map movements through the centre	Identify patterns of movement and use of seating over time	Map of movements Statistical summary of average sitting times Written narrative showing movements throughout one day
What range of customer needs do the benches meet? What different needs might be met by alternative strategies?	Observe who uses benches, when and why Interview customers about their practices Interview managers and retailers	Thematic analysis— common needs, range of perspectives	Case study of customer and retailer needs and perspectives
What would be the most suitable bench design for this purpose, taking into account aesthetic appeal, economy, ergonomics and environmental impact?	Materials research— sustainability, environmental impact and production techniques Historical research— bench designs Ergonomic research	Synthesize information	Present options for bench design and positioning according to the different criteria researched

Some final suggestions to guide you as you embark on the process of planning research.

1. Your whole research project grows out of your original research problem or question. You may need to work and rework your research question several times to arrive at a clear focus. Do not be surprised if this process seems time-consuming, as your work to achieve clarity here will ensure that your later planning is effective.
2. Involve other people such as your supervisor, panel members or fellow researchers as sounding boards and critical friends. The very process of articulating your ideas can help you clarify your thinking and identify gaps or inconsistencies.
3. Spend time thinking through your research position, and the methodological constraints and possibilities that are particular to your research context. Take these factors into account in your planning.
4. Take the time to investigate what other researchers have done in research contexts that are similar to yours. Doing so will help you identify your own focus and help you establish clear boundaries for your inquiry.
5. As a designer/researcher you are already part of a research/knowledge community in design. Consult the relevant literature widely to establish where you fit in the broader community of designer/researchers.
6. Remember that your methodology will grow out of your research question.

6

IN THE PICTURE: ETHNOGRAPHY AND OBSERVATION

What is ethnography?

Ethnographic research has a long tradition, and provides a useful introduction to the social research processes we discuss in this book. Its name reflects the key goal of ethnography, which involves the description of, or writing about, a particular cultural group or particular cultural practices. An ethnographer can therefore be characterized as both researcher and writer. In this chapter we explore the potential of ethnographic approaches to research in design, with a particular focus on the value of ethnographic research to identify and elaborate the social and cultural dimensions of design problems and solutions. We begin by describing classic ethnographic research, tracing the methodology back to its roots in anthropology. We then consider some key methodological and epistemological concerns associated with ethnography and explore how ethnographic approaches and aims have evolved in response to post-colonial and globalized contexts. The chapter then focuses on methods for conducting observations as part of an ethnographic study, concentrating on the possibilities, cautions and strategies associated with observation. Finally we outline some examples of research in design where ethnographic approaches might be applied.

The origins of ethnography

Ethnographic research grew out of the discipline of anthropology: the study of human beings, their lived experiences and their cultural practices. As a discipline, anthropology became important when colonial expansion led to the 'discovery' of societies of people living in geographically remote parts of the world, far away from the centres of colonial power. Anthropological researchers were intrigued by the differences between the practices of the newly discovered societies and those of the groups at the colonial 'centre', and attempted to document and explain how those newly discovered societies experienced daily life. Anthropological research

was typically empirical, and took place in the field; anthropologists would spend long periods of time (several months or even years) living alongside the people under scrutiny, immersed in their daily lives, and recording the experience in the form of field notes or diaries.

Our interest in this form of research arises from its focus on what can be learnt about cultural practices by studying the objects that are integral to those practices, and *vice versa*. Objects displayed in museums across colonial centres have been studied for what they convey about the cultures and societies from which anthropologists have collected (some might say stolen) them (Smith, 1999). Designed objects have for many centuries been seen as important devices for understanding a particular culture and its practices. Research into the cultural practices of remote and unfamiliar communities in far-flung corners of the globe is no longer relevant in the contemporary circumstances of a globalized, post-colonial world. Nevertheless, the basic principle that there is an intimate connection between a culture and its designed objects leads us to advocate for an ethnographic approach to research in design where cultural practices are the focus of inquiry.

As an example, the mobile phone was developed partly in response to particular cultural practices such as the intensification of work (which mean that it became important to be able to contact work colleagues when they were out of the office) and the use of the motor car (because such phones were originally designed to be used in cars). As the use of mobile phones proliferated and demand for them grew, smaller and lighter phones were designed that were more capable of being hand-held. At the same time different features such as wireless broadband and built-in cameras added to their utility and popularity. As a result the practices of cultures where mobile phones are commonplace have evolved significantly, not only in terms of how people communicate and interact with one another but also with respect to issues such as privacy and surveillance, etiquette in meetings or other public spaces, and bullying and harassment in the workplace and schools. Objects such as mobile phones have been designed in response to changing cultural practices, and in this way could be said to reflect those practices, but their presence also transforms them. For these reasons, research methodologies such as ethnography, that help us better understand cultural practices, are invaluable for designers.

The evolution of ethnographic research out of anthropology has meant that while both approaches overlap in their broad research focus and research methods, they differ somewhat in their research purpose. Ethnographers focus explicitly on cultural questions by examining the behaviour, language or cultural artefacts particular to the group that is being studied (Creswell, 1998). In this sense, developing an understanding of what is meant by culture is an important preliminary to ethnographic research. Giddens defined culture as the 'ways of life of the members of a society, or of groups within a society' (1997, p. 18), pointing out that while society and culture are different neither one would exist without the other. This reinforces the central role of culture in providing a context in which humans can interact meaningfully with one another in social relationships within a society. In this sense

our culture is what binds us together as social animals and enables us to understand and be understood by others. To have a culture in common with someone else is to have a shared identification based on common understandings of a set of particular experiences. Geertz similarly explains culture as that which enables humans to associate with one another through systems of shared meaning making. He describes it as a series of 'webs of significance' (1973, p. 5) created by humans through their daily interactions.

These definitions of culture are useful for ethnographers, since they provide contexts in which ethnographic work can take place. It is possible to focus on any one of the multitude of cultural practices found in a society, which include how people dress, their patterns of working life, how they pursue their leisure as well as how the artefacts or designed objects reflect particular cultural practices or values. This notion of culture as an accumulation of interconnected social discourses suggests the methods by which a society might be understood through exploring its cultural practices.

Offering a definition of culture that is based on how patterns of meanings develop and are shared through the symbols maintained by a particular group also opens up new possibilities for defining cultural groups. People in the same workplace, people in the same profession, people who engage in similar leisure activities are each members of a particular cultural group, and through their shared social discourses share a common identity. Of course they are also members of other cultural groups based for example on their shared language, shared geography or shared nationality. In this sense, every individual is a member of the multiple cultural groups that make up a society. For many people, their culture is invisible. They are so immersed in the practices of the culture to which they belong that it is imperceptible to them. The significance of practices in defining and maintaining a culture can be seen in the ways that members of subcultures—groups of individuals who share a common identity and whose cultural practices explicitly present a challenge to social norms (Hebdige, 1979)—communicate their identification with the subculture through such practices as distinctive physical appearance, preferred leisure activities and language use that is impenetrable and exclusionary to outsiders. To use Bourdieu's terms, such groups create their own social and cultural capital.

By exploring in detail a specific social or cultural group, a key aim of ethnography is to try to understand how individual members of a cultural group experience that culture. Creswell (2008) emphasizes the ethnographic researcher's focus on patterns of daily living. Ethnographers often aim to look beneath the surface of cultural practices to examine how particular features of the culture impact on the experiences of individual members: in Armstrong's words, exploring 'central questions about the nature of human existence' (2008, p. 55). Building on this interest in everyday life, ethnographic researchers increasingly employ the methods of anthropology to conduct ethnographies in many settings that are close to home, such as workplaces, hospitals and schools.

For example, to return to the bench project (see Chapter 5) introduced in an earlier chapter, an ethnographic study of the cultural practices associated with

shopping might expose some underlying values about who does or does not have the right to sit down in a shopping centre, and for how long. Questions about the benches that address quantity, type and placement lead to deeper questions about the purpose of the shopping centre: is it business or pleasure? If pleasure, then it might be likened to a park, where benches are everywhere and sitting on them is a normal part of the cultural practice of visiting a park. If business, then benches are an unnecessary luxury and should only be provided for temporary rest.

If, as ethnographers, we examine the semiotics of a shopping centre, we might easily come to the conclusion that it is a place of pleasure. The bright lights, the soothing music, the fragrances of coffee or fresh flowers wafting from open shop doors, the spectacle of beautiful things to buy all suggest this is a place of pleasure, not business. But of course the purpose of the shopping centre is business. Everyone who goes there is in the business of buying or selling and the spectacle is illusory, designed to entice the buyer to spend money. With this perspective, benches are probably detrimental to business success as they encourage people to stay in one place instead of walk around and possibly buy something they didn't intend to. So for the designer who has been asked to provide benches, an ethnographic perspective will provide different insights into the task and enable a much more informed outcome based on a deeper understanding of the cultural practices that have grown up around the day-to-day experiences of visiting a shopping centre.

Methodological concerns

While anthropological research and ethnographic research differ somewhat in terms of their broad purposes, both use similar methods to conduct the research. In this book the word methods is used to refer to the strategies or practices used in conducting research. Methodology is used to mean the analysis or study of the principles from which particular methods have developed; and epistemology refers to questions of how we know and what constitutes reality.

The following account of concerns surrounding methodological practices in ethnographic research draws on the work of anthropologist Bronislaw Malinowski. We have used this example to illustrate the risks associated with trying to understand a culture when it is immensely different from one's own. As you read you will see how Malinowski's particular perspective leads him to interpret the behaviour of the islanders in a *culturally specific* way; in other words, he reads the islanders' behaviour through the lens of his own cultural experiences. Using the terminology of this book, Malinowski failed to approach his research reflexively: he did not take into account that his position as a researcher itself shaped the research, nor did he consider how his own habitus might frame the way he understood the society he was observing.

While the discussion of Malinowski's work relates specifically to practices in research, as you read it think about the risks for designers of failing to approach a design problem un-reflexively, or without taking account of how their habitus

frames the way they understand the world. The economic failure of the Sinclair C5 battery-powered electric vehicle (Adamson & Kennedy, 1986) could be attributed to the designer's lack of reflexive understanding of the limitations of his worldview, which encompassed neither an understanding of the influences of the powerful road lobby and petroleum industry on the marketability of the vehicle, nor a recognition of the influence on consumer choice of the culturally framed association between car ownership and social prestige. In other words, the failure of the Sinclair C5 could in part be attributed to the designer's habitus, which led him to understand the designed product in isolation from the field of its potential use. To be effective in the global marketplace, designers need to be able to make judgements that look beyond their own narrow viewpoints and take account of the perspectives of others from different cultural, economic and social backgrounds (Salvador, Bell & Anderson, 1999). As the following account of Malinowski's work shows, taking account of others' perspectives is not as easy as might appear.

Malinowski's best-known research was conducted while living on the remote Trobriand Islands in the Pacific. Here, he developed the form of fieldwork he called participant observation. In this method, researchers become *participants* in their own right in the culture and practices of the society. It was expected that by becoming an accepted member of the group, the researcher could gain a close and intimate understanding of the points of view of those observed. Participant observation requires intensive, long-term observation and participation, making use of a group of associated methods such as individual and group interviews, observations, the collection of life narratives, and records of the researcher's experience of being a participant in the society. Malinowski's research methods have since been widely adopted and developed by ethnographers.

Malinowski's diaries are instructive in revealing a key methodological problem with participant observation. Using an example from the diaries, published in 1967—twenty-five years after his death—and what Geertz (1988) therefore calls 'that backstage masterpiece of anthropology' that sits behind Malinowski's published, 'official' account of his research, Geertz explores a problem that lies at the heart of the practice of participant observation.

> On the whole the village struck me rather unfavorably. There is a certain disorganization . . . the rowdiness and persistence of the people who laugh and stare and lie discouraged me somewhat. Went to the village hoping to photograph a few stages of the *bara* dance. I handed out half-sticks of tobacco, then watched a few dances; then took pictures—but the results were poor. They would not pose long enough for time exposures. At moments I was furious at them, particularly because after I gave them their portions of tobacco they all went away. (1988, p. 75)

While this extract (which is a very small part of a very large work) was never intended for publication, it nevertheless raises important cautions about the possibilities and the limitations inherent in the role of the participant observer. The diary

extract clearly betrays the researcher's own highly subjective response to the people he was living with, and reminds us of the contradictions intrinsic to the researcher's situation as both participant and observer.

These contradictions are partly methodological. In such a conflicting position, under what conditions is it possible to be both inside and engaged with the events that are observed, and at the same time located outside and detached from them? This contradiction continues to perplex ethnographers. There is also an epistemological dimension, since ethnographers must ask whose reality it is that they are experiencing. To develop this problem further it must be asked to what extent the subjective viewpoint captured in the diaries limits both the research process (what was seen and what was not seen because of this limited perspective) and the research product. How does the researcher's perspective finally colour the official text wherein the research is reported? In other words, whose point of view is represented in the final research, and how, as readers, do we know?

This leads finally to an ethical question: by what right does the researcher speak for, or on behalf of, the research subjects? As Tedlock points out, 'ethnographers' lives are *embedded within* [our emphasis] their field experiences' so that 'all of their interactions involve moral choices' (2003, p. 165). Much recent critique of ethnographic practices focuses around this ethical problem, or what Denzin and Lincoln (2008) call the 'crisis of representation'.

These concerns reveal how necessary it is to engage *reflexively* in the process of research. We do not suggest that these concerns render ethnographic research impossible. What they do lead to is a different way of framing ethnographic research so as to place these considerations in the foreground, by attempting to understand and take account of the researcher's subjectivity, and to build that understanding into both the research process and the research text. We will return to this problem throughout the book. We should make it clear that, in relation to Malinowski's diaries, what we take issue with is not his attitudes to the islanders but his lack of reflexivity that led to his misrecognition/lack of consciousness of the particular perspective through which he understood the field of his research.

Geertz's work (1973, 1988) has been influential in drawing attention to the problems inherent in the practices of participant observation and in 'doing ethnography'. His perspectives on the disciplines of anthropology and ethnography develop from his view that a study of cultures is at heart a study of meaning making and interpretation. Social meanings are not immediately apparent to people who are not familiar with particular socially established codes used to convey meaning. They are 'enigmatical' (Geertz, 1973, p. 5). As an intellectual activity, ethnography is concerned with understanding meanings through examining what people in cultures do to convey meaning. Of course meaning is not immediately apparent at the surface of a text.

Geertz points out that in attempting to understand the meaning of gestures, symbols or texts one is involved in picking a way through structures of 'piled up inferences and implication' (1973, p. 7). Often, the information we need to understand

a particular event exists in the background to (for example prior to, or in another place than) the actual event under scrutiny. Hence the role of ethnographers includes explicating the significance of a particular event or observation on the basis of what else has been observed or discovered in the background. This is further complicated by the fact that the only information we have access to is that which our research participants (or 'informants') have been able to lead us to understand. As Geertz says, while 'it is not necessary to know everything in order to understand something' (1973, p. 20), the notion that we can only ever have a partial understanding of cultural or social meanings does mean that ethnographic work at best is a series of educated guesses.

The role of the ethnographer in this process is complex, since it is not possible to reproduce in its entirety the experience of engaging with a particular culture. Hence researchers must, from the outset, take into account the particular perspective from which they are to understand the culture they observe, and maintain a reflexive stance as they engage in the interpretation and representation of the culture. This requires the researcher to constantly step into and step away from the culture observed. It also requires one to take account of the ways the researcher thinks about and understands the culture which is as important as taking account of what is unmasked about the culture itself.

As this discussion has shown, ethnographers cannot remove themselves from their observations. Since researchers' interpretations and observations of other people are permeated with the researchers' own worldviews and personal perspectives, there can be no 'innocent' observations. However, this is not to say that a researcher should give up on observation as a method for gathering information. Rather, it suggests that the identity of the researcher becomes a central concern that should be thought about and reflected on throughout the research process. Dunne, Pryor and Yates are explicit about this. They suggest that since the researcher is 'always and inevitably biasing the research . . . what becomes important is an aspect of reflexivity, that identity issues are seen as problematic and discussed in the research report' (2005, p. 61).

Debates about the role of the researcher have led to significant shifts in how ethnographies have been conceptualized. Concerns about the colonizing practices of some ethnographic research (hooks, 1990) and concerns about the legitimacy of research, where a researcher in a position of power 'gives voice' to research subjects who are in a relationship of powerlessness or subordination, led researchers to take particular notice of issues of gender, race and social class when conducting research (Denzin & Lincoln, 2008). Such concerns have not only alerted researchers to the potentially oppressive practices associated with the ethnocentrism of an observer of a culture that is different from their own, they have also opened up possibilities for researchers from marginalized or minority positions, such as women, people of colour or indigenous researchers, to step into the field and conduct research about members of their own social or cultural background in their own right. Added to this is the impact on ethnographic practices of the end of

colonialism, described by Geertz (1988) as having 'altered radically the nature of the social relationship between those who ask and look and those who are asked and looked at' (p. 131).

Typical ethnographic methods are participant observation and in-depth interviewing, which lead to the creation of 'thick' descriptions of the cultural practices being observed. In early examples of ethnographic research, these strategies for collecting data were thought of as ways an outside observer might come to know another culture as an insider might know it. In other words, there was an expectation that participation would lead to a direct or realistic understanding of the experiences of others, through researcher participation in the culture and practices studied. However, as ethnographic practices developed over time, so too did the recognition that such depictions of a culture, no matter how rich and detailed, could not communicate the reality of a particular culture directly. What was communicated was the researcher's interpretation of the reality of the cultural experience.

Recognition of this insurmountable problem—that any depiction of a culture could only take place from the limited perspective of the observer—led to shifts in ethnographic practices and purposes. Ethnographic strategies began to be seen as methods to better understand the events, social interactions and experiences that take place in social and cultural contexts, by taking the social and cultural contexts into consideration. This is why we advocate the use of ethnographic methods to help us understand how individuals act within the particular social world that they are part of, and how the behaviour, values and understandings of an individual or group are related to their broader social and cultural context. Researchers often adopt ethnographic methods, even when they are not engaged in true ethnographic research. Doing this enables researchers to foreground the context-specific nature of the research, by acknowledging that 'social action and human experience are . . . highly contextualised' (Carspecken, 1996, p. 25).

New ethnographies

Classic ethnographies (which involved participant observation and long-term cultural immersion in an unfamiliar culture) are now conducted less often. In the context of a post-colonial, globalized world, such practices are increasingly irrelevant. Yet the strategies developed by early ethnographers have been adopted and modified by researchers to the extent that most research in the social realm has been influenced and informed in significant ways by ethnographic practices. Fieldwork in exotic settings has largely been replaced by research in local, more familiar settings, and much is still to be learned by asking questions such as what is this culture like, how does it operate and what are its characteristic practices when the setting is a workplace, or when the research participants are members of a minority cultural group within a larger cultural or social setting.

There has also been a shift in the goals of ethnography, from interpretation to critique. In critical ethnography, researchers assume a conflict between the individual's lifeworld and the system, in which the system colonizes the individual and relations between the individual and the system have broken down. Critical ethnography explores facets of the relationship between the individual and the wider society, recognizing that there is a political dimension in all research. Critical researchers aim to explore issues of power and the marginalization of social groups, wanting to achieve social change and social justice.

The *Fuel from the Fields* project does just this, by finding alternatives to cooking fuels such as wood, charcoal or dung. These biofuels are used traditionally in majority world communities but are both damaging to the health of individuals and have a negative environmental impact (Smith, 2007). This project did not only seek to find alternative fuel sources, it also recognized how important it was for the people involved in producing and selling the fuels to be able to maintain their livelihoods, and so incorporated their perspectives into the final design solution. Smith was well placed to do this because of her prior experience as a member of the Peace Corps in Botswana, where she lived alongside the villagers and participated in the same routine tasks such as carrying water and pounding sorghum into flour, until she felt 'the ache in my back'. These experiences gave her 'a critical understanding' of the need for designers to gain a good understanding 'of the contexts in which they are designing and of the people using their products' (Smith, 2007, p. 30). Smith's prior experiences not only gave her a sound understanding of the field in which she was designing, they also changed her habitus as a designer.

Critical ethnography has also opened up possibilities for research conducted by members of minority or marginalized communities. The practice of ethnography has given opportunities for feminists, gays and lesbians, members of cultural minority or culturally hybrid groups, and third and fourth world researchers to make their voices heard by writing about their own cultures and communities. Out of the critical concern that research conducted on behalf of the 'other' risks further silencing of marginalized individuals has grown an acknowledgement that when researchers use the research process to speak for themselves, there is greater potential for transformation and empowerment.

Autoethnography is a further offshoot of ethnographic research, reflecting both an interest in individual lifeworlds and the valuing of individual voice and lived experience. In autoethnography, the researcher writes herself or himself into the text, and the ethnographic focus is the researcher's culture and his or her place in it. Here, the researcher's own experiences become 'a primary data source' (Patton, 2002, p. 86). Increasingly, researchers will create an autoethnography that forms part of the final research text, even though the broad intent is not to write an autoethnography. Such autoethnograpic sections enable the researcher to make his or her perspectives explicit (including their values and ideologies), and may include

explorations of researcher identity as a way to make obvious the relationship between the researcher, the context and the individuals that he or she is researching.

Methods in ethnographic research: observation

Observation is a key strategy for research in the social realm, and is particularly important for ethnographers. As we discussed earlier, observation is a strategy that enables researchers to engage with and observe the field that is the focus of their research. In other words, it is a strategy for 'going out and getting close to the activities and everyday experiences of other people' (Emerson, Fretz & Shaw, 1995, p. 1) and enables a researcher to become 'immersed' in the research setting. Observation has been described as the 'most comprehensive of all types of research strategies' (Patton, 2002, p. 21). It helps researchers to put together a detailed picture of what goes on before, during and after a particular event, and enables them to take account of multiple perspectives. In this sense, it is more capable of capturing the complexity of experiences than other approaches such as interviews. For ethnographers, it is the key to understanding the bigger picture context in which particular individuals engage in particular events or particular practices.

It is important to point out that ethnographers rarely use observations alone in their research, and often supplement observation data with interview texts, documents or other artefacts to enrich, clarify and validate their observations. Such *bricolage*, where the researcher uses a multiplicity of data collection methods and combines them in creative and innovative ways as the research evolves, is commonplace in qualitative research (Patton, 2002). Observation and interviewing are particularly complementary methods, with observations providing the wide-angle viewpoint that is then given more focus through interviews. We explore interviewing in depth in Chapter 7 in connection with our discussion of narrative research. At this point, it is useful to remind you that the intention for this book is not to provide recipes or suggest a formulaic approach to the selection of methods for research, but rather to present possibilities from which you can make some informed decisions. Your choice of methods will be based on the decisions you make about the nature of the problem, your choice of questions and the particular needs of your research project. If these decisions are well made, then at a fundamental level your methods will find you.

Observers may watch, listen, converse, write, draw, film or take photographs. They may choose one, several or all of these approaches to record what they observe. Observation has a key role in orienting the researcher to the particularities of the research setting in order to understand them better. Observation then provides data sources that will help address the research problem, though this is not the only goal. Observation notes provide rich information that, when used to elaborate and contextualize the research report, enhances the researcher's credibility and helps the reader engage with and make sense of the final research text (Dunne, Pryor &

Yates, 2005; Patton, 2002). When making decisions about how to observe and what to collect, it is worth remembering that these resources will later be used to create the final research text. This text will be crucial in helping the reader to connect with the setting, the people and the research, and can take many forms including performance, life history and poetry (Denzin, 2003). Designers will want to consider innovative ways to present their final research, and may have in mind the form of the final research text when making decisions about what to collect during observations.

Observer roles: some possibilities

While the core principle behind Malinowski's use of participant observation remains—to enable the researcher to establish close and sustained connections with the people and the cultural setting and thereby to achieve a deeper understanding—it is now widely acknowledged that there can be different levels of connection between the researcher and the research setting. Total immersion in the setting is not always necessary for research to be credible. Different continua have been suggested to show the range from complete participation to non-involved, pure observation (see Ary, Jacobs & Sorensen, 2010; Dunne, Pryor & Yates, 2005). Non-participant observers do not attempt to develop a close familiarity with the setting, but instead take on a slightly detached role in their observations and do not attempt to take part in the actual experiences (Ary, Jacobs & Sorensen, 2010, pp. 432–433). This is the difference between a researcher who, as part of a research project to explore collaboration, works as a team member in a design studio (a full participant) and a researcher who visits the design studio to observe aspects of collaboration but never works alongside the other designers (a non-participant). Clearly while each approach could be valuable (and its value would depend on the particular research question), each researcher would collect very different data depending on the nature of their immersion in the setting.

However, if both researchers were designers as well—in a sense insiders within the culture of design practice—their experiences would be different again from those of researchers (outsiders) who had never worked in design. It is now acknowledged that the role of participant observer is not exclusive to researchers who come in as outsiders to a setting or cultural group that is unfamiliar to them, but that the strategy is equally valuable for those who are insiders by virtue of their existing membership of the culture that is being researched. Thus, there is a further dimension to participant observation, when the researcher is an insider in the larger field of cultural practices of which the particular research setting is a small constituent.

Observer roles: some cautions

There are advantages and disadvantages in both insider and outsider roles. Insider researchers may have more credibility and may more readily gain the acceptance of

other research participants. Similarly, when the research setting encompasses groups of people who are marginalized from mainstream society, as would be the case if research participants were members of a minority cultural group such as indigenous peoples or refugees, an inside observer would avoid the potentially oppressive practices associated with having an observer who was a member of the dominant culture. However, observing a research setting as an insider reduces considerably the potential for fresh insights, as much of the setting that would seem new and different to an outsider will escape an insider's attention. Insider researchers need to be particularly aware of the need to problematize commonsense perspectives and to try to see the familiar as if it were strange. The outside observer, while having the advantage of approaching an unfamiliar setting with fresh eyes, also risks focusing attention on what is novel or exotic to them and so losing sight of the everyday experiences. There are thus different challenges associated with making the familiar strange, and making the strange familiar.

Observation is at its core a reflexive process, since the 'very process of observing becomes loaded with the [researcher's] theories of the world' (Dunne, Pryor & Yates, 2005, p. 67). No matter whether the researcher is observing from inside, outside or from a place in between, observations are neither value-neutral nor objective. An observer's existing perspectives will unconsciously shape his or her observations, by predisposing the observer to take notice of those events that fit within his or her frame of reference. Dunne, Pryor and Yates (2005) point out that besides the planned research questions formulated by researchers, they are also likely to have 'tacit' questions in play that unconsciously shape what they see to be important. This does not mean that observations are useless as research data, but simply that it is important to contextualize the observations in terms of both the researchers' theoretical orientation and their practical perspectives. This is why we advocate the use of reflexive records in which researchers show how they recognize and take account of the limitations of their perspective, and that in the final research 'text' (whatever form it takes) the researcher's positioning is made clear. The nature of these limitations also suggests the importance of making modest claims in the final research text, and avoiding drawing conclusions that attempt to make a final statement about the research question. The conclusions should be capable of adding to existing understandings while at the same time leaving open possibilities for other researchers to make further interpretations and extend those understandings.

Another limitation is that observers, by their very presence, influence the behaviour of those who are observed and thus what is observed can never be a wholly natural setting (Dunne, Pryor & Yates, 2005; Patton, 2002). People behave differently when they know they are being observed. This is more marked in more intimate settings such as workplaces, and when the observer is a complete outsider. Some outsider researchers have addressed the problem by taking on a role within the setting that enables them to participate more naturally in the day-to-day activities of the place. This could involve taking on a volunteer role in a design practice, or in a designed setting such as an office space or school.

In all cases it is important to negotiate the nature of the participation and the conduct of the observation, to obtain permission from participants to ensure that what takes place is both useful and appropriate for the research, and to follow ethical practices. Similarly, ethical considerations rule out covert observation when individuals are going to be observed closely. In every case it will be important to inform people that you are observing them, unless the size of the group to be observed makes this impractical or unnecessary (e.g. if the focus of the observation is people's movement through a building). It is worth remembering that you are observing real people, and that your presence and your observation practices will have at least a small impact on their lives.

Observation strategies

The collection of data through observation is a dynamic process. Data collection usually begins with a wide focus, which is then successively narrowed so that the researcher finds out more and more about less and less until a saturation point is achieved. At this point the data stops giving rise to new insights but instead begins to reconfirm what has already been established. Sometimes the focus shifts again, as new questions arise and new observation contexts or focuses suggest themselves. 'Wide-angle' data collection often starts before the research project even begins, as the researcher's life experiences lead to informal observations about a research problem or a research context. Personal journals, notes and reflections on readings can all form part of such preliminary observations. And often when the research has a link to a professional context, the two dimensions—personal (or habitus) and professional (or field)—inform one another repeatedly. It is useful to remember that the research process will not be linear and static but always has the potential to shift direction in response to changing conditions or the emergence of a new focus.

It is tempting to think that observation is a simple, natural activity. After all, isn't that what we do when we sit in cafés and people watch? However, as Patton (2002) reminds us, *purposeful* observation is not something we do naturally. Rather, it brings into play a range of complex capabilities such as being able to listen and pay attention, having the ability to write focused descriptions, being able to select what is important from a mass of fleeting and conflicting impressions, and on top of that being conscious of both the strengths and the limitations of our own perspectives. Some degree of prior experience and careful planning will be needed if we are to make the fullest use of the opportunities provided by observation. We suggest practising by closely observing family or friends (with permission), or keeping notes on the comings and goings on a street.

Dunne, Pryor and Yates (2005, pp. 56–57) recommend the use of two columns when making observation notes, with detailed descriptions appearing on the left hand side and commentary and interpretations appearing on the right. Such records quickly become extremely complex, and techniques for capturing events accurately need to be developed alongside techniques for recording the researcher's responses,

reflections and emerging ideas. Examples of other people's observation notes can also be studied for a sense of the level of detail that is useful (see Creswell, 2008, p. 224; Emerson, Fretz & Shaw, 1995; Patton, 2002, p. 304). It is a useful strategy to look over field notes as soon as possible to check that they make sense and add comments or elaborate while the experience is fresh in your memory.

In every case you must have some overall plan for the different stages in the process of observation, such as how you will choose the site, how you will gain access, what different levels of engagement you will have and when and how to finish (see example in Creswell, 2008, p. 225). Different research needs will require different levels of planning. While using a preplanned observation schedule can lead a researcher to missing something important when it does not fall within the scope of the schedule (Dunne, Pryor & Yates, 2005), it is useful to develop a series of general 'sensitizing concepts' to organize and guide the research (Patton, 2002, p. 278). Even short periods of observation will generate vast amounts of data, and when time is a constraint it is practical to devise a means of maintaining a focus. In the final section of this chapter, where some examples of research projects are outlined, some related sensitizing concepts are suggested that could be used to help frame the observations.

As you spend time in the research setting, you will come to know well the people you are observing. As the research progresses, you may find that the process continues beyond the formal data collection period as you bump into participants regularly and become drawn in to the natural interactions that take place in the setting where you are observing. Although such opportunistic interactions may not have formed part of your planned observations, they nevertheless will be invaluable. Throughout the period of data collection (and beyond), it will be useful to keep a research journal to record 'thick' descriptions (Neuman, 2000) of naturally occurring data (Silverman, 2001) such as conversations, encounters and your own reflections on these experiences. Extracts from the research journal can be included as research data, for example to give a sense of your personal contact and involvement with participants.

Decisions made about how to conduct observations and how to use the information collected—decisions about method—are not merely practical but are also methodological questions. Such questions incorporate the political context, which in turn affects our identities as researchers/designers and as individuals and our ethical positions. These decisions are also based on our epistemological and ontological positions—how we think we come to know the world, and what exists in the world to be known. So in thinking about 'how to' questions, we take into account our overarching methodological stance, which includes the kinds of data that fit our research purposes, the participants who would be most appropriate, the time period over which the research should be conducted and why, and so on.

The political context, at both macro and micro levels, links back to our methodological decisions. Who has the right to speak about this issue, who 'owns' the problem and whose voices should be heard are all political questions. Then our

identities as people and as researchers further inform our methodological decisions. Is the designer or researcher uppermost in our thinking as we plan the research? How might our interests as a designer be reflected in the final research product, and how will this in turn influence how we go about recording our observations? Given our particular identities, are there individuals among the research participants to whom we will relate well, or badly, and how will this affect the research? And what ethical considerations flow from our answers to these questions? And finally, but not least, what do we think it is possible to know, and what are the limits to our knowing this? As our research takes shape, methodological considerations will continue to inform everything we do.

To end this section on observation, we turn to an example of a research text that has been produced as the result of observations by a design teacher over the period of a year. We do not have access to the observation texts that Szenasy collected during that year. Observation notes are not usually published, although extracts from them will form part of the final research text. Here Szenasy's final text reveals both the identity of the researcher/teacher/designer and the shifting attitudes of the designers in her class to the idea that 'the creative professions make a huge difference in the ways we live' (Szenasy, 2003, p. 20).

Beginning with a brief account of one design student's dismissal of sustainability as 'not my issue', Szenasy charts the progress over the year of her students who at start are 'sceptical, even cynical' (p. 21) about the possibility of individual designers being able to resist the 'throw away culture' to which we are enslaved. Through gradual exposure to film, text and the ideas and practices of designers who deliberately worked against the grain of the majority culture, the students' attitudes begin to change and individuals begin to put forward arguments in their own right about the immorality of certain practices they have encountered in the observations of design practices.

Szenasy traces in some detail the subtle and complex shifts in perspective of the members of the class, and thus uses her observation records to explore possibilities for cultural change in her class of student designers. Her final text is part polemic but also part research report that has the potential in its turn to suggest strategies for other teachers of design who wish to challenge their students' perspectives. Her approach exemplifies the point that 'a narrative approach to observation, being there, provides many opportunities for establishing *critical empathy*' (Dunne, Pryor & Yates, 2005, p. 71). By being there, the researcher herself becomes part of the research and is no longer a detached, objective observer.

Ethnography for research in design

To bring this chapter to a close some further examples of research problems in design that invite an ethnographic approach are introduced. We look first at the experiences of Kayo, an emerging fashion designer who is trying to build a design

business in a regional city. She is looking for a niche market for her designs and has noticed that the market for glamorous gowns is a healthy one, particularly among young women sixteen to eighteen years old who readily spend large amounts of money on dresses for the school ball or prom. As a designer Kayo feels that the choices available to young women are very limited, with the designs more appropriate for older women, celebrities or socialites. She herself resisted the pressure to conform by dressing in a man's suit at her own school ball. She decides to research the cultural and social practices associated with the buying of the school ball gown, with the aim of identifying a niche for her work as a designer of alternatives to the traditional satin and pastel confections.

In making this choice, Kayo is exploring the relationship between her habitus (which includes her ideas about fashion) and the field (which contains a particular set of cultural practices—in this instance the practices associated with choosing a ball gown). However, the cultural practices of gown buying are themselves constituted by broader cultural practices within the wider society. These practices are shaped by values and ideologies such as the nature of femininity and how clothing reflects this, the importance of conformity and the role of the school ball as a rite of passage for young women. Kayo's design and research practice is therefore located within a set of cultural practices that are constituents of the wider society of which she is a part. For these reasons, an ethnographic research approach would be well suited to Kayo's design problem.

The project *Design for the Other 90%* (Smithsonian Institution, 2007) is another example of the usefulness of an ethnographic approach to the solution of design problems. The project was established out of a desire to address the fact that around 90 per cent of the world's population have minimal access to the kinds of products and services that members of the minority world take for granted (Smithsonian Institution, 2007). The project brought together a group of designers who were interested in finding creative solutions to the challenges of finding innovative and low-cost solutions to this problem. In one project, designer Mohammed Bah Abba (2007) based his solution to a practical design problem on his knowledge of cultural practices as well as on his knowledge of design. The design solution—the 'pot-in-pot cooler'—is based on traditional technology that uses two earthenware pots, a smaller one nesting inside a larger one, to store water and keep it cool. When wet sand is placed in the gap between the two pots, it helps keep the contents of the inner pot cool. Such pots used to be in common use, but in recent years the villagers had stopped using them.

Bah Abba understood the problem in terms of the relationship between design solutions and social realm problems. He observed that it was the girls of the villages who were expected to take local produce to the market to sell, and to fetch fresh foods from the market. With no means to store perishable foods, the girls had to make daily trips to the markets to buy and sell produce such as mangoes and onions, which prevented them from going to school. The designer had used such pots as a child in rural Nigeria, for water storage, and because of his familiarity with this cultural practice as well as his framing of the problem in terms of its social and cultural

dimensions, he was able to further develop the traditional technology to enable the pots to be used more widely and for a wider range of purposes. Now, with the pot-in-pot cooler widely available again and able to be used for storing a wide range of produce, the girls of the local villages have time to go to school.

The possibilities for using ethnographic approaches to research in design are numerous. We now suggest in brief some further ideas to show how ethnographic approaches might be applied to research in three specialist areas in design. The areas are fashion and textiles, interior design and handcrafts. In each case we identify a possible research focus and frame a research problem, then suggest some focus questions and sensitizing concepts, recommend appropriate methods for data collection and analysis, indicate the type of data that would result, suggest what type of research text might be produced and indicate who might benefit from the proposed research. We follow this pattern in each of the chapters on research methodologies, by offering brief sketches of possible research projects drawn from different specialist areas in design and using the methodological approach that is the focus of each chapter.

Questions for reflection

For all researchers whose aim is to understand cultural practices there are key questions:

1. What are some strategies for taking account of our ideological positioning?
2. Are ethnographers who share the cultural, class, gender, race backgrounds of those researched better placed to experience participants' experiences than those who are strangers? Or not?
3. To what extent would an ethnographic approach be appropriate for your research?
4. Make a list of the values, experiences, attitudes and personal views that make up your habitus and that might impact on how you plan and conduct your research.
5. Where do these prior perspectives come from? Think about personal experience, cultural background, personal social context (gender, social class, age and so on) and worldview.
6. If you were being observed as part of an ethnographic study, what could the observer do to make you feel comfortable about being observed?

FASHION AND TEXTILES

Research focus: Fashion and cultural identity.
Research problem: What are some distinctive features of a particular subculture's relationship to clothing?
Sensitizing concepts: Users of design, designers, cultural practices, subcultures, identity, fashion.

Methods:

Observe and record examples of how members of the subculture dress.

Conduct open-ended interviews with designers who market clothes for this group, and with members of the chosen subculture (use focus groups).

Collect narratives from selected members of the two groups. Use snowball sampling or invite volunteers from focus groups.

Data collected: Observation notes and illustrations, interview data, personal narratives.

Final text: Illustrated ethnographic study.

Who is the research for? Fashion designers working within the avant-garde.

INTERIOR DESIGN

Research focus: Creating a physical and material environment that is conducive to study.

Research problem: What are the emotional effects of colour in schools?

Sensitizing concepts: User behaviour/preference, social and cultural factors, purpose and use of space, learning environments.

Methods:

Observe student behaviours in different settings with different colour use.

Conduct open-ended interviews with teachers and students to identify perceptions and preferences.

Use interviews as baseline data to develop survey to focus in detail on key concepts and explore veracity of earlier interview data.

Document research and observation: colour use in different settings.

Data collected: Observation notes, interview data and survey data.

Final text: Research report that documents research processes and outcomes and provides suggestions for future practice.

Who is the research for? Interior designers, educators.

HANDCRAFTS

Research focus: Adapting a minority culture's designs for application in another cultural context.

Research problem: Given the cultural origins of a particular design, is it appropriate to adapt it for contemporary use by a craftsperson from a different culture?

Sensitizing concepts: Designed object, designer, symbolism, cultural practices, appropriation.

Methods:
Museum research—cultural/anthropological evidence of traditional use of designs.
Interviews with custodians of cultural heritage (individual or focus group, as appropriate).
Data collected:
Historical records showing the cultural origins and significance of the design.
Interview data to supplement the above.
Final text: An ethnography of the design that locates it within a set of cultural practices, and includes critical analysis of the appropriateness of its adoption.
Who is the research for? Contemporary designers who intend to adopt the designs of any minority culture.

Conclusion

Based on our definitions of the nature of design and the work of the designer, ethnographic approaches have a valuable role to play in research in design. Ethnographic research enables us to understand more of the broad backdrop of social and cultural contexts within which users of design experience their everyday lives. If we acknowledge both the need to take account of the social contexts in which design problems arise and are addressed, and that all design involves the end user of the designed object or system, the potential of ethnographic research for designers is obvious. An ethnographic perspective helps identify those features of the designed object, of the system, and of the work of the designer that require an understanding of cultural and social practices.

Ethnographic research provides a methodological approach that enables designers to:

- Develop an in-depth understanding of the social and cultural interactions within which their own practices take place;
- Identify relationships between users' practices and the broader cultural context;
- Understand how users might engage with designed objects or systems;
- Understand how that engagement might be optimized or enhanced or alternatively be limited, restricted or nonexistent because of the cultural contexts in which the user is situated;
- Gain a variety of perspectives that either confirm, extend or challenge one's existing preconceptions as a designer.

We encourage you to explore some of these possibilities.

UNDERSTANDING THROUGH STORY: NARRATIVES

Using stories or narratives in research, although drawing on the very ancient tradition of storytelling, is a comparatively new research methodology that has exciting potential for researchers who are interested in exploring lived experience. While its methods are still evolving, narrative research is becoming widely recognized as a means to enrich research that focuses on people's 'storied lives' (Creswell, 2008). In this chapter we explore some possibilities for using narrative in research in design.

What is narrative?

Stories have been told throughout history. Every culture has its store of traditional stories: the Dreaming stories of Indigenous Australia; the Ramayana of India; the tale of the *Journey to the West* from China; and the fables of Aesop familiar in Western cultures. Stories in their many forms (film, novel, graphic novels) continue to entrance and delight us. They also help us understand ourselves and other people, help us make sense of the world and enable us to communicate our experiences and understandings with others (Merriam, 2009).

Two examples from the field of design illustrate the value of narrative to help us make sense of the world. First, the stories of the Spangler Design Team and Ken Freiberg Design illustrate how two designers have shaped their design praxis by doing *pro bono* design work or work for the public good, offering good design to nonprofit organizations such as the Juvenile Diabetes Foundation and the Minnesota Homeless Project (Baugnet, 2003). The stories include accounts of the original motivations that led the designers to take these directions in their work, descriptions of some of their projects and the positive impact their decisions to work differently had on their reputation and success. In both these stories, the personal dimensions of the experience (such as the feelings of pride the designers have when they see their work out in the community and the satisfaction of engaging in creative work for the good of others) help others understand some of the possibilities for their own design praxis. The stories also encompass ideas about the optimum conditions

that enable such prosocial work to take place, such as the value of working in a small design team, the need to develop a close personal connection with clients and the importance of being highly professional in everything they do.

A second example uses narrative to explore an experience of failure, and in so doing help others understand better the complex nature of design practice. Designer Veronique Vienne, in a brief autobiography, looks back at some of her early design work with new eyes, and analyses some of the reasons why she now sees it as her 'worst work'. Her narrative describes occasions when she made decisions about how to 'do' design, such as when as an art director for a magazine for parents she would try to create images from the point of view of toddlers by asking photographers to take picture when lying on the ground. At the time she considered this her 'best' work, while her 'worst' work was when trying to conform to the regimes of an 'abusive' work environment (Vienne, 2008). When later in her career she rethought her understandings of best and worst she discovered her values had changed and that what at the time had seemed to be her worst work was actually, from a different perspective, 'pretty good'—and vice versa. Vienne's autobiographical narrative engages us in understanding some important features of the field of design, from the perspective of this particular designer's habitus.

To help understand what a narrative is it is helpful to begin by looking at narrative as a type of text. The term narrative is often used to describe any kind of non-academic prose that recounts an incident or personal experience. There is an important distinction between texts whose purpose is to give an account of an incident, personal experience or series of events in sequential order (sometimes called recounts) and narratives. This distinction, which is well established in the fields of literature and linguistics, is helpful in clarifying the purpose and value of narrative in research.

In a literary sense, a narrative is a text that is deliberately shaped to imply 'a change in situations as expressed by the unfolding of a specific sequence of events' (Franzosi, 1998, p. 520). Narratives are organized to follow the journeys of the characters as they move towards a key incident (or complication) that leads to a change in their fortunes or some other kind of disruption in their lives. Following the disruption, there is a resolution that marks the start of a new equilibrium for the characters involved (Berger, 1997; Franzosi, 1998). In terms of the concepts of habitus and field that we have been using to explore practice, the complication in a narrative could be seen as analogous to (but not the same as) a moment when the individual's habitus becomes challenged as a result of his or her reflexive engagement with the field. As the new information from the field is reconciled with one's habitus, the resolution is the emergence of a renegotiated habitus that accommodates the new knowledge of the interrelationship between habitus and field.

Since narrative form is built around the destabilization of the status quo and the return to a new equilibrium, narrative is a research tool to explore that moment of destabilization both as it happens in oneself and as it may happen in others. In a sense, narrative as a process is at the heart of all research, insofar as the researcher

seeks disruption to the status quo through questioning and troubling what is taken for granted. Narrative therefore has the potential to enable individuals to engage reflexively and critically with the field (Pearce, 2008b). This way of understanding narrative is helpful for a later discussion of the role of narrative in research.

Narratives in research

The term narrative, in the context of research, is used to describe both a research process and a research product. As a research process it signifies both an episte-mological perspective and a methodological approach, and as a research product it signifies a particular kind of research text. In narrative research these three com-ponents complement one another. First, by placing people's lived experiences 'as lived and told in story' (Clandinin & Connelly, 2000, p. 128) at the centre of the research, and by valuing the 'knowing that is discoverable in our experiences as embodied beings' (Gustafson, 1999, p. 250), narrative research adopts a particular epistemological perspective.

The methods associated with narrative research have developed from a particu-lar epistemological position: that lived experiences form a valid basis for building knowledge about the world. The starting point for all narrative research is lived ex-perience, as 'narrative inquiry is a way . . . to think about experience' (Clandinin & Connelly, 2000, p. 80). Narrative research values lived experience over formalist or theoretical approaches to knowing (Clandinin & Connelly, 2000). Narrative re-searchers engage with people and seek to hear, record and understand their life experiences as stories. Stories in narrative research are typically first person, oral accounts of events, and interviewing individuals or small groups is a common ap-proach found in narrative research. Later in this chapter we explore strategies for gathering first-hand accounts or reflections on experience through interviews. Nar-rative researchers may also collect other related data such as photographs, personal journals, diaries or letters to enhance the understanding of someone's story. Con-temporary devices for communication such as emails or blog entries can also pro-vide additional rich data for narrative researchers.

Having collected the data, researchers go about making sense of stories through a particular approach to the analysis. This is hermeneutic analysis, which 'offers a perspective for interpreting stories' (Patton, 2002, p. 114) by emphasizing the im-portance of understanding stories in terms of their cultural or historical contexts. It is important for researchers to remember that no story is 'innocent', in that every narrator's cultural background, points of view and personal ideologies are infused in the storytelling process and influence the choice of what is put in and what is left out. One key role for researchers is to interpret stories in light of whatever broader understanding they have of the particular context from which the stories emerged. For example, by collecting stories from several people who all share a similar experi-ence (such as work colleagues telling stories about a particular event) the researcher

will develop a broad understanding of the event described. The researcher will then be able to interpret each individual story in light of what else he or she 'knows' about the bigger picture.

Finally, a narrative is a type of text, as well as an approach to research. Not only does a narrative approach provide us with ways to think about and understand experiences, it also provides a way to write a research text that 'addresses both personal and social issues' (Clandinin & Connelly, 2000, p. 50) and enables new stories to be told in the form of a research text. The researcher draws on the original stories to create a text that itself takes the form of a narrative. In narrative research the researcher deliberately shapes the text so that the key elements of the research story can be told in ways that retain elements of the research participants' voices and enhance the authenticity and legitimacy of the research. Using a narrative form as part of the research text also helps the writer to shape the text to make it accessible to the reader. For example, most people when they talk do so in unstructured ways as they jump from one incident or memory to another and back again. The researcher can give these disconnected pieces of story a shape by creating a text that uses typical narrative devices such as narrative structure, a focus on significant incidents, descriptive language and the expression of a person's feelings and experiences.

The research may lead to the creation of a narrative that forms the research output in its entirety, or the research text might make use of narrative elements that are then analysed as data. See Pearce (2008b) for an example of this, where the writer took a personal story and used it as the basis for analysis and discussion. The potential of narrative to add richness or detail to a research text is increasingly acknowledged. Elements of narrative are often found in texts that report other kinds of research, whether to explain the researcher's interests and background (as a means for the researcher to explore his or her ideological positioning) or to directly represent the experiences of participants in an ethnography or case study. Having engaged with the earlier chapters of this book, readers will be aware that all research has the personal narrative of the researcher embedded somewhere within it. Autobiographies or autoethnographies are ways to make these embedded researcher narratives visible.

Narratives for research in design

There are three possible ways that narrative approaches can be used in design research: stories of self, such as are told by the researcher/designer; stories told by other people, such as other designers or other users of a designed object; and stories of the designed object or designed system itself. First, we look at opportunities for using stories of the self, in which the designer/researcher develops a story in the form of an autobiography or autoethnography. Such stories provide possibilities for understanding the basis from which our professional selves develop. Examining the changes recorded through narrative and exploring the personal viewpoints, values

and ideologies hidden beneath the way experiences are described and given value can be powerful tools for practitioners as they develop an understanding of their emerging professional selves. Narrative research is increasingly used in the study of professional practice, which enables practitioners to challenge the technical or skills-based views of practice and also enables practitioners' stories to be valued, as they become the focus of research (Creswell, 2008). Narrative can become a tool for the study of practice 'in all its imaginative complexity' (Clandinin & Connelly, 2000, p. 37).

Stories of the self: Iris

Narrative research provides an opportunity for designers and other professionals to explore the basis of their practice by writing an autobiography, a life history or an autoethnography in which a personal history is framed in terms of the social and cultural influences that have shaped it. We discussed earlier the notions of habitus and life-world. According to Bourdieu (1977), habitus results from our continuing interactions between objective structures and personal experiences or histories. A narrative approach to research provides us with opportunities to make these interactions our research focus, and enables us to take up a reflexive position in relation to how those interactions have taken place and have resulted in our particular positioning as a designer. For the designer/researcher, the stories of the self that are produced can be used reflexively to explain the origins of professional practice, as in the following example.

Iris is a postgraduate design student whose designs reflect her personal experiences of using and designing objects. She is a reflexive person and is aware that her design decisions are based on the particular ideologies that have grown out of her experiences. Ever since she decided she wanted to become a designer she has kept a personal journal in which she has recorded key experiences along her journey. The process of keeping a journal (which is a research method in itself) has proved a valuable tool for initiating reflection. As she looks back on the narrative of her development as a designer, she is able to pinpoint critical incidents that have influenced her work and have led her to review and analyse her design decisions. By doing this she has been able to trace how her identity as a designer has been shaped during this formative period. Giddens calls identity the 'ongoing story of the self' (1991, p. 52) and suggests that our identities are revealed in the stories we tell about ourselves. As part of her final submission for examination, Iris is required to produce an exegesis that explains how and why her designs have developed in the way they have. She decides to write a reflexive autobiography in which she analyses the different influences and critical incidents that have shaped her design praxis.

For a long time Iris had been interested in the work of Indigenous Australian artists such as Gloria Petyarre, Clifford Possum Tjapaltjarri, Emily Kngwarreye and their associates. She recorded her growing fascination and admiration for these artists in her journal, and early in her studies she came to a decision to adopt some of

the motifs found in these paintings into her own designs. However, as she continued to research the work of these artists, originally to become familiar with the works' imagery, colour and composition, she began to understand the field of Indigenous art and in particular the importance of art as capital for Indigenous communities. Her research revealed that her own status was as a designer working within a field that was comparatively privileged, supported with the resources of the university where she was studying and based in a mainstream non-Indigenous culture. She has decided to make her exegesis a reflexive autobiography in which she details the development of her understandings of her own positioning in the field of design and charts her final decision to move away from adopting motifs from Indigenous art to use motifs originating in her own cultural background. What should Iris bear in mind as she writes this text?

Iris's reflexive autobiography draws on Giddens's notion of the reflexive self, since 'reflexive awareness', which is the process of constantly monitoring the circumstances of individual action, is 'characteristic of all human action' (Giddens, 1991, p. 35). An integral element in reflexive monitoring is 'practical consciousness', which has a 'tacit or taken-for-granted quality' and is therefore 'non-conscious' (but not unconscious). It is important to recognize that practical consciousness does not exist in an individualistic vacuum, since a 'shared framework of reality' is necessary for human beings to be able to distinguish between appropriate and inappropriate responses to the situations that arise in everyday social interaction (Giddens, 1991, p. 36).

In the particular context of the work of designers as we have defined it in this book, individuals constantly monitor their actions in relation to shared frameworks of reality that are social, political, cultural and ethical in nature. The use of such frameworks for interpreting the professional context is important in enabling individuals to negotiate reflexively between themselves and the social/institutional milieu. In choosing to write a personal narrative, Iris is engaging in this reflexive negotiation. Iris sees that narrative provides a vehicle for her to reflexively engage with key events in her life history in ways that help her understand and frame her design practices in reflexive ways. The process of writing narratives for professional reflection has opened up possibilities for Iris to understand the basis from which her professional habitus has developed.

The value of personal narratives as research is controversial, in part because of the risk that such narratives become simply records of subjective experiences that have no value as research texts (Patton, 2002). Based on one of the criteria for judging research that we noted in Chapter 4, personal narratives must aim to do more than recount the personal experiences of the researcher; they should also lead to an enhanced understanding of the phenomena that the narrative depicts (Patton, 2002). Another criticism of narrative research is that personal narratives as texts are better fitted to literary genres rather than genres of research. We agree that there are elements of artistry in creating personal narratives, and maintain that the job of any

narrator is to deliberately shape the reader's experience of the events by deciding what to include and how to use language to tell the story (Berger, 1997).

Narratives typically include descriptive and evaluative language that reflects the narrator's point of view by 'ideologically colouring a text' (Franzosi, 1998, p. 532). As mentioned earlier, a narrator makes choices when creating a narrative. It is therefore not an innocent piece, but it comes from a particular social, cultural, ethical and political space. The narrator's personal values and ideologies play a role in choosing what to include and what to leave out. The ideological colouring of the narrative applies whether the teller is a research participant or the researcher herself. That having been said, it is important to understand where to draw the line between personal expression and the intellectual work that characterizes research writing.

When a narrative is mere description, or is too subjective, it may contribute neither to the 'creation of new knowledge' nor to the generation of 'new concepts, methodologies and understandings' expected of a research text (ERA, 2009, p. 10). While the process of constructing a reflexive narrative can be transforming and empowering for the individual who writes it, if the narrative is to work as a research text it needs to also be explanatory or critical. Richardson (2000, in Patton, 2002, pp. 86–87) suggests that narrative texts should be 'held to high and difficult standards', and provides criteria for judging a research narrative's quality. The following questions are adapted from Richardson's criteria.

1. What substantive contribution does the text make?
2. How has the writer reflexively engaged with her story?
3. Has the writer detailed how the experiences have impacted on her positioning and her work? What is the nature of the impact? Is the impact emotional or intellectual, or both? What actions has she taken in light of her experiences, thoughts and feelings?
4. Is the text satisfying to read? Does it engage the reader?
5. Does the text 'ring true' as an expression of real experience?

Based on these criteria, for Iris's narrative to be acceptable as a research text, it will need to contribute substantively to a collective understanding of the social realm or, using the terminology of this book, the field with which it engages. In doing this, Iris's narrative will need to show how she has developed a reflexive understanding of herself as a designer (her habitus) working in a professional context (the field of design), and thereby enable a reader to make judgements about how Iris's position changes as a result of the research she has undertaken while creating the narrative. Iris will need to show self-awareness and engage in 'self-exposure' (Richardson, 2000, in Patton, 2002, p. 87) for this to happen.

Iris will also need to express her embodied experiences of engagement with the field of Indigenous culture by exploring her emotional responses to what she finds out and by detailing her changing insights and intellectual shifts as she constantly renegotiates her habitus and develops new knowledge. Iris will also need to consider ways to creatively engage her audience as she writes the text. This expectation gives

scope for her to take some risks when writing her narrative, as it can be a very different kind of text than the more traditional research report. Finally, if Iris can convey the reality of her different experiences in such a way as to make them seem credible or recognizable to her readers, her text is likely to meet the high and difficult standards expected of personal writing in research.

Other people's stories

Other people's stories typically take the form of biographies, life histories or oral histories. The other people might be celebrated or innovative designers, whose biographies are illustrative of particular approaches to problem solving, of the use of particular materials, or of philosophical approaches to design. Alternatively, the other people might be the users of design, and the stories they tell are of their experiences of using designed objects. For example de Bruijn, Nyamnjoh and Brinkman (2009) have collected stories about the use of mobile phones and the Internet from people in so-called 'marginal communities' in Africa. Importantly, by collecting and presenting such narratives the researcher can give voice to those who are often silenced (Wink, 2005), such as people who are affected by the design decisions made by professionals whose cultures and life experiences are very different from those of the users of design.

These personal narratives may also, to an extent, incorporate the histories and experiences of the researcher, as other people's stories often resonate with those of the collector of stories. The researcher's own stories will intersect and interact with those of others—our own social and cultural narratives shape the stories that we tell even though they are not our own. The reflexive dimension of this process is acknowledged by Clandinin and Connelly, who describe the need for narrative researchers to become 'autobiographically conscious' (2000, p. 45) as they listen to and write about the stories of others. We are reminded that in narrative inquiry, both the storyteller and the writer are composing stories, and that in this sense a narrative is not an innocent text and may be unreliable as a factual account of the people and events described. Other witnesses to the events might tell very different stories. For researchers who seek to interpret these stories, the capacity to stand back and understand the narrative in its broader context, including the particular social and cultural context from which the story emerged, is essential.

Stories of the designed object: tomato ketchup

Because of its focus on events over time, narrative research is also a valuable tool for exploring the histories, origins and functioning of designed systems and designed objects that initially appear as 'ready made'; that is, it may be used to trace the development or practices of an organization, a product or an idea. This is elaborated on in the example below.

This project uses narrative approaches in slightly different ways from those typically found in social research and illustrates the adaptable nature of narrative inquiry and its applicability to a variety of research problems. In this instance, by creating a narrative of the product, the researchers have been able to bring together every element in its production into one cohesive text that shows the combined impact of the production processes. The narrative allows us to understand the whole system in a more meaningful way than would be possible had we looked at the discrete elements separately.

The bottle of tomato ketchup that was bought in Sweden has an interesting story. As Andersson, Ohlsson and Olsson (1998) showed, it is an incredibly well-travelled product that in the course of its entire life history touches the lives of farmers, who grow and harvest the tomatoes; production workers, who process the tomatoes to preserve them; transport workers; production workers, who create the consumer product; and refuse collectors, who manage the waste materials that remain after the ketchup has been produced and consumed. As Andersson, Ohlsson and Olsson also showed, the environmental impact of the processes involved is complex and significant.

The ketchup in the bottle starts its life as a tomato grown in Italy, where it is harvested and made into tomato paste. Aseptic bags, made in the Netherlands, are sent to Italy to be filled with the paste. These filled bags are then packed inside steel barrels, which have been made in Sweden and transported to Italy, for the paste's journey to Sweden. In Sweden the paste is made into ketchup; packaged in five-layered plastic bottles made in the United Kingdom or Sweden from materials originating in Belgium, Denmark, Italy, the United States and Japan; and finished with a screw cap manufactured in Denmark. The bottles of ketchup are finally packed on cardboard trays and wrapped with shrink film (made in Sweden) for distribution to supermarkets throughout Sweden and ultimately to the home refrigerator. Of course the other ingredients of ketchup, such as sugar, vinegar, water, spices and salt, each have equally complex life histories.

In the story of the bottle of tomato ketchup, narrative works in two ways. First, it shapes the methodology of the research by providing the means by which the data is collected. The researchers set out to explore the life cycle of the ketchup as a form of narrative or sequence of events over time, to make sense of what was happening in the production processes. By going back to the origins of each of the components and showing how they were brought together in the bottle of ketchup, the researchers were able to tease out the relationships between the different components in the system designed to produce, package and distribute tomato ketchup.

By examining these relationships, the researchers were then able to identify the environmental impact of the final product, which was the research intention. By presenting a story that captures the key events in the product's life cycle, narrative has provided a way to make a complex process understandable. Thus, narrative research both uses story and tells a story. In this case, narrative has been used

to explore a designed system through the particular conceptual lens or sensitizing concepts of 'food miles', which is the distance food travels from production to consumption (Paxton, 1994). Another researcher could, by shaping the story differently and using different sensitizing concepts, explore the designed system from a different perspective, such as the input of different designers at the different stages of the production of ketchup.

Methods in narrative research: interviewing

Face-to-face, open-ended and semi-structured interviews (Carspecken, 1996; Gillham, 2000; Sarantakos, 1993) are important methods of data collection in narrative and other forms of research, such as ethnography. In these interviews, the researcher's goal is to capture the experiences and perspectives of the research participants in such a way as to get as close to the reality of these experiences as possible. In every interview where the research focus is on the experiences of participants, it is important for researchers to try to set aside their own views or perspectives on the topic. Again, the need to be 'autobiographically conscious' (Clandinin & Connelly, 2000, p. 45) arises, since what we choose to ask, what we are able to hear and how we interpret the stories of others will be influenced by who we are and limited by our own lived experiences. Specifically, personal characteristics such as gender, ethnicity and age will all 'influence the way questions asked or interpreted' (Ary, Jacobs & Sorensen, 2010, p. 380). We need to be conscious of the ways in which this is happening throughout the research process and take note of how we as interviewers are implicated in creating meanings that on the surface appear to be those of your interviewees (Holstein & Gubrium, 2002).

There are strategies to minimize the interference of personal experiences. Semi-structured interviews, where the researcher plans a general focus for the interview without wishing complete control of the process, allow the researcher to shape the discussion to some extent while also giving participants considerable freedom to direct its progress. When the interview may touch on issues that are private or potentially painful to disclose, a researcher has a responsibility to protect participants' privacy by being sensitive to their rights to refuse to disclose information they do not wish to share.

Feminist research makes much use of semi-structured interviews because of the possibilities for openness, and hence the possibility for giving voice to participants (Reinharz, 1992). This potential is also important in narrative research that, as we mentioned earlier, seeks to allow people who are often silenced to have a voice. The concept of 'soft' interviews (Sarantakos, 1993) is also important in allowing participants to have a voice. Here, participants are guided through the interview process without putting pressure on them to answer when questions might be painful or distressing. Sensitive questions might be more difficult to answer in

the presence of a comparative stranger, and these questions should be made optional. This is an important strategy to help participants feel safe in the interview situation.

The researcher's role

It is essential for you to be clear about your own role as a researcher and of the implications this has for the kind of data you can collect. If you see an interview as a cooperative process or an 'active, meaning-making occasion' (Holstein & Gubrium, 2002, p. 117), it is helpful to think about the practices of 'receptive' interviewers, in which the interviewer is an 'empathic listener' rather than an interrogator (Sarantakos, 1993, p. 186). While interviews should be organized to enable a focus on issues that you want to explore, the questions can be little more than prompts or cues to open up opportunities for talk. In these types of interviews, your role as an active listener comes to the fore, and it will be important for you to be as unobtrusive as possible. This can be achieved by using minimal verbal interventions; often it is only necessary to ask the first question to generate a conversation that shapes itself but nevertheless takes in the concepts relevant to the interview. As a rule of thumb, concepts that appear spontaneously in the interviews are equally as important as those that arise from the interviewer's prompts.

To encourage this, you should take seriously Gillham's (2000) suggestion that a research interviewer needs to listen well and say little. Carspecken's typology of interview responses provides some practical examples of how you might do this. He warns against interviewing in a 'leading' manner, advising instead the use of 'bland encouragements', 'low inference paraphrasing', 'nonleading leads' and 'active listening'. These strategies will both make disclosure easier for participants, and will avoid leading them into assenting to statements or views they do not in fact agree with (1996, pp. 158–162).

Strategies to adopt include such gentle interventions as nods and smiles, verbal encouragements ('I see', 'Yes' and 'Can you tell me more?') and checking understanding by paraphrasing ('So what you seem to be saying is . . .' and 'Have I got this right?'). The interview transcript is a valuable tool for checking how much talking you have done yourself in the interview, compared to how much talking the participant has done. Ideally, your input should consist of little more than the questions and encouragements, as indicated. However, the possibility for engaging in a conversation with participants should not be ruled out, as often this can elicit a deeper understanding of the experiences and perspectives of the research participant.

The decision to conduct narrative research will rest on the particular purposes of your research project: a narrative approach must be an appropriate way to generate data that fits the purposes of your research. If you are interested in events in participants' lives, face-to-face interviews provide opportunities for you to engage with participants quite intimately, and this closer relationship brings with it the possibility for more open sharing of experiences. Often, participants enjoy being

asked to share perspectives or opinions, and will relish the opportunity to talk about experiences or incidents that are important to them.

This possibility makes interviewing an ideal strategy for exploring the experiences of the end users of design, whose perspectives are crucial in evaluating the usefulness or effectiveness of a designed object or system. Focus group interviews, which typically involve small groups of people (between six and ten) who can provide different perspectives on a common experience or a particular issue, are valuable if you are interested in drawing out a range of different perspectives and opinions on a particular designed object or system. Depending on the nature of the research, participants may see the opportunity to get things off their chest, for example if the research touches on experiences that have been difficult or puzzling. Involvement in research of this nature can be as rewarding for the participants as it is for the researcher, and it will be important for you as the researcher to take steps to ensure that the participation is worthwhile and not onerous, intimidating or even harmful.

The interpersonal exchanges that this intensive and personal approach to interviewing invites will undoubtedly enrich the research process, but at the same time your close engagement with participants' life experiences may make unexpected demands on you. Through our own experiences of engaging with other people in these intense ways, we have begun to understand that the role of the interviewer can shift into something more akin to that of a mentor or counsellor of sorts, guiding reflections so that people feel comfortable about disclosure without feeling compelled to share information that is too personal. Often, being the interviewer in these contexts means being a real, attentive and supportive presence in the research (not the third person researcher) as an audience for participants' reflections. There is a considerable responsibility associated with this work when participants are sharing personal and sometimes difficult experiences. It can also be an unexpectedly rich experience.

As you can imagine, qualitative interviewing demands specific skills that every interviewer needs to practice. In an open interview situation it takes confidence to feel able to go with the flow of the interview. One of the most difficult skills is to know when to stay silent (to give time for participants to work through their answer) and when to move on (by prompting or asking a different question). A useful rule of thumb is to listen more and talk less (Ary, Jacobs & Sorensen, 2010, p. 439). When participants take the interview in completely unexpected directions, which is not unusual, the researcher is faced with some tricky decisions about whether to refocus the conversation or to let it run its course. However, for the reasons discussed above it is usually important to allow interviews to take unexpected directions, at least for a while.

Your responsibility to the participants does not end when the interview is finished. You will need to preserve participants' rights to control the information you have collected about them; it is, of course, personal information. It is usual to record interviews (with the informed consent of participants), which will then be

transcribed. Opinion varies as to who should do the transcribing. There are many advantages in transcribing your own interview data; it is an excellent way to become intimately familiar with the data. Often, key themes, concepts or insights will emerge as you listen and transcribe. However, interview transcription is time-consuming unless you have the skills. Once typed, transcriptions will normally be sent to participants for their approval. It is usual to invite participants to amend, edit or comment as they wish, in spite of the possible risk of thereby achieving a skewed picture. It may be that participants, on reflection, may want to withdraw comments or modify responses made reactively. At every further stage of the research process, it is usual to give participants access to all writing that is based on information they have provided, and their agreement to make this information public should be sought. In our experience, involving participants in these ways is more likely to elicit additional clarification or further reflection than lead to withdrawal of information. But it is sound ethical practice to give participants the opportunity to do this.

Asking good questions

Some general principles for setting up and conducting the interview have been established, and we now turn to ways to frame the questions. Interview questions are different from research questions, which are written to shape the whole project. The use of open questions in interviews supports the open process of semi-structured exchanges. By using open questions you are more likely to obtain unexpected responses and are also less at risk of unconsciously influencing the participants' responses by framing questions that reflect your own bias or blind spots. This approach also allows participants to focus on what is really important to them, rather than limit the issues discussed to what you believe to be important.

A major reason to use open questions as a 'framing device' (Holstein & Gubrium, 1995, p. 29) is that they can open up new possibilities. The potential of the interview for jointly developing new insights (Tripp, 1983) suggests the use of the 'active interview' in which interviewer and interviewee are jointly engaged in meaning making (Holstein & Gubrium, 1995, 2002). This process is supported by the use of open questions. Throughout the interview process it is important to remember that the interviewee is 'not an object, but a subject with agency, history and his or her own idiosyncratic command of story' (Madison, 2005, p. 25). A semi-structured framework, together with the use of open questions, acknowledges that agency and provides space for that history and story to emerge.

Choosing the right kinds of questions to use within the overall interview structure is also important (see also Chapter 8 for further discussion of ways to frame questions). Closed questions pre-empt or pre-suppose an answer, and are not helpful if your intention is to allow a participant scope to tell about his or her own experiences. By framing open questions you allow space for participants to interpret and respond in ways that reflect their particular perspectives or experiences. How a

Table 3 Closed and Open Questions

'Closed' questions	More 'open' versions of the same questions
Do you enjoy working in a design partnership? (Invites 'yes' or 'no' answer and leaves limited scope for elaboration.)	Tell me about your experiences of working in a design partnership.
How important is it for you that your electronic goods are nice to look at? (Assumes that this the sole criterion for judging an object.)	Give me an example of how you make decisions when choosing electronic goods.
What do you think of the idea, attributed to Thomas Edison, that genius is 1% inspiration and 99% perspiration? (Invites focus on Edison's perspective rather than on participant's own.)	What advice would you give to a young designer about what it takes to be successful?
Who is your favourite designer? (Provides limited information and may need a prompt to elicit more.)	What do you admire about the work of your favourite designer?

person first responds to a question is often an indication of what he or she believes to be most important, and using open questions allows for more spontaneous responses that better reflect the particular reality of the research participants.

In Table 3 are some suggestions of how more open questions can be developed from the original closed questions. The open questions are more likely to elicit descriptions of personal experience and lead to storytelling. You will see that most of the open questions are not framed as questions at all but as invitations to give information. If you are not familiar with ways of framing open questions, it can be useful to instead use invitations, such as 'Tell me about . . .', as shown in these examples. The open questions in this table reflect Clandinin and Connelly's (2000) point that questions should be significant, and have meaning and purpose.

Writing open questions can be difficult and time-consuming. Patton's suggestion (2002, pp. 348–351) that it is useful to develop questions based on six different types of inquiries provides a useful framework to help begin to develop questions. Note that each type of question has particular relevance for narrative research, as the focus of each is personal experience.

1. Experience and behaviour questions
 These focus on what a person does, their actions or daily activities. They can be used to develop a sense of what participants experience day by day, or on what they did at a particular time or in response to a particular situation.
2. Opinion and value questions
 These questions ask participants to talk about their opinions, values and judgments about a concept, situation or experience.

3. Feeling questions
 Here the questions focus on how people feel or felt on a particular occasion or about a particular issue—are they happy, sad, anxious, confident, intimidated?
4. Knowledge questions
 These elicit information about what a person knows about a procedure or situation.
5. Sensory questions
 These focus on the senses: what was seen, heard, tasted, touched, smelled.
6. Background questions
 These are factual questions (sometimes called demographic questions) about a person's age, gender, education, work experience, and the like. Not all types of demographic questions will be relevant in every research project.

Working with focus groups

Many of the comments made earlier, about the conduct of interviews with individuals, apply equally to focus group interviews. The value of focus groups comes from an assumption that attitudes or beliefs do not form in a vacuum but emerge from shared contexts (Ary, Jacobs & Sorensen, 2010). For researchers it is sometimes important to gain a range of insights. Participants in focus groups also have the advantage of being able to form, develop or refine their opinions in conversation with the others in the group. Focus group interviews may also provide a less threatening context for participants who would be hesitant in a one-to-one interview, but at the same time there is also a risk of some group members being more confident and vocal than others. A skilled interviewer will note this and be able to find ways to make sure that everyone in the group has the opportunity to contribute.

Such interviews may be particularly valuable for research involving users of designed objects or systems, such as the example of the building foyer used at the end of the chapter. Here, a composite narrative of the foyer's use might be created based on data collected in focus group interviews involving people who regularly use the foyer.

Whenever interviews are used in research, interview data can be supplemented by observations and other data such documents, film or video, photographs or other artefacts. The opportunities offered by interviews for close interaction also provide opportunities for the researcher and participant to engage in the co-creation of meaning and texts through keeping journals or sharing written reflections on the interview transcripts.

Sketches of research projects using narrative

To end this chapter, some further possibilities for research problems that use narrative approaches are outlined. Each problem centres on either personal experiences

or events in time, or on a combination of these. For each example used below, the research focus is firstly identified and then used to frame the research problem as a question indicating the sensitizing concepts that will help frame the research process. Some methods for data collection are suggested and what kinds of data might be collected are indicated. Finally, some ideas about what kind of research text might be produced and who might benefit by having access to the research produced are indicated.

Questions for reflection: narrative

1. Write a brief autobiography of yourself as a researcher. Think about what it means to you to be a researcher. What interests you? What experiences have led you to develop these interests? What professional, social and cultural influences have worked together to shape you as a designer/researcher?
2. The interviewee is 'not an object, but a subject with agency, history and his or her own idiosyncratic command of story' (Madison, 2005, p. 25). How might this perspective shape the way you approach the task of interviewing research participants?
3. If you were being interviewed as part of a research study, what could the interviewer do to make you feel comfortable about being interviewed?
4. Choose a familiar, open-ended topic, such as family or work. Develop two or three open questions on this topic, and use them as a starting point for a semi-structured soft interview with one or two willing friends or family members. Audio record (with permission) or make notes. Reflect on the experience of conducting the interview. Was it easy for you to listen, without saying too much? Were you able to ask prompt questions to elicit further information? How did you react if the interview went off topic? Did your questions elicit rich information? Ask the participant about his or her experiences of being interviewed by you. What would you do differently in a real interview situation?

An ethical consideration: Make sure you destroy the interview data as soon as you have completed the exercise.

FASHION AND TEXTILES

Research focus: Fashion buying practices.
The research problem: What is distinctive about the buying habits of the fashion enthusiast over a particular period of time?
Sensitizing concepts: The end user, decision-making processes, practices over time.
Methods:
Work with a single research participant.
Series of open-ended interviews conducted at key points in the year.

Participant suggests suitable data collection points throughout the year.

Questions invite storytelling and reflection on previous interviews.

Ongoing analysis of data that informs each subsequent interview.

Data: Interview data, participant's personal journal, photographs.

Final text: A visual 'buying history' showing the participant's journey over the period of research, with written vignettes to provide a commentary to explain and analyse experiences, opinions, feelings.

Who benefits? Designer, marketing teams, retailers.

INTERIOR DESIGN

Research focus: The use of space in a large hotel foyer.

Research problem: What design factors affect the patterns of use in the hotel foyer?

Sensitizing concepts: End user of design, the designed system, movement within an interior space, mood, setting, environment.

Methods:

Work with multiple participants: workers and frequent and infrequent visitors.

Surveys and focus group interviews.

Observations of movement, behaviour, experiences.

Focus groups identify sensory qualities of the different areas of the foyer.

Data collected

Maps and observation notes tracing visitors' movements around foyer.

Interview data showing patterns of use and reasons for use of the foyer.

Final text

Narratives of use by day/by week.

Movement maps.

Narrative pictures of workers/visitors and how they engage with the space.

Who benefits? Interior designers, hotel management, tourism boards, retailers.

PRODUCT DESIGN

Research focus: Sustainable manufacture and production.

Research problem: What are the social, cultural or environmental impacts of a particular designed product or system?

Sensitizing concepts: The designed system, manufacturing and production processes, environmental consequences.

Methods:
Document analysis.
Interviews with workers, manufacturers, system designers.
Observe and document systemic elements (production lines).
Data collected:
Factual information—costing, fuel use, types of materials and the like.
Observation data.
Flow charts showing sequences of manufacturing processes and interconnected systems.
Final text
Life histories of the product and its components.
Sequential narrative with statistical, environmental and social data to establish the product's
 impact.
Who benefits? Consumers, producers, the environment.

HANDCRAFTS

Research focus: The work of the craftsperson.
Research problem: What are the motivations of a craftsperson in conceiving and making an object?
Sensitizing concepts: The designer, the designed object, life history, conceptualizing and decision-making, motivation, craft skills.
Methods:
Work with single participant over time as he or she conceives of and creates the object.
Interviews, visual records (photographs or film), written observations.
Collect personal history relevant to work as craftsperson, as supporting data (e.g. trace
 background of engagement with craft practices, previous work, motivation in creating
 this particular object, interactions with buyers/exhibitors).
Data collected: Observations and commentaries, interview data, visual.
Final text: Narrative of the step-by-step processes involved in the creation of a crafted object. Written and visual texts.
Who benefits? Designers and craftspeople, public and private funding bodies.

Conclusion

Narrative has exciting potential for research in design. Narrative research enables the researcher to understand how individuals and groups make sense of events and actions in their lives, and is particularly well suited to the study of human

subjectivities and identities. For this reason, it is well suited for designers, both for its potential for charting one's own professional practices and for the possibilities offered for understanding the practices and histories of others. Narrative research may thus be a catalyst for reinstating professional knowledge in the face of the encroachment of skills-based or technicist approaches to design. Examples in this chapter have shown how narrative can represent personal experiences, for example when narrative is used to uncover key experiential elements in a craftsperson's life or to elaborate an individual's relationships to a designed object. Narrative is a strategy for framing complex processes in ways that make them more accessible, as in the case of a systems narrative, or in a time and space narrative, which depicts what happens over a particular period of time or in a particular space.

8

USING CASE STUDIES AND MIXED METHODS

What is case study research?

In case study research, the primary focus is the particular case that is the object of interest. Robert Stake explains that a case study is not a methodological choice but 'a choice of what is to be studied' (2008, p. 119). In case study research the focus of attention is a 'specific, unique and bounded system' (Stake, 2008, p. 121). The case might be bounded by time, place, events, processes or activities—in other words, by whatever 'unit of research' makes a 'coherent entity' (David, in Liamputtong, 2009, p. 190). In a design context, the unit of research might be a particular object, a system, a design process or a workplace such as a studio or workshop. In planning and presenting the research, the nature of such boundaries must be made clear (Liamputtong, 2009). Whatever the focus, whether it is the particular location or time frame in which the research takes place, the cultural practices and/or work processes of the group concerned or the broader institutional or professional contexts, the boundaries of the case will all be made explicit both at the start of the research and in the final research text, which is also a 'case study'.

Not all commentators share Stake's position, and the concept of a case has been understood in 'remarkably different ways' (Ragin & Becker, 1995, p. 8). For Creswell, a case study is a particular form of ethnography in which the case is 'separated out for research in terms of time, place, or some physical boundaries': it is a 'procedure of inquiry' (2008, p. 476). Ethnographic approaches are appropriate for much case study research, although in the context of research in the design field, other approaches such as research into materials may be needed (as in the logo example discussed later). In this discussion, Stake's position that case study research is distinguished by its boundedness and not by its methodological choices is adopted, though the methodological choices themselves will be shaped by the need to show the particularities of the case (Stake, 2008). The case to be researched may be a pre-existing concept or theory (such as function or collaboration), an event or a process, or a group of people with some shared experience such as team membership or educational background. In these situations, the case is identified at the start of the

research. In other instances, the case only emerges during the research process as its defining features become evident through analysis of data. While it is useful to consider a case as a specific or particular instance of something, besides collecting data relating to the nature of the case itself, researchers may also decide to explore such elements as the case's historical background, or the economic, political cultural or aesthetic contexts of the case. Indeed, an examination of other comparable cases may be important in identifying the particular features of a specific case (Stake, 2008).

Although in most instances of case study research the nature of the case to be studied is clear in advance, sometimes a case emerges out of a different type of study, such as an ethnography, from which the nature of the case emerges inductively (see Ragin & Becker, 1995). For example, ethnographic research that began with the intention of looking into the work culture of a design studio might bring to light a case of gendered work practices. The research might then be presented in the form of a written case study with the particularities of the location, the individuals involved and other contextual features made explicit in order to explore the case of gendered work practices.

It is worth noting the distinction between a case study as a piece of writing and case study as research. The former is a way of presenting a set of connected information in the form of a case study, whereas case study research is a research approach that when complete will lead to a written case study (Patton, 2002, p. 447). In both cases the term case study is used to bring to the fore the specific focus of the research. For example, written case studies of the creative work of a particular advertising agency, of the design practices of a particular historical period or of the use of a particular material for a particular purpose are all examples of research texts that have a focus that is bounded by the particularities of the case, whether or not the original intention was to conduct research into that particular case.

Sometimes, the decision to use a case study approach is a pragmatic one. When research is constrained by time, by resources, by limited access to the research field or to participants, rather than attempt to encompass as much as possible, the decision can be made to limit the scope of the research so that its boundaries are explicit and the project feasible. Otherwise, as suggested, a specific focus is already built in to the research. Such a focus might be temporal, such as the time period during which a project is developed or implemented; or spatial, such as a particular building or part of a building; or conceptual, such as the use of the logo (Spooner, 2009) or the notion of form in a crafted object.

In case study research it is important that the particular focus of the research is already identified. Similarly, identifying the purpose of the research is important, too, since different kinds of case studies will lead to different types of research outcomes, and it is useful to consider which type of case study best suits the research purpose. Stake (2008) broadly differentiates between intrinsic, instrumental and collective case studies. A researcher will conduct an intrinsic case study to understand the particular case better. Kayo's ethnographic research into the cultural

practices associated with the school ball could be reframed as an intrinsic study. Here, the intention is not to generalize from the case but to explore the particularities of the case, which are themselves of interest in.

The intention behind an instrumental case study is to help us understand something outside the case by providing additional insight or helping illustrate a phenomenon or issue (Creswell, 2008; Stake, 2008). Here, the case assists our understanding of other cases, either because it is typical or because it is not. For example, case study research into the effect on family relationships of the introduction of a particular new piece of technology into the home could be used instrumentally as a means of exploring a more general problem of the introduction of new objects into the home environment. It is important to bear in mind that while one strength of case study research is its potential to explore a phenomenon in depth, case study research is limited in its breadth. The insights gained from the close study of one context do not necessarily transfer to another (Ary, Jacobs & Sorensen, 2010, p. 457), although the insights gained from one case may help inform our understanding of others. As with every research project in design, each new case study in design will add to the body of knowledge in the field.

Where the intention is to explore different aspects of the same issue through the lenses of several cases, Stake suggests the implementation of a collective case study (2008, p. 123). Patton extends this idea somewhat when he refers to the idea of a 'layered or nested' approach to case study research, where larger units of study are built up out of smaller ones (2002, p. 447). Often, the main study is made up of descriptions of other smaller events of interest such as celebrations or critical incidents, and for this reason the final case is the product of a series of nested studies (Patton, 2002, p. 297). Collective or nested case studies might be adopted explicitly when the case under examination is large and complex. A team approach, whereby different individuals or small teams collaborate in the production of a multilayered case study by each focusing on research into smaller, more specific cases that are then brought together into a larger study, can be worthwhile when the project is large. This approach may be very appropriate for a team of designers faced with a complex task. For example, a research project aimed at determining the most successful strategies for designing, marketing and distributing a particular fashion item such as a surf T-shirt requires a focus on numerous different processes, including manufacturing, designing, advertising and distributing the T-shirts. In such a complex case study, a collaborative approach will be important. However, even when the case study is made up of several nested cases, Patton (2002) nevertheless advises us to ensure we do justice to the individual case by focusing initially on the smallest unit. Otherwise, there is a risk that the detail will be lost in the complexity of the whole. Since the research focus is the case then the final research text should itself reflect the case.

In having these very explicit boundaries, case study research differs from the more open-ended approaches characteristic of ethnographic and narrative approaches to research that we discussed earlier, because the limits of the research focus are in

place from the start. However, the example of the logo development that follows shows how, within the particular case that we are studying, we might draw on ethnographic, narrative or other methods depending on the research question and the research context. The use of multiple sources and techniques to gather data about a specific problem or phenomenon is a key feature of case study research. Depending on the type of case study, different methodological decisions will be appropriate (Patton, 2002). Given the range of methodological approaches that are typical in case study research, it will not be a surprise to know that the final product of the research may be made up of a range of different kinds of texts. Written case studies may for instance include narrative accounts of a series of events; vignettes or brief descriptions written to capture the essence of an event or experience; tables or charts to present quantitative data; or figures or diagrams that represent significant findings in visual form (Ary, Jacobs & Sorensen, 2010).

The logo project: a case study

Your clients want you to develop a logo for their healthy fast food restaurant. The logo will be used in signage outside the restaurant as well as in all print and online promotional material and on menus and tableware. Your brief is to create a logo that will ensure that the restaurant will stand out as being different from other fast food outlets while at the same time attracting a similar clientele: families and young people looking for healthy fast food. From this brief, a research question emerges: what logo would best communicate the two key messages of a new healthy fast food restaurant?

Because your research focus is clearly defined—to design a logo that will best suit this client's needs—you decide to use a case study approach to the research you will undertake to resolve this problem. However, as you begin to think through the different components of the problem, you discover that there are a number of smaller cases that are, as Patton states, 'nested' within the larger case (2002, p. 297). You decide that your case study will in effect be made up of a series of smaller interrelated cases, and your research design develops with this in mind. As your research plan develops, you also realize that each different case lends itself to the use of different methods.

Your first stage is to identify what the clients' feelings are about the kind of logo they want, and you decide to explore how your clients developed their ideas for their business, what their motivations were for taking their chosen direction, and how they imagine their restaurant will look when it is open for business. The focus on experiences, actions, values and feelings suggests a narrative approach to this phase of the research.

Secondly, you explore the questions of what signifies 'fast food' and what signifies 'healthy food' to potential customers. To do this you research the logos already in use by restaurants in the surrounding area. You make observations, collect visual

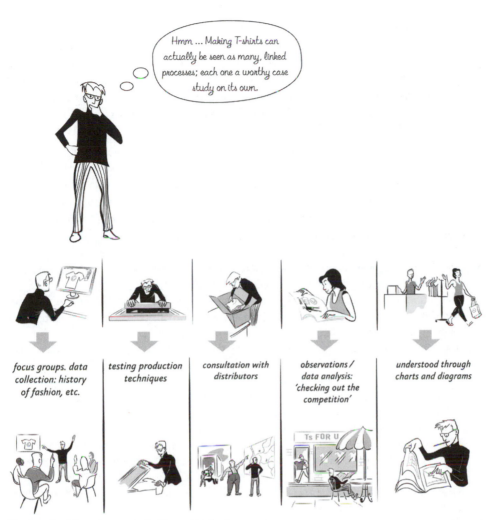

Figure 6 Nested case study (Stuart Medley).

evidence and analyse this data to identify some of the key components of the different logos. You will then be able to analyse and compare the different pieces of evidence. As you start to synthesize the different sets of data, you will be in a position to create some examples of logos. At this stage you might set up some focus group interviews that will enable you to gauge the responses of potential patrons of the restaurant to your different designs. This will be your third case. Based on your work on these three embedded cases, you will now be ready to create some designs to show your clients. This particular case relates back to the first one, as it develops your research into your clients' experiences, feelings and values. Depending on their response, you may need to go back and work through some of the research processes again (which ones they are will depend on the nature of your clients'

responses), or you may be able to proceed with the next stage, which would involve experimental research into different materials. You will need to explore how each design works when scaled up or down, whether the designs are appropriate for the different materials or media you will use for the different products, and do some costing exercises. This phase of the research will provide you with your final case.

The overall research we have described is made up of four distinct case studies that are then brought together to form the single 'big picture' case. To develop a solution that is well informed by research, it has been necessary to develop each nested study with its own particular set of research aims and its own methodological approach. Each separate component is distinct, and given sufficient development could constitute a separate research focus (and a distinct case) in its own right. But in the context of the logo project, each component case is essential to the compilation of the larger, composite case. To elaborate:

- The first case centres around the inspirations, motivations and aspirations of the restaurant owners. How do your clients imagine their future enterprise?
- The second case focuses on how others have solved the problem of designing a logo that signifies a particular kind of eating experience. How have others responded to the problem of using logos for this purpose?
- The third explores the success of your design solutions (shown in the logos you have developed) to convey the particular messages you intend, based on how they are read or understood by members of the public. You would probably use purposive sampling to identify suitable focus groups, and you might devise a 'paired adjective' scale for this purpose. Which solution(s) is/are most successful?
- The fourth case focuses on the processes involved in bringing an image, originally expressed in two dimensions and on paper, into production as signage and as a logo on different items such as stationery, crockery, glassware and table napkins. This has further ramifications in terms of materials research. For example, is the logo adaptable to different formats, such as when reduced in size for printing on paper napkins, or when printed on a curved surface such as the side of a paper cup?
- The whole case is developed as a written case study, in which you explore your work as a designer by making explicit the processes that are involved in fulfilling this design brief.

Methodological choices in case study research

As we have shown in discussing the choices made by the researcher in the logo project, the initial examination of the brief led to a series of research questions that each focused in more detail on smaller components of the larger case. However, in this example each small case was clearly framed both in terms of the limits of its focus and in terms of its relation to the larger case, which also had clearly defined boundaries. Each different nested case required the use of different research methods, and for each case the methodological choices were suggested by the nature of the research problem. It should be obvious from this example that the use of mixed research methods is particularly appropriate for case study research. In fact, the idea

of mixing research methods within any methodological framework is becoming widespread, and has many advantages for researchers.

Case study research is less open-ended in design than ethnographic or narrative research. Often, in the interests of gaining a full picture of the case, a great deal of information will be gathered, and unlike most ethnographic and narrative research, the types of data will be extremely diverse. Typically, such methods as observations, in-depth interviews with individuals and focus groups, and opportunistic conversations with participants are combined with analysis of personal journals, documents, photographs or film, archives or physical artefacts or even numerical data (Liamputtong, 2009; Patton, 2002; Yin, 2008). As with ethnographic research, the triangulation of data, typically achieved by using different sources of data (such as interviews with both designers and with consumers) or by using different methods of data collection (such as large scale surveys, small scale interviews and observations), will be important to ensure that the diverse perceptions and different realities of the individuals at the centre of the study are identified (Stake, 1995, p. 113). However, given that the boundaries of the case will suggest particular methodological approaches, case study research is distinguished by 'the choice of case rather than the choice of methods' (Liamputtong, 2009, p. 191).

For example if the research focus was an examination of the effectiveness of an advertising campaign, certain methodological choices would follow from the definition of the research boundaries. Here, sampling is most likely to be purposive to give the most useful data in relation to the case, and participants may be chosen from among those groups that are part of the typical audience for the campaign (Glesne, 2011; Patton, 2002). Data collection methods will also be suggested by the particular focus of the case. In this instance, individual and focus group interviews will elicit more useful data than observations when there is the need for targeted, specific information, but such ethnographic types of data might be supplemented by survey data to identify changes in brand awareness across larger populations, and statistical data might be used to show the effect of the campaign on product sales. In case study research, the planning process is crucial in determining the research focus and identifying the precise boundaries of the case. Having made these decisions, the methodological choices should follow on clearly. Based on the project's needs, the researcher should feel confident in choosing a mixture of methods when appropriate.

Mixed methods in case study research

A major advantage of using mixed methods is that they provide opportunities for triangulation of data (Patton, 2002, p. 247). As mentioned, triangulation can strengthen a study by providing evidence from different perspectives that serves to cross check and provide validity for the claims being made (Patton, 2002, p. 248). While in Chapter 6 we suggested that observation is particularly appropriate for ethnographic research, other approaches such as interviews and document analysis

are invaluable to enable the researcher to gain fuller perspectives. Similarly, while in-depth, open-ended interviews are particularly suitable for narrative research, these could usefully be supplemented by data based on observations, for example observations of a craftsperson at work or in interaction with clients. No matter the project, it will be essential for researchers to explore every possibility for using a range of methods to add depth to their understandings and make their studies more credible.

We have so far suggested possibilities for combining different methods from within qualitative traditions. Increasingly, researchers are choosing to combine qualitative and quantitative methodological approaches when such a combination is suggested by their research purposes (Ary, Jacobs & Sorensen, 2010; Tashakkori & Teddlie, 2003; Teddlie & Tashakkori, 2009). Quoting Aldous Huxley's words, 'That which works, works', and arguing that the sole use of a qualitative approach may leave gaps in the data that could be filled using quantitative methods, Ary, Jacobs and Sorensen suggest that by mixing qualitative and quantitative methods researchers may obtain 'better information to understand a particular phenomenon' (2010, p. 558). Where words and narratives can add meaning and richness to numerical data, numbers can add clarity and precision to the qualitative data (Ary, Jacobs & Sorensen, 2010). For example, in the logo case study mentioned throughout this chapter, the data collected using the Likert-type scales could be presented simply and effectively in numerical form, perhaps as percentages. This mixing of data can occur at all stages of the research: by combining quantitative and qualitative approaches to data collection (such as using a large scale survey that is then supplemented by data collected in interviews with individuals), and by using quantitative and qualitative tools for analysis or for presenting the research (Tashakkori & Teddlie, 2003).

An example of the latter is a continuum, which is a quantitative device for showing a gradual transition from one state to another but would be a very suitable choice to represent continuity of experience (such as how participants' perspectives changed over time) and could therefore be used to summarize and present qualitative data clearly and succinctly (see Pearce, 2008a). While a research project can be considerably enhanced by the combination of qualitative and quantitative methods, the project should be designed to allow the different components of the research to be brought together in logical and purposeful ways, to avoid the risk of conducting two distinctly different studies (Yin, 2006, in Ary, Jacobs & Sorensen, 2010). In other words, the qualitative components such as written narratives or vignettes might be used to elaborate or explain quantitative data, or quantitative devices might be used to summarize or encapsulate qualitative data. As with all research, the coherence of the research design, the appropriateness of the methods and the consistency of interpretations across qualitative and quantitative phases of the study should all be examined for their rigour (Ary, Jacobs & Sorensen, 2010, p. 567). Choices about how to present data should be made that ensure the research outcomes are presented in meaningful ways.

Quantitative methods enable researchers to gather data that reflects the perspectives of large groups of people or populations. These approaches may be particularly valuable for designers, since their work often involves providing solutions that will work for large numbers of people such as the population that comprises a representative sample of all possible users of a new product. For these reasons, a mixed methods approach might be valuable for many design-focused research projects. Given the importance of matching the research methods to the case, we suggest that the possibilities of using mixed methods are explored whenever case study research is undertaken. A mixed methods approach would certainly be appropriate for the logo project discussed in this chapter. We earlier noted the stages at which methods such as individual and focus group interviews and observations could be used in this project. In the next part of the chapter, we further illustrate how quantitative methods such as surveys could be incorporated into the logo project.

Survey research

While it is true that using methods from qualitative and quantitative traditions together can be more time consuming and more demanding of research expertise than working within one tradition (Ary, Jacobs & Sorensen, 2010), it is possible to find creative ways to combine both qualitative and quantitative approaches without embarking on approaches to data gathering that require complicated procedures. Some typical qualitative methods were discussed in Chapters 6 and 7; we now suggest some accessible ways to develop quantitative approaches such as surveys that could be used in research in design. Some advantages of using surveys are their versatility—they can be used to research a wide range of topics—and their usefulness for collecting a large amount of data from a large number of people relatively quickly (Walter, 2010a, p. 152). They have disadvantages, too. The data can quickly become out of date, responses are subjective and they can only give a limited picture of the issue that is researched (Walter, 2010a). As always, the decision about whether or not to use surveys in research goes back to the original research question. What potential do these methods have for helping you find out what you need to know?

The first task in developing a survey is, as with any research, to develop the initial research question (Punch, 2005). By doing this you will successively refine the focus of your research and clearly identify what you plan to find out. In the logo project, the research question ('what logo would best communicate the two key messages of a new healthy fast-food restaurant?') has developed from a professional problem, defined in terms of the clients' needs. Then, having defined the concepts to be explored and having decided that a survey is the most suitable approach for the planned research, the process of developing and administering a survey involves defining the sample to be surveyed, developing the survey itself, then conducting the survey and, finally, analysing and interpreting the data. Each stage also involves

further detailed tasks such as writing and refining the questions, piloting the questionnaire, and deciding how best to present the data that has emerged (Ary, Jacobs & Sorensen, 2010; Walter, 2010a). In a study that uses mixed methods, careful decisions will be needed about how and at what stage to present the different types of data, and how to synthesize the different data that has emerged from the different data collection methods.

Several options are available to researchers whose project would benefit from the use of surveys. We list these briefly here, but if planning to use survey methods, we would recommend you to read further to clarify and refine your understanding before embarking on the project. (Here it is worth noting that creating surveys is a complex process, and there are numerous useful guides that will provide more detail then we can do here. The list of references provided at the end of the book includes several useful texts.)

Different types of surveys

Should you choose to undertake survey research, you will need to decide what type best serves your needs. One key task is to decide who will participate in the survey. Sample surveys are manageable ways for individual researchers to collect information that can be used as the basis for making inferences for the population as a whole (Ary, Jacobs & Sorensen, 2010; Creswell, 2008). A sample is a proportion of the total population, chosen for a particular reason and to suit the research purposes. You might use random or cross-sectional sampling, in which you choose individuals at random to be representative of the whole population (Walter, 2010a), or you might use convenience sampling, where the researcher chooses participants because of their availability and their willingness to take part. Such a sample cannot be said to be representative, however. An alternative to convenience sampling is snowball sampling, where existing research participants are asked to recommend others to take part in the research. Researchers planning a qualitative study will use purposeful sampling, where individuals are chosen specifically for their capacity to provide information about the research topic. This practice is particularly relevant to case study research, where the nature of the case will suggest the sample (Stake, 2008). See also Ary, Jacobs and Sorensen (2010) and Creswell (2008) for further information about sampling.

Surveys may then be designed to collect information over a period of time (longitudinal surveys) or at a specific point in time (cross-sectional surveys). Longitudinal surveys explore change over time either with the same group of participants, or with different individuals such as in a study of trends, or with cohorts of people having something in common with each other such as age, education or social status. In cross-sectional surveys the focus is a study of a cross-section or sample of a population at a given point in time. This has the advantage that the data collection takes place on only one occasion, whereas longitudinal studies require data to be collected on several different occasions. Having decided to use surveys as a data

collection method, there are four ways you can administer them: as printed surveys that are posted to people; as electronic surveys emailed to people; as surveys placed on a Web site constructed by the researcher and made available through the Internet; or they may be personally administered to a group of people in a specific place or on a specific occasion. Different advantages and disadvantages are associated with these different approaches to administering surveys (Ary, Jacobs & Sorensen, 2010, pp. 384–387).

Finally, surveys may be designed to focus on tangibles, by asking for straightforward information such as who uses what, how often, where and when, or on intangibles, which ask participants to respond on more complex factors such as their values, opinions, attitudes (Ary, Jacobs & Sorensen, 2010, pp. 375–376). Surveys used in research in design might well need to focus on both tangibles (questions about practices or preferences in using a designed object or system) and intangibles (questions about attitudes to or feelings about a particular product), depending on the research purpose.

Surveys: asking good questions

The introduction of the question into the problem/solution dialogue is helpful for the designer who is thinking about research. From this perspective, questions have a role at the higher levels of thinking about design problems, to help identify what the problem actually is and to shape strategies for the eventual resolution of the problem. Thus, questions become intellectual tools for exploring the problem/solution dynamic. Another role for questions is as intellectual tools for eliciting information that can be used by the researcher to move towards solutions. The use of questions to gather information from research participants, whether in interviews or through surveys, is one of the most important strategies in social research.

In Chapter 7 some approaches to framing questions in relation to interviews were explored, and the use of semi-structured interviews and open-ended questions to provide opportunities for research participants to engage in open conversations with the interviewer and shape the research in their own ways was advocated. In contrast, written surveys are carefully structured so that each participant is given the opportunity to respond to exactly the same items in exactly the same way. It is therefore important to develop questions that really work well to elicit the kinds of information that are of interest. Written surveys typically use a combination of open and closed questions (see also Chapter 7). Survey questions might ask for relevant demographic questions such as age group, gender or size of family, or questions about practices that are relevant to the research. Answers to these will be useful later when analysing responses, as they will help identity any common patterns based on age or gender. Surveys often include some open-ended questions in the form of completion questions (What does this logo remind you of?) or that give respondents the option to make additional comments. The outcome of a survey can be significantly influenced by the way questions are phrased, the amount of

information provided and the choice of answers made available to participants (Ary, Jacobs & Sorensen, 2010, p. 395). Ary, Jacobs and Sorensen list eleven factors to be considered when writing survey questions. These include the need to:

- Be brief
- Make the questions easy to understand
- Ensure that questions will not give rise to ambiguous answers
- Ensure that questions do not predetermine an answer
- Avoid leading questions
- Avoid writing questions that attempt to ask two questions in one (2010, pp. 395–397)

When writing questions it is important to be aware that sometimes how a question is asked 'may prescribe the answer' (Ary, Jacobs & Sorensen, 2010, p. 395). Every question should be checked for evidence of the researcher's agenda coming through in the phrasing. For example, in the question, 'How often do you take your children to fast food restaurants?' there is an assumption that the respondent both has children and regularly takes them to fast food restaurants. Only someone to whom both these conditions apply can answer the question, so this would only be an appropriate question for a member of a particular research sample. Piloting questions is a vital stage in the process of survey development, to ensure that survey respondents read the questions in the ways intended, and to identify any possible ambiguous words or phrases. Finally, it will be important to make sure that the questions are both necessary and appropriate to the research purpose (Walter, 2010a).

Examples of survey questions

Simple examples of survey questions invite participants to write an answer to open-ended questions or complete a phrase or sentence using their own words. Checklists, where participants are asked to tick items that apply to them from a list provided, are also often found in surveys. Scaled items, where participants are asked to rate a concept or situation on the basis of a concept such as quality or frequency are also useful, as are ranking items and Likert-type items (see further on for a fuller description). Examples of a Likert scale and a rating scale are shown below. Surveys may incorporate some element of ranking or rating at the start. The different surveys shown here are particularly relevant to research in design, as they explore people's attitudes, beliefs, behaviour and opinions. The particular examples all relate to the logo project.

Attitude scales are used when the researcher is interested in research participants' attitudes or opinions, and measure the degree to which an individual exhibits a particular characteristic or attitude. They can be used alone or in combination with methods such as observation and interviews (both individual and group). The Likert scale, developed by psychologist Rensis Likert in 1932 to measure attitudes (Ary, Jacobs & Sorensen, 2010, p. 209), is a well-established

instrument commonly used in surveys. It enables the respondent to show the extent of their agreement with a particular statement by marking the appropriate box in response to each statement. Note that statements are used, not questions. Most Likert surveys have an odd number of possible responses (five is common), with a neutral option in the middle and agree and disagree items on either side (see Table 4).

A well-designed Likert scale will use a large numbers of statements about a topic, evenly divided between statements that express a positive attitude and those that express a negative one. Taken together the statements should as far as possible represent the full range of possible responses to the topic (Ary, Jacobs & Sorensen, 2010). In Table 4, the statements have been chosen to identify the extent to which respondents associate fast food with healthy eating and a pleasant dining experience. To score the scale, the different agree/disagree responses are each given a numeric value and responses are tallied to find the individual's responses to each item. When scoring, a weighting system applies so that the most positive responses are given five points and the most negative, one. However, depending on whether the original statement is negative or positive in its intent, the weighting will apply differently. In the example below, item 1 is a positive statement, so a strongly agree response would score five. Item 2, however, is negative, so a strongly agree response

Table 4 Likert Scale for Logo Project: Attitudes towards Fast Food Restaurants

	Strongly agree	Agree	Neither agree nor disagree	Disagree	Strongly disagree
1. Fast food can be healthy					
2. Fast food restaurants encourage poor eating habits in children					
3. Fast food restaurants are ideal for everyone					
4. I would not go to a fast food restaurant if I wanted a healthy meal					
5. Fast food restaurants are not my idea of a pleasant dining experience					
6. Fast food restaurants are great for young families					

would score only one. The final score shows the individual's overall attitude towards the subject. The results of the survey will help a designer to pitch the logo appropriately, either to emphasize the fast food nature of the projected dining experience or to play down the association with typical fast food establishments.

For the logo project, a rating scale might be used as a preliminary exercise, to find out such things as how regularly participants visit fast food restaurants, the types of meals they eat there most frequently (breakfast, lunch, snacks), and whether they visit more often alone, with family or with friends. Such questions can be useful to provide confirmatory data that can then be matched against participants' responses to other questions, and will also help orient participants to the main topic or ideas (such as how participants read a logo) explored more specifically through the rest of the survey.

As it will be crucial to identify an appropriate range of statements when developing the survey, prior research involving relevant literature, examples of similar surveys or the input of experts will be important. Where the research is in response to a client's brief, it will be important to involve the client in the process of developing the statements.

An alternative device used to identify attitudes is the paired adjective scale (Ary, Jacobs & Sorensen, 2010, p. 212). Here, a list of adjective pairs is provided for research participants to tick to show where on a five- or seven-point scale their attitude is best represented (Table 5). This is a useful and flexible device and can be used to measure attitudes or opinions about a large range of topics or situations. It is easy to develop and quick for participants to use. There is a highly creative dimension to thinking up adjectives that relate well to the project. In the logo project, we have devised this scale to find out what is signified by the different logos produced during the third phase of the case study. The scale might be presented to different sample groups and a selection of logos provided for participants to rate, based on the same scale.

In this example there is no clear positive or negative end point on the continuum. This encourages respondents to read and think about each item separately before making their decisions. The responses are scored by converting the positions on the continuum into ratings (in this case from one to seven) depending on which

Table 5 Paired Adjective Scale for Logo Project

What does this logo remind you of?							
Healthy food							Comfort food
Simple food							Gourmet food
Alternative food							Traditional food
Family dining							Fine dining

features the designer wants the logo to signify. The scores can then be averaged for each different logo presented, to find out which ones convey the desired message most successfully.

Another device used to measure attitudes is a rating scale (Table 6). In this case, a number of statements about a phenomenon are grouped in a list along with a scale of categories.

This rating scale could be used to initiate discussion in a focus group, with further questions developed to explore further the reasons for participants' ratings.

Finally, a ranking scale (Ary, Jacobs & Sorensen, 2010; Creswell, 2008) allows participants to show their attitudes to different attributes or concepts by placing them in rank order (see Table 7).

Scores are then tallied for each item, and an average found. The item with the lowest average score is the most important, and so on.

Data collected in these ways can also be used to inform later stages of the research. For example, having analysed the results of the surveys the results could be used to devise questions for focus groups that will enable exploration of the research outcomes in more detail. In the case of the logo project, focus groups might

Table 6 Rating Scale for Logo Project
Please Rate the Logo Based on the Categories Listed in the Left Hand Column.
This logo is:

	Very	**Fairly**	**Not at all**
Readable			
Attractive			
Distinctive			
Memorable			
Appealing			

Table 7 Ranking Scale for Logo Project: What Makes a Logo Stand Out?

Features of a logo	**Order of importance (1 = most important, 6 = least important)**
Use of colour	
Size	
Distinctiveness	
Originality	
Clear association with the product	
Sends a clear message	

USING CASE STUDIES AND MIXED METHODS

provide feedback about the different logos developed in light of the results of the surveys administered at an earlier stage of the project. Alternatively different survey questions could be developed to further investigate particular research outcomes. It is useful to keep in mind the possibility of using a range of devices for collecting data, and that project design needs to be flexible depending on the outcomes (which are often unexpected). We reiterate Stake's (2008) point that in case study research the methodological choices themselves will be shaped by the need to show the particularities of the case. This being so, we can expect our methodological choices to change as the research unfolds.

Sketches of research projects using a case study approach

We now outline some examples of research that use a case study approach. We have developed an example of a nested case study, in which the overall focus is 'design for liveable hospitals'. The research problem is: how can design be used to ensure that a hospital is a welcoming place for patients, visitors and staff? In the examples, several smaller case studies make up the larger one. They each focus on a different one of five specialist areas in design: fashion and textiles, interior design, architecture, product design and digital design.

FASHION, FABRICS AND TEXTILES

Research focus: Uniform design.
Research problem: To design a uniform that is functional, hygienic, reflects the status of the wearer but does not make the wearer appear intimidating to patients and visitors.
Sensitizing concepts: Designed object, users of design, function, aesthetics.
Methods:
Interviews with hospital staff, patients and visitors.
Materials research: durability, washability, comfort and wearability, functionality, attractiveness.
Research into other uniform designs and design solutions.
Data collected:
Interview data, observations of work practices.
Results of materials testing.
Final text: Case study of research process, including report of results and proposed uniform prototypes and patterns.
Who is the research for? Uniform designers, uniform wearers, hospital administrators.

INTERIOR DESIGN

Research focus: Signage and way-finding.
Research problem: To design a way-finding system to enable ease of movement throughout the building.
Sensitizing concepts: Designed system, user of designed system, signage, movement, space, logistics.
Methods:
Observations.
Research signage and way-finding systems in other locations.
Logistical analyses.
Focus group interviews.
Data collected: Observation records, spatial and logistical analyses, movement modelling, interview data.
Final text: Case study reporting research process and including recommendations, sample signage and mapping of movement.
Who is the research for? Hospital administrators, staff, patients and visitors.

ARCHITECTURE

Research focus: Public and private space.
Research problem: How to create private spaces in wards without compromising patient safety and staff efficiency.
Sensitizing concepts: Designed system, users of design, private and public space, efficiency, emotional security.
Methods:
Observe movement in wards, medical and support staff, patients, visitors.
Individual interviews with medical and support staff, patients, visitors.
Research solutions in other locations.
Materials research, partition systems, blinds, curtains.
Focus group interviews to explore maquettes produced.
Data collected:
Mapping of movements around wards.
Interview data.
Results of materials testing.
Focus group feedback.
Final text:
Case study including research report and recommendations.
Plans and maquettes.
Who is the research for? Hospital administrators, staff, patients and visitors, architects.

PRODUCT DESIGN

Research focus: Workspace design.

Research problem: To design a site-specific nurses' station for an established children's ward. The workstation must function successfully as an observation point and focal point in the ward while being aesthetically appropriate for children.

Sensitizing concepts: Designed object, designed system, users of design, ergonomics, aesthetics.

Methods:

Observe work patterns of nurses.

Individual interviews with nurses, children with parents/caregivers.

Research solutions in other child-friendly locations.

Materials research—durability, ergonomics.

Design options—style, colour, finishes.

Focus group interviews to explore maquettes produced.

Data collected:

Mapping of work patterns.

Interview data.

Results of materials and styling research.

Focus group feedback.

Final text:

Case study including research report and recommendations.

Plans and maquettes.

Who is the research for? Nurses and children, other product designers.

2D AND DIGITAL DESIGN

Research focus: Web design for ease of use.

Research problem: To redesign a hospital website to make it more accessible, by improving navigation, legibility and appearance.

Sensitizing concepts: Designed system, users of designed system, visual literacy, digital literacy.

Methods:

Analysis of existing website navigation, involving focus groups (observe and interview).

Identify aspects that need revision and redesign.

Research navigation systems in other websites.

Prepare and test newly modelled site, involving same focus groups for comparison.

Analysis of existing visual appearance of website, involving focus groups (observe and interview).

Identify aspects that need revision and redesign.

Research visual solutions in other websites.

Prepare and test newly modelled site, involving same focus groups for comparison.

Data collected:

Feedback from observations and interviews with focus groups.

Results of research into other website solutions.

Feedback on redesigned website.

Final text: Case study including research report and redesigned website.

Who is the research for? All users of this website, web designers.

Conclusion

What can we learn from case studies? Perhaps because of its value strategically to 'draw attention to what can be learned from a single case' (Schram, in Glesne, 2011, p. 22), case study research is found in several professional fields such as social work, education and health, as well as used as a method in social research generally. It also enables focused research into systems and institutional practices, and has the potential to provide both large-scale portrayals and detailed insights. The focus on experiential knowledge in case study research assists our understanding of the social, political and cultural contexts of individual and collective experience, or the real life of the case (Liamputtong, 2009; Stake, 2008). Case study research is also valuable when we are interested in 'how?' or 'why?' questions (Yin, 2008) in the context of a new or previously unknown phenomenon such as social networking. Furthermore, a single case study can form a starting point for further investigations and theory development (Flyvberg, 2006, in Liamputtong, 2009). For these reasons, case study research has considerable potential for those who are working and researching in the field of design.

For further examples of case studies in design we suggest you explore the following sites:

http://www.designcouncil.org.uk/Case-studies/: this site provides examples of design success written in the form of case studies.

http://www.smashingmagazine.com/2009/09/20/showcase-of-case-studies-in-design-portfolios/: sometimes case studies are used for promotional purposes, as in this example. The site provides examples of how designers have used case studies to enhance their portfolios.

http://www.blog.spoongraphics.co.uk/tutorials/logo-design-process-and-walkthrough-for-vivid-ways: this site describes a case study that focuses on logo design.

9

ACTION RESEARCH

What is action research?

Action research is perhaps the most powerful and liberating form of research available to practising designers. There is a close connection between the philosophy of action research and the idea of praxis, since in action research the connections between thought and action (particularly action in professional contexts) become central to the research process. While a common goal of action research can be to simply improve efficiency, it has far greater potential for transformation of practice (Kemmis & McTaggart, 2003).

In most action research, practitioners themselves examine and evaluate their own practice, both individually and collaboratively, to 'find ways of living more fully in the direction of their ... values' (McNiff & Whitehead, 2006, p. 7). Used in this way, with its potential for ownership and control of the research process, action research leads to opportunities for practitioners to have more control over how they work, and opens up possibilities for them to develop or consolidate their practice in ways that better reflect what is important to them.

A key principle of action research is that people's practices are not fixed but can be changed to produce more ethical, socially just or sustainable outcomes (McNiff & Whitehead, 2006). To practice action research is therefore an act of optimism, and action research begins with the premise that practices can and should be changed. Action research is also potentially critical research, in that the process of examining people's practices can throw up instances of injustice, silencing, alienation and barriers to participation (Fine, n.d.). For designers, engaging in action research can be a powerful tool for initiating change, and provides a structure for design researchers to engage in the dynamic process of problem framing and solution finding that we discussed in Chapter 2.

Action research has become a familiar tool for professionals in many settings such as business, nursing and education who want to explore possibilities for making changes to improve their practices. Because of this variety of applications, conceptions of what constitutes action research are diverse. Action research designs

are necessarily flexible, to allow researchers to put together a range of research strategies according to the specific needs of the research. Action research exemplifies the importance of allowing the research questions to drive the research process. Action research typically deals with problems that are 'local' (Ary, Jacobs & Sorensen, 2010, p. 516) or significant to the practitioners themselves, who then plan the research process, decide on suitable strategies, conduct the research and make decisions for action based on the research outcomes.

The goal of action research is to develop practical and relevant solutions to the problems identified. This intention makes action research quite unlike other forms of research, which seek primarily to develop new theories or explanations or to produce new knowledge about phenomena in the world. The possibility for researchers themselves to own the research process and the research findings is powerful, and makes action research clearly distinct from forms of research where the processes are decided by 'expert' researchers who then own the findings and impose the solutions (Ary, Jacobs & Sorensen, 2010, p. 514). Action research is conducted by those individuals who are most implicated in the research problem. In Kemmis and McTaggart's words, participants in action research 'live with the consequences of what they have done' (2003, p. 376), for better or worse! The same can be said for designers. The involvement of insiders such as designer colleagues or the users of design at every stage of the research process marks action research as significantly different from those forms of research where a researcher from outside sits apart from the main action and remains uninvolved.

Action research might provide strong evidence that affirms the quality or success of existing practices in a workplace, and when this success needs to be demonstrated, it can be done far more convincingly by engaging in some form of disciplined, systematic study than simply by going on a hunch. More frequently, the research will open up possibilities for change. In both cases it is important that the practitioners own the research and the information. Furthermore, if the intention is to create an 'inquiry stance' towards one's practice (Ary, Jacobs & Sorensen, 2010, p. 513), action research has the potential to make inquiry become part of the culture of a workplace as the process of questioning one's practices becomes 'part of the work' (Ary, Jacobs & Sorensen, 2010, p. 513). Such inquiry can provide evidence and generate insights that can assist in the 'critical transformation of practice' (Kemmis & McTaggart, 2003, p. 378). So action research is research in and for action.

Arguably, all professionals engage at all times in the processes of questioning, analysing and reflecting that Schön brought to our attention (1983, 1987). While action research, too, incorporates reflective processes into its design, it is distinct from other forms of reflective practice in being deliberate, planned and systematic, with a distinct purpose and deliberate strategies for moving from reflection to research. Ideas for change develop from the research, and then become the focus of further research. The process of action research is typically cyclical or iterative in nature, beginning with a process of reflection and identification of the problem. This is not a linear process, and the design needs to be flexible. The process can be messy, since

as one change is initiated it leads to further consequences that in turn need to be researched (Kemmis & McTaggart, 2003). Action research is therefore conducted 'within practice' and is distinct from research that is about practice (Kemmis & McTaggart, 2003). Swann suggests that, because of its inherent flexibility and openness, action research is a particularly suitable methodology for a design project 'where the final outcome is undefined' (2002, p. 58).

The so-called 'action research cycle' is characterized as consisting of a series of distinct phases of research. At its simplest level, the cycle incorporates processes of observing, reflecting, planning and acting, with the end result being the

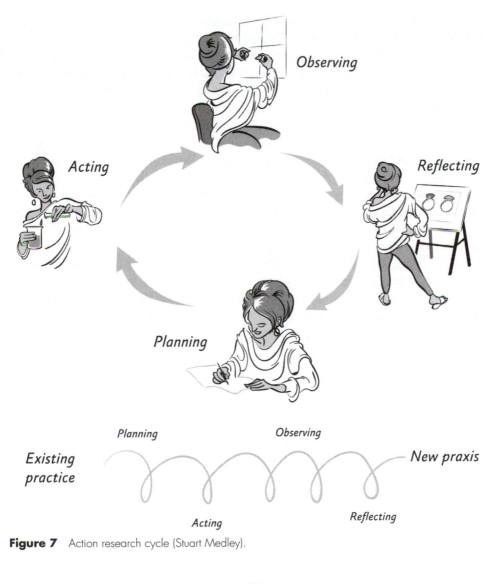

Figure 7 Action research cycle (Stuart Medley).

development of new practices. The process is commonly represented as a cycle or spiral, to make clear the importance of reviewing and revisiting decisions and practices. Some researchers suggest different entry points (for example beginning with planning rather than observing), and others represent that process as if it were an endless repetition of the 'observe, reflect, plan, act' process (see for example Ary, Jacobs & Sorensen, 2010, p. 518). Our preference is for a representation that indicates movement forward to new praxis, so the spiral represents a generative process.

Action research and design praxis

Action research appeals to designers for a number of reasons. Action research enables designers to make visible their design processes, and in this sense is particularly apposite in a climate in which the public is increasingly holding the 'designers of our environment' accountable for their design decisions (Swann, 2002, pp. 55–56). The process of action research closely mirrors that of design in its iterative, exploratory nature, and is thus well suited to resolving design problems which typically require review, amendment, adaptation and refinement as the initial concept is developed and the problem tackled (Swann, 2002). It will be useful at this point to delineate the subtle but significant ways in which the process of action research is both distinct from and more than the process of reflection that is characteristic of professional practice (Ary, Jacobs & Sorensen, 2010; Schön, 1983). In fact, Kemmis and McTaggart see participatory action research as 'practice' in that the participants in the research 'make, and learn from, changes they make as they go' (2003, p. 359). In this sense, action research can be likened to praxis.

A key distinguishing feature of action research is its systematic, deliberate nature. Because it is systematic, it is possible through action research to move out of existing parameters of practice and explore new ones. While professionals may deliberately engage in reflecting on day-to-day experiences and events, in order to critique and review their practice, such reflection is often short-term and reactive, coming after the event. In such a case, it is likely that any changes will be situated within the existing parameters of practice. For example, designers who reflect on how economically they have used particular materials may in the future use the same materials more economically as a result of their reflections, but based on the parameters of these reflections will not consider other factors that come into play in the choice of materials. In this case, as a result of these reflections designers may improve their efficiency but their practice will not be changed at a deeper level.

In contrast, action research that is deliberately planned, and so proactive, provides an opportunity to step outside the habits of practice and take a much broader view of the conditions in which the practice takes place; in other words, to adopt a

reflexive position, as we have defined it in Chapter 3. Such an approach offers more opportunities to develop transformative goals and challenge taken-for-granted ideas about how we practice. Furthermore, because the research takes place over a period of time, the outcomes of the research can be fully investigated for their viability and appropriateness to the context, and any changes suggested by the research are more likely to become embedded in practice.

A review process, which is integral to the action research cycle because of its iterative nature, is another feature of this approach that has the potential to enhance professional practice. Opportunities to review actions are often missing in professional contexts, when time pressures often demand quick decisions and instant responses in the form of action. The process of review is crucial in analysing the results of action and in consolidating changed practices, and in action research this process is built in. Action research also allows professionals to have control over what they wish to focus on. It may be difficult to maintain a focus when simply reflecting, as day-to-day so many different issues may present themselves for attention. However, the choice of focus may well come about as a consequence of day-to-day reflections. Action research has many possible outcomes, including the potential to produce a written case study that adds to the knowledge base of the profession. This is unlike private reflections, which often remain private, or shared only by one's closest colleagues. Finally, because action research is methodologically systematic, rigorous and documented, others in similar settings can replicate its methodological rationale. In these ways it is unlike reflection, which is typically idiosyncratic and personal.

The following examples of research projects in design that use action research methods are not intended to be models but are provided as opportunities to illustrate some key principles of action research. In the first example, Anusha's Project, the basic phases of observe, reflect, plan, act have been expanded into seven, to illustrate progress through the cycle. In developing these phases we have drawn on Ary, Jacobs and Sorensen (2010, pp. 518–519), McNiff and Whitehead (2006, p. 9) and the steps suggested by Creswell (2008, pp. 606–607).

Practical action research: Anusha's project

This scenario shows how a jeweller, Anusha, might use an action research process to solve a practical problem she has identified in her jewellery making. The example shows Anusha researching within practice, as is shown by the original questions that frame her research. Anusha's project begins with the question: how can I extend my use of materials in ways that enable me to explore different design options while still being able to work sustainably? We suggest that Anusha's process might be based on a combination of Ary, Jacobs and Sorensen's outline of an action research process (2010, pp. 518–520), McNiff and Whitehead's suggestion

Table 8 Action Research Phases in Anusha's Project

Basic phases	Action research phases developed in 'Anusha's project'
Observe	Observe, take stock and identify a concern
Reflect/plan	Reflect on some possible ways forward and begin to plan a solution
Act	Take action to try out the solution
Observe	Monitor and observe the outcomes
Reflect	Evaluate and reflect on what has happened
Plan	Modify practice
Act	Move in new directions OR Return to the observe/reflect/act cycle

for an action plan (2006, pp. 8–9) and the steps suggested by Creswell (2008, pp. 606–607). This process is outlined in Table 8, and each phase is discussed in more detail below.

Phase one: observe, take stock and identify a concern

Anusha is a jewellery designer who is experiencing growing demand for her delicate sea-glass jewellery. She enjoys using this material. It is natural, safe for the environment and interesting to use because each piece of glass is unique and easy to work with. However, she has become aware of an overabundance of sea-glass jewellery in the sustainable jewellery marketplace and is beginning to experience difficulties with the supply of suitable pieces of glass. She also feels she would like to branch out and experiment with different materials. Sea glass is lovely, but Anusha finds that her creativity is sometimes constrained by the limited forms or colours of the glass she is able to obtain.

Here Anusha reflects on what exactly the problem is that she wants to explore, and takes stock of what she already knows. It will be worthwhile for Anusha to spend time at this stage to describe the problem, since it will help her create boundaries for her research and help her identify what falls within and what is outside the scope of her research project.

Strategies for problem identification include reflecting on her current practices and describing or explaining why she practices in the ways she does. For example, Anusha might decide to keep a journal to document her current practices as a way to identify what she already values in her practice and as a device for later evaluating the change she has made. At this stage, it may also be useful for her to explore what other jewellers do, perhaps by contacting designers in her network or

by reading relevant literature or product specifications. She might also brainstorm options (see Ary, Jacobs & Sorensen, 2010, p. 521).

Phase two: reflect on some possible ways forward and begin to plan a solution

Based on her initial reflections and investigations, Anusha is now able to make decisions about a possible way forward. Her research so far has led her to become attracted to the idea of using resin to make her jewellery. She likes the way that the material can take strong colour, and is excited by the opportunities that resin offers for creating custom shapes. Anusha will need to select a single plan of action, to enable her to focus her subsequent evaluation on the single change she has made to her practice. She has decided to focus on using resin to create a new range of jewellery.

Phase three: take action to try out the solution

Anusha is now ready to act on her chosen solution. Her next step is to obtain some resin samples and experiment with this new material by making jewellery samples. This phase of the research will involve empirical research as she explores how the new material handles, its physical features such as plasticity and brittleness, as well as its capacity to take dye and its durability.

Phase four: monitor and observe the outcomes

As Anusha takes action she will collect data, observe, and record what happens as she experiments to see whether the new materials provide the opportunities she needs to develop new designs.

Phase five: evaluate and reflect on what has happened

Anusha is now able to look back on what she has done, and evaluate what she has achieved. She has enjoyed working with the resin. It is easy to use and provides her with many new opportunities for innovative jewellery design. However, as a jeweller she is committed to sustainable and environmentally friendly practices, and does not know enough about the environmental footprint of resin to be able to make a decision about whether to adopt it as her preferred material. She has become aware that synthetic resins are by-products of the petrochemical industry, and while in this sense they can be said to be recycled, they are still connected to the environmentally damaging processes involved in oil extraction. As part of her evaluation process, Anusha has decided that she needs to embark on further empirical research, to find out how resin is made and identify the environmental footprint of the different types used in jewellery making, before she can say that her research is complete.

As the result of her reflections so far, Anusha will be able to modify her practices, either by adopting these resins for her future designs or by going back to the beginning and searching for different options. In either case, these reflections will take her back to the beginning of the action research cycle again, as she further explores different materials and continues to work towards solving the original design problem.

Anusha discovers the existence of bioresins such as cornstarch resin, and other resins made from recycled plastics. Since she is determined that her decision about choice of materials will depend on environmental considerations, she decides to begin another cycle of research, this time using resins that she is confident are less harmful to the environment.

We have presented a simplified overview of the action research process that any designer who is working on a practical problem might initiate. So far we have limited the research to questions about the materials that Anusha is experimenting with. But it will be vital for Anusha to make sure she can still appeal to her existing clientéle, who buy her sea-glass jewellery, while at the same time develop a wider audience for her work. A further dimension to her action research process might then be to conduct client surveys to gauge how people respond to her new work. She will use the same cyclical approach as before but with different focus and different research methods.

This scenario has shown how a designer might embark on a practical action research project. We have imagined Anusha researching her own work as a jeweller, focusing on how the new materials could be used, weighing up their advantages and disadvantages from the perspectives of sustainability, creativity and economy, and exploring the appeal of the new designs to her existing and potential clientele. The example has demonstrated some common features of action research, such as the non-linear, often messy nature of the process (Anusha did not foresee the emergence of environmental problems with resins) and the need for researchers to be flexible. As one change was initiated, it led to other consequences that in turn needed to be researched. The example has shown how action research takes place within practice, and also shows how the practice of design has been enhanced by the research process. As a result of her research, Anusha has:

- Learned how to work with new materials and extended her repertoire of skills;
- Developed new knowledge and understandings of the materials she has used, that she can extend to the making of different objects;
- Created a new range of jewellery;
- Renewed her practices;

- Produced documented evidence of her research and of her practices that can be shared with other designers;
- Produced new knowledge in the field of jewellery making;
- Produced new knowledge about processes of designing.

Anusha's project has brought to the fore the concept that designers are part of the social world, and that their practices are crucially influenced by the social contexts in which they work and in turn have the potential to change the world. An example of how jewellery making can be a catalyst for changed practices is the Australian Museum's Fashion Less Waste 2010 competition (see http://australianmuseum. net.au/Fashion-Less-Waste/).

Participatory action research: urban playground

In professional contexts such as design, the consequences of our actions are felt by many. This is illustrated in Anusha's project when she began to ask questions about the environmental consequences of the use of resin. She understood that her choice of materials should be based not only on technical or economic criteria such as durability or cost but that her choice should also take into account broader social and environmental consequences. This reinforces the idea we discussed earlier that design is about initiating change through the design of man-made things (Jones, 1991). What we expect of action research, and what we can achieve by it, depends on the particular view of practice that we adopt (Kemmis & McTaggart, 2003). Kemmis and McTaggart suggest that practice is reflexive, dynamic and relational, and 'constituted and reconstituted by human agency and social action' (2003, p. 358).

From this perspective it makes sense to include as participants in research those people who are affected by our professional practice when we conduct research that aims to change that practice. Participants in the research might include fellow professionals, for example in a design team, as well as those individuals who are most affected by the outcomes of the design process. As Swann points out, the decision-making of professionals is increasingly subject to the scrutiny of those affected by its outcomes, and he argues that design practices are already moving towards encouraging the participation of users, consumers and the public in the design process (2002). A further argument for participatory research is that participation by those most affected by research outcomes is a means to ensure that the research is relevant (Foth & Axup, 2006). The use of participatory action research in design is informed by the participatory design movement, which invokes the need to involve all stakeholders (such as co-designers, workers, clients, design partners, end users, the general public) in the design process to ensure that the products of design actually meet their needs (Foth & Axup, 2006). As with participatory action research, with its focus on empowering individuals through democratic processes (Fine, n.d.), participatory design also seeks to make the design process more democratic.

While Anusha's project has the potential for further dissemination to others in the profession, her research has not deliberately involved others such as colleagues or consumers in its process. The following project, Urban Playground, is illustrative of how a design project can be fully participatory. Once again we draw on Ary, Jacobs and Sorensen (2010, pp. 518–520), McNiff and Whitehead (2006, pp. 8–9) and Creswell (2008, pp. 606–607) to outline how the project might be organized in distinct phases. However, since this research problem is much more complex than Anusha's, the process is likely to be much messier. The following outline is only speculative as to the possible sequence of events and outcomes once the initial identification of the problem and reflection on the issues has taken place. The project involves Brad, a landscape architect with a particular interest and expertise in designing spaces for playing and learning. He has been given a brief to revitalize a run-down playground in the centre of a large city. He begins to tackle this design problem by taking stock of the situation, using a mixture of reflecting on his existing knowledge and experience and by describing and explaining the parameters of the problem.

Phase one: observe, take stock and identify a concern

Brad is an expert in the design of urban play spaces. Having already conducted empirical research, he is knowledgeable about flexibility, safety, durability and cost of the materials used in play equipment. He is also experienced in designing challenging but safe play areas. But past experience shows that his existing technical knowledge and skills by themselves are not enough to create a workable solution to a design problem that has a significant social dimension.

Because of this social dimension, he sees the playground development in terms of a co-design project (den Besten, Horton & Krafti, 2008; Hussain, 2010) and decides he must undertake some form of additional research to help him understand the needs of the future users of the playground, according to the principles of co-design. This will have priority over any research into materials or playground design. He starts by conducting a small-scale ethnographic project, to determine how community members use the playground, what their views are about its current value and how they think the playground could be best used in future. He employs a small team of researchers to gather survey data and conduct focus group interviews while his design team observes what is happening in the playground at different times of the day.

Brad's ethnographic study reveals a key concern. The playground is the only large open space in the neighbourhood, and is situated next to the local primary (elementary) school. It is the only play space available for the children in the school, but is also well used by many other different groups in the community. In the evenings, older children play on the equipment and use the space for ball games, skateboarding or just hanging out. Residents claim that less welcome groups such as drug users and the homeless frequent the playground later at night. During school holidays, the playground is usually busy all day as toddlers, children, teens and parents visit to play and socialize.

The playground's popularity is both a blessing and a curse for the community. It provides much needed access to safe open space, but because everyone can use it, there has been a long history of misuse and vandalism of the space and the equipment. Many members of the school community—including teachers, parents and school students—are adamant that there should be limited access to the new playground. As it will continue to be an important play space for the school children, they want to be able to control who uses it, and restrict access to groups of people who might misuse the facilities. But many other members of the local community see the playground as a valuable resource for everyone. Throughout the information gathering exercise, there has been some lively debate about who in the community should be able to use the playground.

Phase two: reflect on some possible ways forward and begin to plan a solution

As Brad explores the multiple factors that inform this design problem, he becomes acutely aware that the ultimate success of his design will depend on how well he succeeds in gaining consensus from the different interest groups in the community, to ensure that as far as possible the people all feel they have been consulted and have contributed in some way to the decision making. Furthermore, the community's sense of shared ownership of the playground is likely to be enhanced if everyone is given the opportunity to have a share in the process of designing the playground. Only by involving people in this way does Brad feel that the playground will have a sustainable future.

Brad's design brief thus evolves into a different kind of design problem. He now adopts a participatory action research project approach which will enable a wide range of stakeholders to have a role in finding a solution to this design challenge.

Phase three: take action to try out the solution

Brad's interim solution is to consult widely with all users of the playground to try to find some common starting points and to identify the key representatives of the important community groups. Brad and his team generate a list of questions that will help them gather this information:

1. Who is currently using the site and how?
2. Who else might want to use the site but does not or is unwilling to?
3. How does the site currently provide for the needs of the community?
4. How might it provide for the future needs of the community?
5. Who are the possible stakeholders and how might they contribute to the project?
6. What expertise/values and knowledge does the team of designers bring to the process?
7. What gaps in their expertise might be filled by community members?
8. How important is community engagement with the project and why is it important?

9. What do people want? What possibilities and limitations are there?
10. Who in the community has expertise or knowledge that you can use?
11. Who will be in the design team, and how will the team canvass for opinions?
12. How will the design team keep the community informed about progress?

Phase four: monitor and observe the outcomes

Brad and his team now have a huge mass of data to inform their design. Based on this they produce a plan and disseminate it for further consultation, and at the same time develop and administer a survey to accompany it so they can gauge reactions. The data are analysed and a summary presented to participants.

Phase five: evaluate and reflect on what has happened

The plan that has been produced is an attempt to reflect the needs of the whole community. However the plan meets with negative responses from some community members. A particular sticking point is the position of those teachers and parents who still maintain that the school community should have the sole use of the playground. Brad and his team begin to wonder whether it is actually possible to design a playground that is capable of meeting the needs of all community members. They realize that, at the very least, some negotiation will have to take place to address those aspects of the design that are attracting conflicting responses.

Phase six: modify practice

The problems of limiting the use of the playground to specific groups in the community is handed back to a team of community members made up of representatives of the teacher/parent group and representatives of those who advocate open access. This team will work together to address the differences of perspective and analyse some of the reasons for the divergent opinions. They might be encouraged to use a selection of those strategies advocated by Ary, Jacobs and Sorensen as being useful for problem identification (2010, pp. 523–524): reflecting, describing, explaining, reviewing literature and brainstorming. In this sense, the community team will go back to phase one of the action research cycle, since they will be involved in observing, taking stock and re-identifying a concern.

Phase seven: move in new directions or return to the observe/reflect/act cycle

This community group will also have access to all the decision making as Brad and his team proceed with the playground design, and will act as advisers to Brad and his team as the design takes shape. Members of this select group will be given the opportunity to provide input about the design solutions that the team comes up with, from their different perspectives. Thus members of the community will be

involved at every stage of the design and will be intimately engaged in solving the problems as and when they occur, and not just at the front end.

This is a simple example of how a designer might employ a participatory action research process with the goal of providing the best possible solution to a design problem that is complex because of its possible social consequences. The process is far more time-consuming and far less efficient than a more technical approach would be, but nevertheless such approaches are not uncommon in the design field.

You might be interested in these examples of similar projects: http://www. furnasslandscaping.com.au/playgr.htm; http://www.earthartist.com/.

In the above illustrations, we have shown a shift from the more practical focus of Anusha's project (which nevertheless goes beyond research about technique to encompass problems with the ethical implications of practice) to the participatory example of the playground development where the research process can be directly traced back to the designer's personal ideology and the epistemological position that flows from that. In both these instances, when faced with a problem in their design practice, the designers' research decisions (and their methodological decisions) are based on theories about practice, and theories about research, and go beyond simply picking a method and applying it. The examples we have used here reinforce the idea that personal ideology and epistemology underpin methodological decisions. Both designers operate from a personal ideology, which is that their decisions about how to practice should include a consideration of the social, cultural, ethical and environmental impacts of those decisions. This gives rise to an epistemological position that in turn generates a particular methodological position. This is an intellectual process, and it involves the researchers theorizing about the world and their place in it.

Had Brad decided simply to provide brightly coloured equipment that children (and adults, on behalf of the children) would find appealing, this would not in itself address the whole of the problem, just that part which is most amenable to a solution. Brad's personal view of his ethical responsibilities as a designer led him to particular decisions about methodology. It was a decision that made his task much more complex, and so was not efficient, but the final outcomes were a playground design that had more potential for being sustainable and community minded (and hence enhanced the experiences of everyone who lived in that community) and the growth of new knowledge both about the design process and about design solutions.

What is important in both the examples of action research is that:

- The designer is also the researcher;
- The designer uses knowledge about the possibilities offered by social research;
- The designer uses social research methods to inform and shape the design project;
- The designer's work is shaped or transformed by knowledge of how his or her design practices impact the social realm;
- There is the possibility for creating a case study that can be used by other designers to inform their own work, and thus add to the sum of professional knowledge in the field of design.

In these examples both designers have recognized the potential for research to help them solve a complex design problem. Both have engaged reflexively by questioning ways in which their practices have become normalized and both have begun to look beyond these normalized practices. Both, while employing the typical research method of the action research cycle, have drawn freely on other research methods such as interviews, surveys or empirical methods, according to need and appropriateness. In both cases, the methodological decisions have been led by the research question.

Sketch of a research project using action research

In this chapter we have already explored in some detail two action research projects based within the specialist areas of handcrafts and landscape architecture. In the sketch below, we provide an outline of a generic action research project that focuses on improving practices across a team of designers through working more closely with clients. We have located this example within design practice in general, as the process outlined could be applied to a design team working with clients in any specialist area. As in previous sketches, we have identified a possible research focus and framed a research problem, then suggested some sensitizing concepts, recommended appropriate methods for data collection and analysis, indicated the type of data that would result, suggested what type of research text might be produced and indicated who might benefit from the proposed research.

Questions for reflection

1. What do I think needs improving in my practice, and why?
2. How did my practice come to be like this? What are some assumptions that underpin the way I work?
3. What possibilities are there for me to change? What are the limitations?
4. Who else is involved in my practice? What role might they play as participants in an action research project?

DESIGN

Research focus: Improving communication systems within a creative organization.
Research problem: How might a design team improve the ways it responds to a client's brief without compromising autonomy and creativity?
Sensitizing concepts: The designed system, the user of design, the designer, praxis, collaboration, team process, creativity.

Methods:
Participatory action research involving design team and clients.
Representative reference group leading the process and responsible for calling and running meetings, developing agenda and collecting data as requested.
Clients co-opted to work alongside designers and observe decision-making processes.
Ongoing interviews with design teams and clients as process unfolds.
Data collected:
Records of meetings.
Records of decision-making processes.
Interviews with all participants, analysed according to changing perspectives of the designer/client relationship and understanding of the needs of the groups concerned.
Final text: Case study detailing the collaborative process and reporting outcomes.
Who is the research for? Designers and their clients.

Conclusion: action research and design practice

Action research is increasingly used as a tool for designers (Swann, 2002). Since it focuses on human action, not analysis of products, it supports a focus on the activities that designers engage in (Stapleton, 2005) and furthers the development of design communities of practice. Design itself can be understood as a form of action research. The more practitioners engage in action research and identify and document processes and practices, the more the field of design as a whole is enriched by their contributions. By sharing stories of research with others, the knowledge base of the field as a whole is developed, particularly when the research results in convincing evidence of exemplary work. Such accounts of research 'come to stand as their own practical theories of practice, from which others can learn' (McNiff & Whitehead, 2006, p. 7).

Swann (2002), writing specifically about design, highlights the potential for the reports or case studies developed from action research projects to make the design and reflection processes more visible, and hence contribute to the development of new knowledge about design processes. The question of who 'speaks' in the research text needs particular attention in action research. Unlike in other forms of interpretive research, where the researcher's voice usually carries more weight than the voices of the participants, in a truly participatory project it is important that everyone's voice is heard. An action research text will therefore be written differently from other research texts. Even when researchers have focused solely on their own practices, their text is likely to be more personal and less dispassionate than research texts where the writer is less at the centre of the experience. In this sense, the outcomes of action research are applicable to a wide range of design contexts.

10

WRITING ABOUT RESEARCH

This chapter will introduce you to ways of thinking about how your research may be communicated to an audience. While we will briefly talk about the forms that academic and professional research reporting takes, you will find many specialist texts that can give you far more detailed instructions on how to do it. Our intention is to familiarize you with writing as part of the research process, the purpose of reporting research, academic forms of writing and strategies for representing data visually.

Writing as part of the research process

Writing notes

Note taking is an important part of conducting research. Whether they are notes that record the evolution of a developing concept, that record of the results of empirical testing or whether they are used to annotate and summarize your reading, they must be understandable and accurate. Using notebook and pens and pencil is the natural default state for some, while others are so familiar with using electronic media that the idea of not having access to a keyboard at any time would be a deeply odd experience. Use whatever format you are happiest with, but with electronic media remember to always back up your documents. It is often recommended that you take notes on file cards as these can be filed and reorganized as your ideas change during the course of your research. When working on a project, such as devising a service system for a café, or designing a bicycle rack or making on-site drawings, it is important that the trace of your ideas has an order so that you can retrace your steps or simply keep a record of a sequence of events. Taking notes in these circumstances falls into two overlapping concepts: a diary function and a depository of ideas. It is always good to use notebooks that you enjoy writing in. A notebook that gives you aesthetic pleasure will be carried around, opened and written in. Try to remember to date your entries; it is an easy habit to acquire and means that random information is easier to track down. Most of us have associative

memories that can help locate information by identifying where we were, and who we were with, on what day of the week when such and such happened.

Keeping notes of empirical data has to be approached with meticulous care. Notes need to be written up and kept in a similar format throughout the period in which data is collected. The same care needs to be taken with notes used in ethnographic research. Specialist texts can give you more details (Emerson, Fretz & Shaw, 1995; Sanjek, 1990). Taking notes from readings as you engage in research is as strategic an exercise as the reading itself. To attempt to précis everything you have read is as pointless as attempting to read every book from cover to cover. One role of note writing is to edit experiences down to a kernel that later on can be used to develop other ideas more fully. Some keys points to remember are:

- Reading and note taking are dependent upon what you need to know. Just as you would not read indiscriminately, neither should you take notes indiscriminately;
- Take notes tactically, have a general sense of what it is you are investigating and record information that relates to those ideas. Have a separate section in your notebook or file on your computer for ideas that emerge from your reading but are not necessarily immediately applicable;
- Keep your notes clearly organized, as they serve a different function from your project notes. Keep a meticulous bibliographic records including authors' names, titles, dates and page numbers. Regularly update your bibliography;
- Summarize passages and ideas in your own words as soon as you have read the original and think what is there is valuable. Keep a record of the source;
- Either use double spacing so you can add annotations, or use just one side of a notebook spread so the other side is clear for revisions and fresh observations;
- It may be worth investing in one of the commercial software packages to help manage bibliographic information and organize references.

The key to successful note taking is in planning and taking regular breaks from what you are reading. It is better to decide to read one chapter purposefully than skim a whole book. Always make a conscious decision to read something, rather than start reading by default, and settle down with your notebook, or cards or computer and work consciously through your ideas.

Developing ideas, developing theories and writing drafts

During the course of your research, as you collect data and start to put information together, patterns will emerge that will help you understand the information you are gathering. As we discussed in Chapter 3, ideas are generated by facts. As we observe relationships forming in the information we gather, we are able to draw comparisons about things and build ideas about what is happening. For example, the information gathered from focus groups about a new range of pens might reveal that styling is more important than function to certain members of the group. We build ideas based on those observations using deductive, inductive and abductive

ways of thinking and build theories about how we might develop a range of pens to fit niche demands and perhaps to cut across all tastes.

As was observed in Chapter 2, thinking and doing work together in helping us to generate ideas; on one hand, our theories help us to spot relationships, while on the other, ordering information helps us to identify relationships that generate theories. This is the case in researching and also in the process of articulating the results of that research in writing.

An easy strategy to help in the formation and analysis of ideas and theories is listing and ranking.

1. List all the ideas that have emerged after an examination of your data. Separate them into those that directly relate to your research question and those that seem less closely related.
2. You now have two lists. Take the first list and rank the ideas in order of their importance. Are all your ideas of equal importance? If not, can ideas be grouped together? Do some grouped ideas now have more importance than single ideas? We can determine their relationship by now ranking those ideas in sequence. Is it possible to create a narrative of ideas that unfold from a tightly compacted idea at the top of the list that generates other lists, rather like a genealogy does?
3. Look at your second list. Is it now possible to take ideas that seemed at first only marginally related to your initial question and now see them as subsets of ideas in your first list?

What this strategy does is to force you to take the component parts of what you know and rearrange them into new relationships and patterns. This strategy forces you to arrange your ideas or discoveries in light of your original premise and then generate new relationships by reordering information. There are other ways of doing this that you can find described in specialist texts dedicated to writing essays and theses.

Writing drafts is the way in which initial ideas about structure are turned into more developed pieces of writing. Your ideas are developed and linked together in sequences that relate to one another. At this stage, it is useful to break down your writing into sections or chapters. A series of written parts is easier to conceptualize and envisage completing than a single unified block. Expect to write many drafts, and remind yourself that is why it is a called a draft. Adopt the same approach to writing that you use for design, endlessly revising until you are satisfied that it approaches a solution.

The purpose of reporting research

The form that your research reporting takes is dependent upon the purpose of the research, for whom the research was undertaken, and who will be reading the report. Professional reports, research projects in academic institutions and scholarly articles for publication are three types of text that are easily distinguished, though all three have many aspects in common. As in all acts of communication, it is important to match the message to the audience for which it is intended, and to lay before

them a clear account of the choices made and the consequences thereof. Academic research requires a careful description and justification of the ways in which the research has been conducted, in order to see how the research processes might have had an impact on the results. When working with a client who is only interested in seeing a restyled object, it is not always necessary to discuss research methodology in great detail. Reporting back informally to your peers might require a different form of report than if you were reporting back to an outside body who also wishes to hear your research results.

Professional reports

Research reports that are produced in the context of professional activity may vary from those written to present to community members who have been participants in a project, or those written for a production team who will build and test the initial ideas presented by the concept development team. Other professional reports might involve presenting a jewellery design individually to a client, or presenting a design concept to a funding committee. In all these cases, the tone and detail of the report will differ according to purpose and audience, but what is constant is the need to be able to identify the purposes of the research and how the information can be communicated clearly and appropriately. Often, research reports within institutions have an established format that you will need to identify, and then adhere to. In general, the form of the professional report adheres to the basic structure, if not the detail, of academic reports.

Academic reports

Research reporting is playing an increasingly central role in the monitoring and validation of design practices within tertiary institutions. The way in which research is conducted is important in universities because, as we have observed throughout the book, the way in which researchers think about their research and frame how it is undertaken reflects on their eventual findings. Because of this, the form in which researchers submit their findings is standard and regulated. This means researchers are not only reporting on their findings but also on the broader intellectual and procedural context in which the research took place. The reason that academic research is monitored like this is that the generation, collection and analysis of data sometimes needs to be tested, replicated or developed by other researchers. To do this there needs to be an understanding of the research processes used by the other researchers that is as clear and as detailed as is possible. We explain the types and forms of academic reporting in more detail below.

Published research

Sometimes you will publish the findings of your research either in company or institutional newsletters, professional journals, specialist magazines or in academic

journals. Each kind of publication has its own practices and it is best, before you send of material for publication, to find out the form in which the publication accepts manuscripts or submissions. Most publications have detailed instructions about how submissions should be presented. The purpose of publishing your research findings is to find an audience for your research, and to advance knowledge in your community of practice. Working with publishers and finding out what they want from you, and how they want it presented, helps you to make your research better known.

The forms of academic writing

During the course of your research, you will need to communicate your ideas in writing in different forms and in different contexts. This next section looks at those forms in terms of their purpose and structure. At this point we must emphasize that we do not intend to prescribe certain approaches to academic writing. These suggestions are frameworks that can be modified or moulded to suit your particular purposes, audience and writing style. While there are certain expectations associated with academic writing, such as the need for clarity, clear structure, coherence and appropriate use of specialist discourses, we hope the following will enable you to exercise well-informed choices about how to tackle the demands of academic writing. In the sections that follow, we discuss the particular writing tasks and expectations associated with producing the following types of text: the research proposal, the research report, the exegesis and the thesis.

The research proposal

Every project has to start by gaining the approval of a client, a funding body, a supervisory team or committee. Funding bodies usually have pro forma in which the criteria for application are clearly laid out. In the professional world, presentations conform to a house style and some are more formal than others, but whether your audience is academic or professional, the intent is to convey as clearly as possible the reason for the research and explain how it will be undertaken. What follows is a generic introduction to a research proposal. Although it is useful, it cannot encompass every variant on the format. Every institution will have its own practices laid down somewhere; the trick is to find out what these are and to adhere to the format that is required.

A research proposal is used to demonstrate that your research question addresses a problem that is significant enough to warrant investigation. The proposal also needs to demonstrate that you know how to go about investigating in order to produce a result. You will need to suggest the significance of what you are doing, as well. For example are you building on past research by revisiting or reinterpreting past research, or instigating new research?

A research proposal structure would need to include:

The title of your project. Titles are a very important part of framing your research for your readers. If you have a precise title, it immediately frames your research problem and question in a way that is clear and easily understood.

The research problem and the research question. As we have mentioned during the course of the book, the relationship between problem and solution is the well-framed question. Make sure your question is clearly understandable in a sentence or two. It can be developed and expanded in more detail if necessary, but if a question cannot be expressed succinctly then it casts a long shadow over the viability of your whole proposal.

Your aims and objectives. The usual differentiation between aims and objectives is that aims are more general and broader in scope than objectives, which describe the specific intentions and the different stages in the process that will come together to bring about the final accomplishment of your aims.

The background to the research. You may have to summarize your past work in the area in which you are researching and/or indicate the sort of research that has already taken place by others in the form of a brief literature review. You may need to contextualize the way in which your proposed research will complement or contradict other research in parallel areas of study. You will need to document the reasons why this research is important at this particular time. Does the research address a well-defined problem, or is it a problem that has only been recently identified? Does the research form one part of a wider research project, involving a network of researchers, or is this an independent study?

Your methodology and methods. Where does your research fit methodologically, and why have you placed it there? What are the research methods that you have chosen for data collection, and what are the reasons for those choices? It will be useful to discuss your broader research philosophy before you focus on the ways in which you will collect data and how you propose to analyse it.

Your outcomes. How will you articulate what you have discovered? Will your research be made manifest in improved creative and productive thinking on your part? Will it result in the production of objects or systems, or an analysis of objects and systems for publication? Will there be a mixture of outcomes?

Budget. You might need to address the cost of materials or facilities, budget for travel or assistance or provide an overall budget for the cost of the whole project.

Timetable. Is there a time limit set for the completion of your research? How long will the component parts of your research take to complete?

This is a very general structure, and the amount of detail required from you will depend on why the research is being undertaken and for whom. Always remember that the purpose of tasks like this is to communicate to others what you are doing, or intend to do. The fundamental principle of communication theory still applies in environments like this; in order for your message to be understood, it must be framed within the reference points of the receivers of your message. That is, tell your audience what they need to know, not what you think they ought to know.

Matching your intentions with the expectations of funding bodies is especially important. Applicants requesting funding are usually given very clear guidelines as to what is expected from them. In writing funding requests, the proposal structure

would remain much the same, but usually more detail is required from you about your methodology and methods and (obviously) your budget for the project.

The research report

There are common elements to all forms of research reporting. The structures we present below are generic, and institutions have their own formats that you should be aware of. The following outline is that of a typical research report. A research report is used for research that is exclusively empirical or quantitative and deals solely with technical concerns.

1. Introduction. In a research report the introduction, often no more than two pages, summarizes the entire project, and its conclusions in a way similar to an abstract. There are typically three parts to the introduction:
 1.1 The research problem and/or research question. State the problem and/or the question. Describe the context of the problem.
 1.2 Summary of the project. Describe the background context to the research task. Describe the methodologies used. Describe your results.
 1.3 Conclusions. Describe your recommendations. What are the implications of those recommendations? What are the institutional actions required, and what are their costs?
2. Table of contents.
3. The research problem.
 State the problem and/or the question.
 Describe the context and background of the problem.
 Describe how previous research has addressed the current problem in any form.
 Discuss any previously attempted solutions and identify any published reports.
 Analyse the problem by identifying the constituent parts of the problem and explaining how each part will be addressed.
 Discuss your methodology for addressing the problem.
4. Design specifications.
 Describe your design and its functions. Where relevant refer to details and component specifications through the use of diagrams and drawings.
 Describe how the design will meet the specifications raised by the research.
5. Design performance.
 Describe how your design will meet the required needs. Back up your observations with data.
6. Design testing.
 Describe how your design has been/will be tested, and what those tests consist of.
7. Production schedule.
 Describe the production procedures in sequential steps, and if necessary provide a timetable of events.
8. Cost analysis.
 Estimate the cost of parts, materials and production of your design.
9. Conclusion and recommendations.
 Explain how your design solution has resolved the problem.

Explain how this solution may relate to further developments or future projects.
Explain any implications of your solution.
10. References.
11. Appendices.

The exegesis and the thesis

There are two other forms in which research is reported in academic contexts: the exegesis and the thesis. Here we quickly identify the differences between them, as they serve slightly different functions.

The exegesis has a history of association with the creative disciplines, where it is understood as a critical and analytical document submitted alongside a creative project. It is a form that is increasingly being adopted in design areas as well, where an exegesis is submitted alongside a design project. The function of an exegesis in design research is to inform and expand upon the finished design solution. It addresses the contexts of the researcher and the subject of research. It is different from the thesis because the exegesis expands on the methodology, parameters and context of the project rather than being a stand-alone piece in its own right (Ravelli & Ellis, 2004, p. 84). The thesis (sometimes called a dissertation) is based on a research question and is self-contained. It includes a detailed literature review and a methodology section, and it records the results of a programme of research.

The exegesis

An exegesis varies in length from institution to institution, and while the structure may also vary slightly, the purpose of it remains constant. The exegesis should be thought of as integrated into the practice component. Just as the practice of design is a mixture of doing and thinking resulting in praxis, the exegesis should be thought of as a reflexive engagement with the act of designing. In an exegesis, the literature review (see further on) is often incorporated into the main discussion rather than treated as a separate section.

1. Title.
 Titles should be clear and directly relate to the topic of your research.
2. Introduction.
 Introduce the reader to the structure of your exegesis. (This is important, as the structure is different in detail from institution to institution.)
3. The research problem.
 Introduce the research question that drove your design project.
4. The background to your research problem.
 Contextualize the problem.

What are the practical concerns of the problem you are investigating? How does the problem impact upon the material conditions that surround it? How have the material circumstances that surround the problem created the problem?

What are the theoretical issues that surround your problem? Is the problem ideological? How has the problem been theorized previously?

5. Conceptualizing the problem.

Discuss the ideas and theories that surround the problem, including a reference to relevant literature, and explain how your research questions address them. What historical, cultural and social contexts do you need to consider in approaching your project?

6. The practical contexts.

Explain the solutions to your design problem, or the design itself in relation to the material and theoretical points you have already raised.

7. Conclusions.

Summarize the conclusions of your research and discuss the implications of your research.

8. References.

9. Appendices.

The thesis

The format of the thesis is standardized across most tertiary institutions internationally. The sections do not have to be of equal size. Some may be a chapter's length, while others (such as the results and findings) may consist of two or more chapters.

1. Abstract. This is a very short summary of what is in your thesis. It is usually around two hundred words long, and it describes objectively and in the third person the research question, methodology and findings of your research.

2. Table of contents.

3. The research question. Establish the problem you have identified and introduce your research question. Explain briefly how you think your questions resolve the problem and suggest a solution.

4. Background to the study. How has previous research addressed the current problem previously? Has the problem been defined before? Have there been previously attempted solutions? Do you have a personal history of involvement with similar problems, questions and solutions?

5. Literature review. This is a review of books, articles and technical reports that are relevant to your research. We discuss the literature review in more detail below.

6. Theoretical perspectives. Do you have to describe a particular approach you have taken? If so, you will also need to explain what it is and the impact it has had on the way in which your data collection and analysis has taken place.

7. Methodology. Discuss your research position and, in light of that, describe the methodologies you have chosen, explain why you have chosen them and how you used them. We discuss the methodology section in more detail below.

8. Results and findings. In this section you describe the data you collected, explain your analysis of it and justify your interpretations. This could be thought of as the most important part of the thesis, as it is here that your own new research comes to the fore. This is an opportunity for

you to be creative in choosing how best to present your research. We consider some possibilities for this later in the chapter.

9. Conclusions. How successful was your research? How did it relate to other similar problems and solutions? What are the implications of your research? Will it continue? If so how?
10. References.
11. Appendices.

The literature review

A literature review is an essential part of a thesis. Its purpose is to describe and critically assess the body of literature that surrounds your research. It is usually approached in three stages: a literature search, a period of familiarization with the literature as you read it and, finally, a critical review. It is important before you start that you familiarize yourself with your institution's preferred referencing system so that you can keep an accurate bibliographic record of what you have read, as you read it. A common misunderstanding is that the literature review is a record of the work of key writers in the field. The literature review should focus on the key concepts that are relevant to your study, so it is important to ensure that these concepts form the principal themes of your review.

Institutional libraries have search facilities and access to databases that give you access to millions of articles and books. You need to be strategic in your approach to searching such huge amounts of information. Before you start to search for relevant literature, have a series of key words, concepts and subjects that are relevant to your research that you can enter into the search system. The intention of this search is to discover what texts are available to you. When you start, it will seem like an impossible task to identify what the key texts in a field are, but after a couple of sessions of skim reading and cross referencing and going backwards and forwards to the databases, you will soon discover texts which are constantly referenced, and start to build up a picture of other texts which are useful to you.

We have already talked about the necessity of having a system when note taking. Keep accurate and consistent records of the books you are using. Keep track of the passages that are useful to you and that you have paraphrased, and never copy down quotes from a text without making clear that it is a quotation and without recording all the citation details. Prepare for your reading by planning the process and making decisions as to how long you will read and what you want to achieve from it. Taking notes is a deceptive activity. While it can give the illusion that things are happening, sometimes note taking can be a useful way of avoiding having to think more creatively. When you are reading, these are some of the questions that you should be considering:

- What kind of text are you reading? Is it an academic journal article, a professional magazine, a research report, an online article or a book? Is it a descriptive account, an analysis, a report of an empirical study or a theoretical study?

- What discipline area does it come from? Is it a sociological or political study, a cultural studies interpretation, or an historical account? Is it narrow in its discipline focus, or interdisciplinary in its approach?
- Does the author's voice come through in the writing? Does the author have an identifiable ideological or cultural opinion? Is there an identifiable theoretical perspective that runs through the book? Is it interpretive or analytical?
- How can you use this text? Does it support or contradict your position? Is that a good or bad thing?

If you can learn to read critically, then you can start to marshal the texts you are using into different kinds of categories: subject matter, methodological approach, texts that are supportive of your argument, those that are contradictory to your position, factual reports, interpretive, well regarded, mould breaking and so on. Once you have an understanding of the sort of material you have in front of you then you can begin the third phase of the review, which is a critical assessment and analysis of the literature.

A literature review is a synthesis of the literature, not a descriptive account of it. Your original research questions should provide the focus when writing the review, as they will act as a regulator of what you need to discuss. If you start to describe something, the contents of a book or a concept, and you are not sure whether it is relevant, simply ask yourself if it relates to your question. If it doesn't relate then put it to one side.

The structure of your review is that of the classic academic essay: an introduction, your argument and a conclusion.

Introduction. Summarize your research question and identify a number of points that you wish to discuss. These could be ways of defining an issue or debates that surround it. Try and give a sense of where your ideas sit in the general landscape of ideas on the subject.

The argument. Try and organize your review so that it provides a set of interconnected ideas.
Is there an historical perspective that needs to be established?
Are there different discipline perspectives on how to identify and understand your problem?
Are there different ways of interpreting your problem?
What are the key schools of thought that have framed the debates you are examining, and who are the key individuals who have engaged in the debates?
What are the current issues or research focuses that relate to your topic?

Conclusion. Summarize those points that you think are central to your review and analysis of the texts. Most importantly, identify those texts and the ideas they promote that you think are central to your research. Explain how and why they are important.

The literature review is an essential part of your research, and should be thought of as part of the research process as well as part of the final research text. An important function of the literature review is to locate the research and research problem in the context of the knowledge that already exists in the field, so it becomes a guide to the ideas that surround you as you conduct the research. Some texts will present

ideas that have been endlessly discussed and are easily comprehensible. Sometimes you will be reading texts that need constant rereading in order to make sense of them. Such texts may be discussing ideas that are still difficult to grasp even by those who are writing about them. What you are reading is the struggle they are having in comprehending what they are discussing. Whether the texts you are using are easy or difficult to understand, it is your responsibility to ensure you engage with them. If you do not, then you are neglecting an important part of the research process.

Writing about methodology

The methodology chapter of your thesis will be best located so it leads into your presentation of your results and findings. A clear explanation of the methodological decisions that you made is essential for readers to be able to evaluate the reliability, veracity, authenticity or validity of the research that you are about to report. In the methodology section, it will be important to clearly map out and justify the different methodological decisions you made. The methodology chapter should provide a clear account of how you conducted your research, and why you did it that way.

The methodology section of the thesis should have two connected but separate parts: methodology and methods. As discussed in Chapters 4 and 5 of this book, these are distinct but intimately connected components of your research. While each research project will treat the discussion of methodology differently, there will typically be certain core elements.

1. In the discussion of methodology:
 Begin with a statement and discussion of your research position, including an analysis of your perspective in relation to the research problem, a discussion of your theoretical lens (if appropriate) and a rationale for your choice of methodology. For example, have you chosen to conduct an ethnography, or case study, or have you chosen mixed methodologies, and on what basis have you made these decisions?
2. In the discussion of methods:
 Provide a clear outline of the methods you chose to collect data. Did you conduct interviews or observations or analysis of visual texts, or a combination?
 Describe the participants in your research and explain on what basis you selected them. What steps did you take to ensure that the data you collected was authentic/valid/reliable, as well as appropriate? For example, did you use triangulation, and how? Explain the strategies you used for data collection, and why you chose them. List your data collection questions such as interview questions or survey items. (You might prefer to place these in an appendix if they are long.)
 Describe and explain how you analysed the data. If your research involved human participants, provide a brief account of the steps you took to ensure that your research was conducted ethically. If necessary, include any relevant documents that are important to support your discussion of methodology in an appendix (for example information letters and ethical conditions, interview transcripts, lists of questions, survey samples and so on).

Throughout the process of writing your methodology, it will be important at all stages to include the reasons for the choices you made. You may want to think of it as a map of your research project.

While the other sections of the thesis should conform fairly closely to the structures and contents suggested here, in the results and findings section you have much more freedom to explore creative options for presenting your work. Throughout this book we have encouraged you to allow your research decisions to grow out of your original research question, and the results section of your thesis is no exception. For example, if your question focused on how individuals experience a particular system or object, then it makes sense for those experiences to form a central feature of your report. You might for example develop some narrative portraits (see Pearce, 2008a) to capture coherent pictures of participants' experiences. You may also wish to include different kinds of texts, such as personal reflections, recounts of events you have observed or been involved in or illustrated timelines to show developments over time. The project sketches in earlier chapters include some ideas about the different types of research texts that could be produced to correspond well with the subject matter and focus of the research. We encourage you to explore innovative ways to represent your research, which for designers would include the use of visual texts. We now discuss this possibility.

Representing data visually

In this final section of the chapter we focus on strategies for presenting data visually. Like all the ideas we have talked about throughout the book, ideas about what can and can't be presented visually can be challenged, mixed and reinvented. We would encourage you to think about ways of communicating information or concepts in visual form when that is appropriate. We assume that as designers the potential of information graphics is something that you are already aware of, though you might perhaps be unsure of how to use it in reporting your own research. Visuals can be used to represent objects and human interaction with them, and the relationship between systems and objects. Visual information can also be used to contextualize ideas as well as used to represent data graphically.

Illustrations are essential in providing visual examples of objects that are being researched, how the appearance of objects may have changed as the result of research, and data about construction details or page layouts. Sometimes illustrations are records of events that took place and can be used to describe events in narrative sequence. Much design is traditionally about the visual and the appearance of things, but that is no longer necessarily the case as contemporary design moves into the design of systems. The interaction of abstract systems is often best expressed visually rather than in long, descriptive passages of text. Illustrations have the function

Will the concepts be more effectively communicated through pictures or through text? Generally speaking, images alone can be quite ambiguous. You should consider at least some text to anchor the meaning of your diagrams and illustrations.

Figure 8 How to use illustrations (Stuart Medley).

of representing the appearance of things and also in assisting the understanding of abstract concepts.

How you use visual data also depends on what you have to communicate. Sometimes large and often complex amounts of visual data have to be condensed and presented visually, but it is a fallacy to think that because data was collected visually

(either through drawing or by cameras) it also has to be presented visually. For example as part of the redesign of a railway station forecourt, a design team has organized the taking of extensive CCTV footage with the intent of analysing peoples' behaviour when buying magazines at a railway kiosk. Collecting data in this way is useful because it is objective and can be shared amongst researchers in a way that personal notes cannot. (However, personal notes are valuable for different reasons. A note taker can observe and interpret events in context in a way that a camera is unable to.) The footage, though, is just raw visual data that exists in time, and it still needs analysing and abstracting. It might be enough to summarize twenty-four hours of visual footage with a paragraph that describes how the majority of users behave in navigating the space around the kiosk. If the findings are more complex and don't respond to a single summary then a diagram that maps out the varying patterns of movement of people across the platform might be more appropriate. The collection of data visually and its visual representation do not have to match one another. On other occasions there will be data whose collection has no relationship to the visual but is nevertheless best expressed visually. For example after a series of discussions with members of focus groups about how they envisage the station forecourt developing as a retail area, it might be that a variety of opinions held by members across the groups might be expressed in graph form, where the axes are numbers of individuals and the different opinions held.

When representing research into human interactions with systems and designed objects, the visual has a powerful role to play. In some research, you may have been engaged in a form of what is called visual anthropology, what we would prefer to call visual ethnography. In this practice, the researcher uses visual means of recording data about social practices within a community. As the veteran anthropologist Margaret Mead points out, 'It has been possible in the past for the filmmaker to impose on the film his view of culture and people that are the subject of this film' (Mead, 1995, p. 6). There are ethical questions raised about the use of visual material when crossing cultures. For example the designer working with Australian Indigenous groups on design tasks must make sure protocols are followed in both the photographing of objects and people and the subsequent display of them (NFSA, 2009). Researchers who use photographic images to support their findings are faced with the same questions of values, ideology and ethics about using certain visual imagery as they are about other aspects of their research. The reflexive positioning of the researcher is a continual process!

Not all images of cultural practices are as charged as others. Other forms of photographing social practices are very useful in reinforcing narratives about the use of objects. Empirical research into the functionality of an object, for example, could easily involve the filming of people handling objects in order to gain a better understanding of how they are used. For example your research may be an investigation of how users handle a newly designed phone. Your central question could examine whether users would operate the phone with one hand or with two hands. From film of a focus group where users were given the phones to handle you could isolate

images that might show pictorial evidence of the way in which the phones were handled intuitively, and then after instruction. These images could also be used to reinforce a narrative of events in much the same way as comics unfold stories in time.

The unfolding of narratives pictorially (for example, to show the use of playground equipment by children), to show the sequencing of events (to demonstrate the ways in which the assembly of cars can be changed) and to demonstrate the passage of time (to show the effects of stress on designs) can all be revealed through the use of photographic images. These concepts can also be conveyed using other forms of information graphics.

Information graphics, as we currently understand the term, have their origins the work of Otto Neurath who developed the isotype as a form of international visual communication in the first part of the twentieth century (Eve & Burke, 2010). The purpose of Neurath's graphics was to present information as quickly and as efficiently as possible. He showed how complex statistical information can be presented in pictorial forms that are easily understood, how concepts can be summarized and how physical systems that cannot be photographed, such as wiring circuits, can be presented in an edited, abstracted form in which the information about their compete structure can be understood. Information graphics range from devices such as pie charts and graphs to pictograms and visual graphics that are used to explain complex interlocking systems. Information graphics can be used to illustrate physical events that occur over a period of time, such as the evolution of product development, or to illustrate more abstract concepts such as the impact on a consumer's lifestyle of moving to sustainably produced products (Harris, 1999). The key to the successful use of the visual presentation of data is to ensure that the content or the information that you are conveying by visual means is easier to understand visually than through text, and that the information you are presenting in visual form is comprehensible to the person viewing it. Just as sentences can be confusing and poorly constructed, so too can diagrams.

Conclusion

Whoever may be in your audience, the main goal in writing about your research is to represent the processes you engaged in, the new findings and their significance as effectively and convincingly as you can. A reader of your final research text should be able to discover without difficulty the essence of your research. Throughout the research process it will be worth thinking about how best to convey that essence and how to make your final research text compelling. As this is your own research, you should feel confident in making your own informed choices about how that research will best be represented to your audience. We hope this final chapter has provided you with some useful frameworks for making those choices. We also hope that you gain enjoyment and satisfaction from engaging with the intellectual challenges of doing research in design.

REFERENCES

Adamson, I., & Kennedy, R. (1986). *Sinclair and the 'Sunrise' technology: The deconstruction of a myth.* London: Penguin Books.

AGDA. (n.d.). Australian Graphic Design Association code of ethics. Retrieved from http://archive. agda.com.au/aboutagda/more/codeofethics.html.

Allianz Group. (2010). Retrieved from https://www.allianz.com/.

Althusser, L. (1971). *Lenin and philosophy, and other essays.* London: New Left Books.

Andersson, K., Ohlsson, T., & Olsson, P. (1998). Screening life cycle assessment (LCA) of tomato ketchup: A case study. *Journal of Cleaner Production, 6,* 277–288.

Apple, M. (1996). Introduction. In P. F. Carspecken, *Critical ethnography in educational research* (pp. ix–xii). New York: Routledge.

Armstrong, H. (2009). *Graphic design theory.* Princeton, NJ: Architectural Press.

Armstrong, K. (2008). Ethnography and audience. In P. Alasuutari, L. Bickman, & J. Brannen (Eds.), *The SAGE handbook of social research methods* (pp. 54–67). Los Angeles: Sage Publications.

Ary, D., Jacobs, L., & Sorensen, C. (2010). *Introduction to research in education.* Belmont, CA: Wadsworth, Cengage Learning.

Australian Public Services Commission. (2007). *Tackling wicked problems: A public policy perspective.* Canberra, Australia: AGPS.

Bah Abba, M. (2007). Pot-in-pot cooler. In Smithsonian Institution (Ed.), *Design for the other 90%* (pp. 26–31). New York: Cooper Hewitt.

Barnes, B. (2000). *Understanding agency: Social theory and responsible action.* London: Sage Publications.

Baugnet, J. (2003). The weaving of design and community. In S. Heller & V. Vienne (Eds.), *Citizen designer: Perspectives on design responsibility* (pp. 95–105). New York: Allworth Press.

Berger, A. (1997). *Narratives in popular culture, media and everyday life.* Thousand Oaks, CA: Sage Publications.

Berman, D. (2008). *Do good design: How designers can change the world.* New York: Peachpit Press.

Bolam, B., Gleeson, G., & Murphy, S. (2003). 'Lay person' or 'Health expert'? Exploring theoretical and practical aspects of reflexivity in qualitative health research. *Forum: Qualitative Social Research, 4*(2), 26.

Bonsiepe, G. (2006). Design and democracy. *Design Issues, 22*(2), 27–34.

Bonsiepe, G. (2007). The uneasy relationship between design and design research. In R. Michel (Ed.), *Design research now: Essays and selected projects.* Basel: Birkhäuser Verlag.

Bourdieu, P. (1977). *Outline of a theory of practice.* Cambridge: Cambridge University Press.

Bourdieu, P. (1984). *Distinction: A social critique of the judgement of taste.* Cambridge, MA: Harvard University Press.

Bourdieu, P. (1990a). *In other words. Essays toward a reflexive sociology.* Palo Alto, CA: Stanford University Press.

Bourdieu, P. (1990b). *The logic of practice.* Palo Alto, CA: Stanford University Press.

Bourdieu, P. (2000). *Pascalian meditations*. Palo Alto, CA: Stanford University Press.

Bourdieu, P., & Passeron, J-C. (1977). *Reproduction in education, society and culture*. London: Sage.

Broadbent, G. H. (1966). Creativity. In S. Gregory (Ed.), *The design method*. London: Butterworths.

Brookfield, S. D. (1995). *Becoming a critically reflective teacher*. San Francisco: Jossey Bass.

Brown, T. (2009). *Change by design: How design thinking transforms organisations and inspires innovation*. New York: Harper Business Press.

Carspecken, P. H. (1996). *Critical ethnography in educational research*. New York: Routledge.

Cazeaux, C. (2000). *The continental aesthetics reader*. London: Routledge.

Clandinin, J., & Connelly, M. (2000). *Narrative inquiry: Experience and story in qualitative research*. San Francisco: Jossey-Bass.

Coffey, A., & Atkinson, P. (1996). *Making sense of qualitative data*. Thousand Oaks, CA: Sage Publications.

Collins, H. (2010). *Tacit and explicit knowledge*. Chicago: Chicago University Press.

Creswell, J. (1998). *Qualitative inquiry and research design*. Thousand Oaks, CA: Sage Publications.

Creswell, J. (2008). *Educational research: Planning, conducting, and evaluating quantitative and qualitative research* (3rd ed.) Upper Saddle River, NJ: Pearson Education International.

Cross, N. (2001). Designerly ways of knowing: Design discipline versus design science. *Design Issues, 17*(3), 49–55.

Cross, N. (2006). *Designerly ways of knowing*. London: Springer Verlag.

Crouch, C., & Pearce, J. (2010). Research in the creative disciplines: From self-expression to new knowledge. In G. Tchibozo (Ed.), *Proceedings of the 2nd Paris International Conference on Education, Economy and Society* (vol. 1, pp. 122–129). Strasbourg: Analytics.

Danaher, G. (2002). *Understanding Bourdieu*. Crows Nest, NSW, Australia: Allen and Unwin.

Day, C., & Parnell, R. (2002). *Consensus design: Socially inclusive processes*. London: Architectural Press.

de Bruijn, M., Nyamnjoh, F., & Brinkman, I. (Eds.). (2009). *Mobile phones: The new talking drums of everyday Africa*. Cameroon and Leiden: Langaa RPCIG & African Studies Centre.

den Besten, O., Horton, J., & Krafti, P. (2008). Pupil involvement in school (re)design: Participation in policy and practice. *CoDesign: The International Journal of CoCreation and Design in the Arts, 4*(4), 197–210.

Denzin, N. (2003). *Performance ethnography: Critical pedagogy and the politics of culture*. Thousand Oaks, CA: Sage Publications.

Denzin, N., & Lincoln, Y. (2008). Introduction. In N. Denzin & Y. Lincoln (Eds.), *The landscape of qualitative research* (pp. 1–43). Thousand Oaks, CA: Sage Publications

Dunne, M., Pryor, J., & Yates, P. (2005). *Becoming a researcher: A research companion for the social sciences*. Maidenhead, UK: Open University Press.

Emerson, R., Fretz, R., & Shaw, L. (1995). *Writing ethnographic fieldnotes*. Chicago: University of Chicago Press.

ERA. (2009). *2010 submission guidelines*. Canberra: Australian Research Council.

Eve, M., & Burke, C. (Eds.). (2010). *From hieroglyphics to isotype: A visual autobiography*. Princeton, NJ: Princeton Architectural Press.

Ezzy, D. (2010). The research process. In M. Walter (Ed.), *Social research methods* (pp. 61–88). South Melbourne, Australia: Oxford University Press.

Fine, M. (n.d.). *A brief history of the Participatory Action Research Collective*. Retrieved from http://web.gc.cuny.edu.

Forster, K., Gehry, F., & Richter, R. (1998). *Frank O. Gehry, Museo Guggenheim Bilbao*. Fellbach: Axel Menges.

Foth, M., & Axup, J. (2006). Participatory design and action research: Identical twins or synergetic pair? In G. Jacucci, F. Kensing, I. Wagner, & J. Blomberg (Eds.), *Proceedings of the Participatory*

Design Conference 2006: Expanding boundaries in design 2 (pp. 93–96). Trento, Italy: AMC Press.

Franzosi, R. (1998). Narrative analysis—or why (and how) sociologists should be interested in narrative. *Annual Review of Sociology, 24,* 517–554.

Geertz, C. (1973). *The interpretation of cultures.* New York: Basic Books.

Geertz, C. (1988). *Works and lives: The anthropologist as author.* Cambridge: Polity Press.

Giddens, A. (1991). *Modernity and self-identity: Self and society in the late modern age.* Stanford, CA: Stanford University Press.

Giddens, A. (1997). *Sociology* (2nd ed.). Cambridge: Polity Press.

Gillham, B. (2000). *The research interview.* London: Continuum.

Gilmore, J., & Pine, B. (1997). The four faces of mass communication. *Harvard Business Review, 1,* 32–49.

Glaser, B., & Strauss, A. (1967). *The discovery of grounded theory: Strategies for qualitative research.* Chicago: Aldine.

Glesne, C. (2011). *Becoming qualitative researchers: An introduction* (4th ed.). Boston: Pearson.

Gramsci, A., & Forgacs, D. (1999). *A Gramsci reader: Selected writings, 1916–1935.* London: Lawrence & Wishart.

Greenwood, D., & Levin, M. (2008). Reform of the social sciences and of universities through action research. In N. Denzin & Y. Lincoln (Eds.), *The landscape of qualitative research* (pp. 57–86). Los Angeles: Sage Publications.

Gustafson, D. (1999). Embodied learning: The body as an epistemological site. In M. Mayberry & E. Rose (Eds.), *Meeting the challenge: Innovative feminist pedagogies in action* (pp. 249–274). New York: Routledge.

Habermas, J. (1981). *The theory of communicative action.* London: Beacon Press.

Hall, S. (1977). *Representation: Cultural representations and signifying practices.* London: Sage Publications.

Hall, S. (1980). Cultural studies: Two paradigms. *Media, Culture and Society, 2,* 57–72.

Hall, S. (1990). The emergence of cultural studies and the crisis of the humanities. *October, 53,* 11–23.

Hara, K. (2007). *Designing design.* Baden: Lars Müller Publishers.

Harris, R. (1999). *Information graphics.* Oxford: Oxford University Press.

Hartshorne, C., & Weiss, P. (1934). *Collected papers of Charles Sanders Peirce.* Cambridge, MA: Harvard University Press.

Hebdige, D. (1979). *Subculture: The meaning of style.* London: Methuen.

Heller, S., & Vienne, V. (2003). *Citizen designer: Perspectives on design responsibility.* New York: Allworth Press.

Holstein, J., & Gubrium, J. (1995). *The active interview.* Thousand Oaks, CA: Sage Publications.

Holstein, J., & Gubrium, J. (2002). Active interviewing. In D. Weinberg (Ed.), *Qualitative research methods* (pp. 112–126). Oxford: Blackwell Publishers.

hooks, b. (1990). *Yearning: Race, gender and cultural politics.* Boston: South End.

Hussain, S. (2010). Empowering marginalised children in developing countries through participatory design processes. *CoDesign: The International Journal of CoCreation and Design in the Arts, 6*(2), 99–117.

Islam Today. (2010). Retrieved from http://en.islamtoday.net.

IYS. (2008). Retrieved from http://esa.un.org/iys/.

Jenkins, R. (2002). *Pierre Bourdieu.* London: Routledge.

Jihad Watch. (2010). Retrieved from http://www.jihadwatch.org/2010/07/uk.

Jones, J. C. (1991). *Design methods.* London: John Wiley & Sons.

Kaufman, E. (1950). *What is modern design?* New York: Museum of Modern Art.

Kearney, A. T. (2007). Foreign policy globalization index. In A. T. Kearney and the Carnegie Endowment for International Peace (Eds.), *Foreign policy*. Retrieved from: http://www.atkearney.com/index.php/Publications/globalization-index.html.

Kemmis, S., & McTaggart, R. (2003). Participatory Action Research. In N. Denzin & Y. Lincoln (Eds.), *Strategies for qualitative inquiry* (2nd ed., pp. 336–396). Thousand Oaks, CA: Sage Publications.

King, S., Conley, M., Latimer, B., & Ferrari, D. (1989). *Co-design: A process of design participation.* New York: Van Nostrand Rheinhold.

Kitching, G. (1988). *Karl Marx and the philosophy of praxis.* London: Routledge.

Kolb, D. (1984). *Experiential learning: Experience as the source of learning and development.* London: Prentice Hall.

Lather, P. (1991). *Getting smart: Feminist research and pedagogy with/in the postmodern.* New York: Routledge.

Lawrence, G. (2006). Human good and human function. In R. Kraut (Ed.), *The Blackwell guide to Aristotle's Nicomachean ethics.* Oxford: Blackwell.

Lawson, B. (2008). *How designers think.* London: Architectural Press.

Lehrer, J. (2010). *The decisive moment.* Melbourne: Text Publishing.

Liamputtong, P. (2009). *Qualitative research methods* (3rd ed.). South Melbourne: Oxford University Press.

Madison, S. (2005). *Critical ethnography: Method, ethics and performance.* Thousand Oaks, CA: Sage Publications.

Marx, K. (2007). *Capital: A critique of political economy—The process of capitalist production* (Vol. 1, part 1). New York: Cosmo.

Maton, K. (2003). Reflexivity, relationism and research: Pierre Bourdieu and the epistemic conditions of social scientific knowledge. *Space and Culture, 6*(1), 52–65.

McClennan, D. (1969). *The young Hegelians and Karl Marx.* London: Macmillan.

McNiff, J., & Whitehead, J. (2006). *All you need to know about action research.* London: Sage.

Mead, M. (1995). Visual anthropology in a discipline of words. In P. Hockings (Ed.), *Principles of visual anthropology.* New York: Mouton de Gruyter.

Merriam, S. (2009). *Qualitative research: A guide to design and implementation.* San Francisco: Jossey-Bass.

Neuman, W. L. (2000). *Social research methods: Qualitative and quantitative approaches* (4th ed.). Boston: Allyn & Bacon.

NFSA. (2009). Principles and protocols to guide research into Indigenous cultural materials. Retrieved from http://www.nfsa.gov.au/site_media/uploads/file/2010/12/09/Indigenous-FactSheet-1.pdf National Film and Sound Archive.

Norman, D. (2010). Why design education must change. Retrieved from http://www.core77.com/blog/columens/why-design_education_must_change_17993.asp.

Patton, M. (2002). *Qualitative research and evaluation methods* (3rd ed.). Thousand Oaks CA: Sage Publications.

Paxton, A. (1994). *The food miles report.* London: Sustainable Agriculture, Food & Environment Alliance.

Pearce, J. (2008a). *Identity and pedagogy: Critical reflections on university teaching.* Saarbrucken: VDM Verlag.

Pearce, J. (2008b). Narratives for reflexivity: Understanding the professional self. *Creative Approaches to Research, 1*(2), 45–54.

Peters, S., Hudson, C., & Vaughan, L. (2009). Changing ways of thinking and behaving: Using participatory community design for sustainable livelihood development. In C. Crouch (Ed.), *Subjectivity, creativity and the institution.* Boca Raton, FL: Brown Walker Press.

Plato. (1901). *Meno*. E. Seymer Thompson (Trans.). London: Macmillan.

Polanyi, M. (2009). *The tacit dimension*. Chicago: Chicago University Press.

Pugsley, A. (1980). *Isambard Kingdom Brunel: An engineering appreciation*. Cambridge: Cambridge University Press.

Punch, K. (2005). *Introduction to social research: Quantitative and qualitative approaches* (2nd ed.). London: Sage Publications.

Ragin, C., & Becker, H. (Eds.). (1995). *What is a case?: Exploring the foundations of social inquiry*. Cambridge: Cambridge University Press.

Ramazanoglu, C., & Holland, J. (2002). *Feminist methodology: Challenges and choices*. London: Sage Publications.

Ravelli, L., & Ellis, R. (2004). *Analysing academic writing: Contextualized frameworks*. New York: Continuum.

Reinharz, S. (1992). *Feminist methods in social research*. New York: Open University Press.

Reuters. (2010). Squeaky-clean Singapore launches toilet manners campaign. *WA Today*. Retrieved from http://www.watoday.com.au/travel/travel-news/squeakyclean-singapore-launches-toilet-manners-campaign-20101228–198ve.html.

Rittel, H., & Webber, M. (1972). Dilemmas in a general theory of planning. *Policy Sciences, 4*(2), 155–169.

ROCH. (2007). One toilet at a time. Retrieved from http://www.roch.edu/course/doors2cambodia/ourprojects_1toilet.html.

Roudometof, V. (2005). Transnationalism, cosmopolitanism and glocalization. *Current Sociology, 53*(1), 113–135.

Runfola, A., & Guercini, S. (2004). Sourcing strategies in clothing retail firms: Product complexity versus overseas supply chain. Proceedings of the 20th IMP Conference, Copenhagen. Retrieved from http://www.impgroup.org/uloads/papers/4548.pdf.

Salvador, T., Bell, G., & Anderson, K. (1999). Design ethnography. *Design Management, 10*, 4.

Sanjek, R. (1990). *Fieldnotes: The makings of anthropology*. Ithaca, NY: Cornell University Press.

Sanoff, H. (2000). *Community participation methods in design and planning*. New York: Wiley.

Sarantakos, S. (1993). *Social research*. Melbourne: Macmillan.

Sartre, J. P. (2000). *Being and nothingness*. London: Routledge.

Schön, D. (1973). *Beyond the stable state*. Harmondsworth: Penguin.

Schön, D. (1983). *The reflective practitioner: How professionals think in action*. London: Temple Smith.

Schön, D. (1987). *Educating the reflective practitioner*. San Francisco: Jossey Bass.

Shor, I. (1992). *Empowering education: Critical teaching for social change*. Chicago: University of Chicago Press.

Silverman, D. (2001). *Interpreting qualitative data: Methods for analyzing talk, text and interaction* (2nd ed.). London: Sage Publications.

Smith, A. (2007). Fuel from the fields. In Smithsonian Institution (Ed.), *Design for the other 90%* (pp. 26–31). New York: Cooper Hewitt.

Smith, L. T. (1999). *Decolonizing methodologies: Research and indigenous peoples*. Dunedin, NZ: University of Otago Press.

Smithsonian Institution. (2007). *Design for the other 90%*. New York: Cooper Hewitt.

Spooner, C. (2009). *logo design process and walkthrough for vivid ways*. Retrieved from http://www.blog.spoongraphics.co.uk/tutorials/logo-design-process-and-walkthrough-for-vivid-ways.

Stake, R. (1995). *The art of case study research*. Thousand Oaks, CA: Sage Publications.

Stake, R. (2008). Qualitative case studies. In N. Denzin & Y. Lincoln (Eds.), *Strategies of qualitative inquiry* (3rd ed., pp. 119–150). Thousand Oaks, CA: Sage Publications.

Stapleton, A. (2005). Research as design. Design as research. Paper presented at the International Digital Games Research Association Conference, June 16–20, 2005, Vancouver, Canada. Retrieved from http://www.gamesconference.org/digra2005.

Stronach, I., & MacLure, M. (1997). *Educational research undone: The postmodern embrace.* Buckingham: Open University Press.

Swann, C. (2002). Action research and the practice of design. *Design Issues, 18*(1), 49–61.

Swartz, D. (1997). *Culture and power: The sociology of Pierre Bourdieu.* Chicago: University of Chicago Press.

Szenasy, S. (2003). Ethical design education. In S. Heller & V. Vienne (Eds.), *Citizen designer: Perspectives on design responsibility* (pp. 20–24). New York: Alworth Press.

Tashakkori, A., & Teddlie, C. (Eds.). (2003). *Handbook of mixed methods in social and behavioural research.* Thousand Oaks, CA: Sage Publications.

Teddlie, C., & Tashakkori, A. (2009). *Foundations of mixed methods research: Integrating quantitative and qualitative approaches in the social and behavioral sciences.* Thousand Oaks, CA: Sage Publications.

Tedlock, B. (2003). Ethnography and ethnographic representation. In N. Denzin & Y. Lincoln (Eds.), *Strategies of qualitative inquiry* (pp. 165–213). Thousand Oaks, CA: Sage Publications.

Tripp, D. (1983). Co-authorship and negotiation: The interview as act of creation. *Interchange, 14*(3), 32–45.

Usher, R., Bryant, I., & Johnston, R. (1997). *Adult education and the postmodern challenge: Learning beyond the limits.* London: Routledge.

van Toorn, J. (1994). Design and reflexivity. *Visible Language, 28*(4), 316–325.

Vienne, V. (2008). My worst work. In S. Heller (Ed.), *Design disasters: Great designers, fabulous failures and lessons learned* (pp. 163–166). New York: Allworth Press.

Waks, L. (2001). Donald Schön's philosophy of design and design education. *International Journal of Technology and Design Education, 11,* 37–51.

Walter, M. (2010a). Surveys. In M. Walter (Ed.), *Social research methods* (2nd ed., pp. 151–181). South Melbourne: Oxford University Press.

Walter, M. (2010b). The nature of social science research. In M. Walter (Ed.), *Social research methods* (2nd ed., pp. 3–31). South Melbourne: Oxford University Press.

WaterAid. (2010). Water Aid's world's longest toilet queue. Retrieved from http://www.wateraid.org/uk.

Webster, H. (2008). Architectural education after Schön: Cracks, blurs, boundaries and beyond. *The Journal for Education in the Built Environment, 3*(2), 63–74.

Wenger, E. (1999). *Communities of practice: Learning, meaning and identity.* Cambridge: Cambridge University Press.

Williams, R. (2003). *Television: Technology and cultural form.* London: Routledge.

Wink, J. (2005). *Critical pedagogy: Notes from the real world* (3rd ed.). Boston: Pearson Education.

World Toilet Organization. (2010). Retrieved from http://worldtoilet.org.

Yin, R. (2008). *Case study research: Design and methods* (4th ed.). Thousand Oaks, CA: Sage Publications.

INDEX